KT-458-920

Impressionism
&
Modern Art

Impressionism & Modern Art

The Season at Sotheby Parke Bernet
1973-74

Edited by Michel Strauss
Introduction by Douglas Cooper

SOTHEBY PARKE BERNET PUBLICATIONS
LONDON & NEW YORK
1974

© Sotheby Parke Bernet Publications Ltd. 1974
Sotheby Parke Bernet Publications Ltd.,
36 Dover Street, London W1X 3RB
and 81 Adams Drive, Totowa,
New Jersey 07512
Printed and bound in the Netherlands by
4P Drukkerij Reclame B.V., Rotterdam

Assistant editor: Stephanie Evans
Designer: George Evans

ISBN 0 85667 008 1

Contents

Early Collectors of Impressionist Painting

DOUGLAS COOPER

The year 1974 marks the centenary of the opening in Paris of the first exhibition of a mixed group of some thirty relatively unknown, and in part contested, artists who appeared before the public under the label *Société anonyme des artistes peintres, sculpteurs, graveurs etc.* This collective exhibition, organised by Monet, Renoir, Sisley, Pissarro, Degas and Berthe Morisot, in association with other young painters of whose works they approved, was intended to establish a direct contact with the public and avoid having their pictures censored by the Salon jury. They had hoped that Manet, their friend and hero, would also join them, but he declined because he was not prepared, as they were, to flout the Salon and the Fine Arts 'establishment' so openly. The *Société Anonyme* was founded as a joint stock co-operative venture, each member paying his own way with a financial contribution and showing what he chose, the hope being that at the close enough money would be available to pay a dividend. This proved not to be the case after all expenses had been met, but these artists felt that by holding their own exhibition they had at least avoided the stigma of being herded by officialdom into some Salon des Refusés. For this first exhibition, the organisers brought together 165 works by over 30 artists which were shown, in the commercial centre of Paris, in a building on the corner of the Boulevard des Capucines and the Rue Daunou, in premises recently vacated by the photographer Nadar. The opening date was April 15th, 1874.

As it turned out, the paintings on view were greeted with howls of ridicule, both by the critics and by the public who paid to see them, as the work of artists who 'appear to have declared war on beauty', to quote Jules Clarétie an influential critic of the period. No adjective was too strong, no invective too fierce to berate what they considered imbecile, vulgar and a mockery of true art as they understood it. As a result, very few paintings were sold — mostly to friends — and to all appearances the show was a catastrophe. Only some 4,000 people went to see it during the four weeks it remained open — about 100,000 went annually to the Salon — and they no doubt were motivated more by curiosity, outraged smugness and a desire to laugh than by a genuine interest in art. Nevertheless, this exhibition generated a sense of solidarity among the artists concerned and brought them into unexpected contact with people who enjoyed and began to buy their pictures. More importantly, this exhibition — which was to be followed by seven similar ones during the ensuing twelve years — also initiated a fundamental shake-up in the seemingly settled world of art and launched a new pictorial movement, which was variously referred to as 'realism' or 'naturalism' until Courbet's old friend Castagnary, taking his cue from a picture exhibited by Monet, dubbed it 'Impressionism'. Thus began that epoch of independent exploratory creativity in the fine arts for which even now, one hundred years later, no better name has been found than that ridiculous expression 'The Modern Movement'.

What was the fuss all about? John Rewald, in his *History of Impressionism,* sums up the situation after this first exhibition of 1874 as follows: 'The public, obviously, was not yet ready to accept their innovations, but the Impressionists, having tested their methods individually and together, knew that they had established a great step forward in the representation of nature since the days of their masters, Corot, Courbet, Jongkind and Boudin. The general hostility could not shake their convictions, but it could and did make life miserable for them. Yet they stoically accepted, without ever deviating from their chosen path, a situation which obliged them to create in a void. If it took courage to enter upon a way of poverty, how much more was needed to continue for many years making unbelievable efforts without any encouragement? Such a decision required the strength to overcome one's own doubts and to progress with no other guide than oneself. Without hesitation the Impressionists continued in complete isolation their daily efforts toward creation, like a group of actors playing night after night to an empty theatre'.

This so-called First Impressionist Exhibition enshrined a courageous defiance of the art 'establishment' of the Third Republic, and set a precedent which was to inspire resistance in at least three succeeding generations of artists. Yet it is not so much the heroism of these artists but more specifically the freshness of their vision, the vitality and tonal subtlety of their supremely convincing and appealing paintings, their joyous and unalloyed acceptance of life, as well as their attachment to human values celebrated in the commemorative exhibitions of Impressionist Masterpieces held in the Louvre and The Metropolitan Museum of New York during the autumn of 1974. Throughout the one hundred years that separate the 1874 exhibition from today, the paintings of the Impressionist masters have continually grown in popularity around the world and increased several thousand times in financial value. They have also changed hands many times, until nowadays they are widely distributed in public and private collections in many countries.

My purpose here is to examine how, in the face of great hostility, the Impressionist painters nevertheless attracted to themselves early on a body of admirers, collectors and critics, from outside the conventional art world, who took up their cause and bought their works. These men relied on personal discrimination and an innate sense of quality, and in so doing established a pattern of judicious patronage which lasted for some fifty years. Not for them the guidance of those in authority or the flabby compromise of buying by committee. They saw, they knew and they set an intelligent example.

As a result of the initiative of a growing number of enlightened *amateurs* of painting, Manet, Monet and their friends gained acceptance for their way of painting in France and America within fifteen years, so that by the later 1880's they were selling well. By that time, however, a new generation of innovators — Gauguin, Seurat, van Gogh and Toulouse-Lautrec — was meeting the same sort of opposition that the Impressionists had known and facing similar problems with regard to finding purchasers for their paintings. And so it went on through the periods of the Nabis, the Fauves and the Cubists, though with the appearance of each new style the degree of resistance by the public lessened and the time-lag between refusal and acceptance became shorter.

It is easy to account for this transformation of man's artistic tolerance by an unconscious change in his visual sensibility, due to repeated exposure to new and unfamiliar visual experiences. But that is not the whole truth. We must pay no less attention to the role played in activating this

process by those artists, *amateurs,* enthusiasts, dealers and critics who spontaneously supported the misprized innovators through difficult times and contributed directly to the evolution and spreading of European culture by enabling others to share their personal discoveries and aesthetic pleasures. The challenging example of these men encouraged others to take the plunge, to forget about prejudices and conventions and to keep the impetus of the 'modern' movement alive from one decade to another. I propose, therefore, to make my personal contribution to the centennial celebration of Impressionism by recalling the names of some of those highly perceptive individuals who, by praise, patronage and purchase, led the artistic taste of three generations in the West between 1870 and the outbreak of the First World War.

Before I go further, I would underline that the efficacy and validity of their achievements depended entirely on acute personal judgment, on an ability to discriminate between good art and bad, between technical prowess and flummery, between authentic stylistic innovation, dead formulas and a clumsy striving after an eccentric effect. For fifty years the sights of avant-garde patronage were aimed high, serious pictorial innovations flourished and the artists had time gradually to bring them to perfection. But unfortunately familiarity breeds contempt, and a time came in the aftermath of the First World War when art itself, rather than the conventions which had been built up around it, became the target to annihilate. Destruction for its own sake seemed, from then on, more tempting than the pursuit of creative ends, while manifestos, pranks and experiments began to proclaim a new order of things. Thus since 1950 all sense of taste and discrimination have gone by the board, because minds have become progressively befuddled and all meaningful standards of visual and critical awareness lost. Nowadays, therefore, a new buying public, which claims to be interested in art, has appeared on the scene and regrettably displays a willingness to accord equal artistic validity to a brilliant (or even inferior) Impressionist landscape of the 1870's as to a Tahitian painting by Gauguin, a cubist painting by Braque, a cubistic pastiche by Metzinger, a bareboned geometrical equation by Mondrian ,some eye-fooling triviality by Vasarely or a conglomerate of burnt sacking and garbage by a kid of nineteen years of age. Such, alas, is the long-term, negative, aesthetic outcome of the triumphant battle waged by the Impressionists, their successors and their supporters against the deadening hegemony of academic standards and ideals. But I do not intend to give here any more thought to the hideous obverse of the medal.

The new style of painting, which was initiated by Manet in the early 1860's, found its first defender in the budding journalist and novelist Emile Zola, an erstwhile school friend of Paul Cézanne from the Collège Bourbon at Aix, who at that time was still a struggling beginner. Zola was neither rich enough, nor sufficiently knowledgeable in the field of art, to write a valid exegesis of what he saw or to buy a picture that he liked. But from 1866 on, he took up the cudgels on behalf of Cézanne and his Parisian artist friends, defending their right to paint according to their individual temperaments and predicting that in due course their works would be hanging on the walls of galleries in the Louvre. All his life, Zola was to relish an opportunity to fight injustice with the only means at his disposal: a brain, a flow of clever reasoning injected with flashes of telling irony, and a sharp pen. His support of the Impressionist painters and Manet in the early

years was greatly appreciated by the artists and, in due course, he became possessed of a powerful, small collection of paintings which enhanced his growing literary reputation. After Zola, two other personalities attached themselves to the group in 1867-68: Théodore Duret, the son of a rich brandy merchant in Cognac, and Arsène Houssaye. Duret, a cultivated young man who had artistic interests, met Manet by chance in a restaurant in Madrid 1865, worked as a journalist, became an active politician of liberal tendencies, wrote extensively about art (especially that of his contemporaries), and from 1870 onwards assembled a formidable collection of major Impressionist works by Manet, Cézanne, Monet, Renoir, Degas, Pissarro and Sisley which he had to dispose of in 1894 owing to financial difficulties. Arsène Houssaye, on the other hand was a Superintendant of Fine Arts and editor of a periodical called *L'Artiste,* who began by buying Monet's *Women in Green* in 1868 as well as a painting by Renoir, and went on from there during the 1870's to publicise Impressionist painting and make an interesting personal collection.

We may regard these three men as having shown the way for the first purchasers of paintings by the young Impressionists before 1874, who were either close friends or fellow artists. Thus Degas had a supporter in his rich banker friend Henri Rouart, also an amateur painter, who went on to buy Manets in the 1870's. Monet was helped by the purchases of a well-off young medical student-cum-painter from Montpellier, Frédéric Bazille, who had been a fellow pupil with him in Gleyre's studio in 1862-63, as well as by Daubigny, a kind admirer, who bought one of his Dutch canal scenes in 1871. Then too some early works by Monet were acquired in 1868 by a ship-chandler of Le Havre (where the Monet family lived) named Gaudibert, who also commissioned the impoverished young man to paint a full-length portrait of his wife. Renoir, meanwhile, was given some encouragement by the Le Coeurs, a family of architects and artists who found him commissions for decorative wall-paintings and frequently sat for their own portraits. True, Manet, Sisley and Cézanne found no purchasers for their works during the 1860's, but being well-to-do they did not depend on sales for a living.

Materially speaking, the situation of the Impressionists seemed for a while likely to improve immediately after the Commune. But it was not to be. It was in London, in 1870, where they had taken refuge during the Franco-Prussian War, that Monet and Pissarro made the acquaintance of the well-known Parisian dealer Paul Durand-Ruel. During the five years that his gallery on Bond Street was open, Durand-Ruel showed works by the young Impressionists, while in Paris, after 1872, he became the most important single purchaser of works by Manet and the others. But the 1870's were difficult years financially, and Durand-Ruel often had to curb his liberality owing to repeated crises on the Bourse and bankruptcies. Nevertheless, it was basically his support that kept all the Impressionists — except Degas and Cézanne, who had private means — alive, working and on view. Paul Durand-Ruel had inherited from his father, an erstwhile salesman of artists' materials, a successful gallery which specialised in works by Corot and the artists of the 1830 and Barbizon Schools. His patronage of Manet and the Impressionists was an expression of personal taste and flair, though a logical extension of his stock-in-hand. But Durand-Ruel was more than just a dealer to these artists: he became an invaluable friend and, privately, a major collector of their works. Much of his original collection is still preserved today in the hands of his various descendants. Durand-Ruel's first major investment was in more than thirty paintings by Manet,

which he bought in the artist's studio in January 1872. He continued to buy from Manet till the artist's death and acquired more at his posthumous auction sale in 1883. Durand-Ruel's purchases from Monet, Renoir, Sisley, Morisot and Degas extended over more than thirty years, but he only took an interest in the work of Cézanne when prompted to do so by Monet in the 1890's, a period during which many examples appeared at the auction sales of early collectors. On the other hand, Durand-Ruel bought paintings from Gauguin in 1881 but subsequently lost interest in him.

The next most enthusiastic collector of Impressionist painting in the early days was the baritone Jean-Baptiste Faure, who acquired a considerable number of paintings by Manet in 1873. Faure, who had met Durand-Ruel in London in 1871, already owned a collection of Barbizon paintings, but on his return to Paris began exchanging these for works by the new generation of artists, his discovery of Manet leading him quickly on to the acquisition of paintings by Degas, Monet, Sisley and Pissarro. Faure was a compulsive buyer, though he paid relatively low prices, and the artists acquired the habit of turning to him in moments of difficulty because he would usually pay in cash. Thus during the twenty-five years in which he was active as a patron, Faure amassed a very considerable and varied collection of major works. In 1877, Manet painted his portrait in the role of Hamlet in the opera by Thomas.

Other more modest collectors of this time whose names should not be forgotten are Albert Hecht, a banker, who bought works by Manet and Degas; also Comte Armand Doria, another banker, who bought Cézanne's *Maison du Pendu* at the Impressionist exhibition of 1874, and went on to form a very choice collection of works by Renoir, Sisley and Manet. The publisher Georges Charpentier immediately liked a painting by Renoir which he saw in a sale organised by the Impressionist painters themselves in 1875 and bought it. After that he made Renoir's acquaintance, commissioned several family portraits from him and introduced him to people of the political, social and cultural worlds who frequented his weekly *salon*. Charpentier was also attracted by the painting of Monet, Manet and Sisley, whose works he bought. And it was through Charpentier that Renoir met his patron Paul Bérard, who often entertained him at his house at Wargemont near Dieppe. There Renoir was to paint several landscapes, and family portraits, as well as some decorative panels in the living-room. Another active purchaser of Impressionist paintings in the later 1870's and 1880's was Manet's friend the composer Emmanuel Chabrier, whose collection eventually contained seven paintings by Manet, eight by Monet, six by Renoir and one by Cézanne. Nor must I forget Ernest Hoschédé, director of the department store, *Le Gagne-Petit,* who by January 1874, when he was obliged to sell a large part of his collection at auction to cover his financial losses of the previous year, already owned six paintings by Pissarro, and three each by Monet, Sisley and Degas. At this sale, Impressionist paintings fetched good prices, though their values dropped again almost immediately afterwards as a result of new financial disasters. Hoschédé was to survive as a collector for a few years more, until he lost most of his fortune in the slump of 1878. He was then obliged to sell everything to satisfy his creditors and the auction sale catalogue showed him to be the owner of sixteen paintings by Monet, five major works by Manet, thirteen Sisleys, nine Pissarros and three Renoirs. On this occasion, the paintings fetched disastrously low prices. Subsequently Hoschédé exiled himself to Brussels, while his

wife Blanche took their children and went to live with Monet, to whom she was to be married in 1892.

One of the strangest people who handled a varied collection of paintings by the Impressionists and their friends was the modest colour-grinder Julien Tanguy. Tanguy had first come across the Impressionist painters in the mid-1860's, while on his rounds as an itinerant salesman of artists' materials in the environs of Paris. In particular, he was friendly with Pissarro, through whom he met Cézanne, and over the years Tanguy did much business with both artists, often accepting paintings from them instead of payment of his bills. He also gave the same help to Sisley, Gauguin, Signac and especially van Gogh in the later 1880's. Tanguy loved paintings and was a real *brocanteur* at heart, for he acquired or accepted on consignment works by all sorts of artists, which he kept in his little shop in Montmartre and would pull out to show possible customers and friends. The catalogue of his posthumous sale in 1894 lists, for instance, drawings by Carrier-Belleuse, Angrand and Puvis de Chavannes, as well as oils by Monet, Guillaumin, Bernard and Dubois-Pillet. Another unexpected patron of the Impressionist group was a red-haired pastry-cook of the Boulevard Voltaire, Eugène Murer (*né* Meunier), who had been at school with the painter Armand Guillaumin. Guillaumin introduced Murer to his artist friends Pissarro and Cézanne, sponsored the inclusion of some of his paintings in the First Impressionist Exhibition of 1874, and encouraged him to keep open house for impoverished artists and their friends in his small restaurant. Murer invited Pissarro and Renoir to decorate his premises and commissioned them to paint portraits of himself and his sister. He also bought paintings from them as well as from Monet and Sisley, though the prices he was willing to pay were so small that there were frequent disputes. But in 1880, Murer (then aged 34) became ill, closed his Parisian establishment, set up as *patron* of the Hotel du Dauphin et d'Espagne in Rouen, where Pissarro, Renoir and Gauguin stayed at times during the 1880's and began to build a small house for himself and his collection in Auvers. By 1887, according to an article by Paul Alexis, an old friend of Cézanne from Aix, Murer had amassed eight paintings by Cézanne, twenty-four by Pissarro, fourteen by Renoir, nine by Monet, twenty-seven by Sisley and twenty-one by Guillaumin, to which he added during the ensuring six years some further Cézannes and two paintings by van Gogh. But in 1896 catastrophe overtook Murer when his hotel, which had been negligently managed, was facing bankruptcy and he had to sell up his collection.

A further interesting group of lovers of Impressionist painting in Paris during the 1870's consisted of two financiers and a young stockbroker, who had begun to paint in his spare time. Gustave and Achille Arosa, the financiers, were both collectors who, before 1870, had acquired a large collection of oriental ceramics as well as many paintings by Delacroix, Daumier, Corot and Courbet. They had met Pissarro before 1870, Achille commissioned him to paint four overdoors *(The Seasons)* for his house in 1872, and they acquired an interesting group of his paintings over the next fifteen years. The Arosas were also friendly with Aline Gauguin, a widow with two young children, Paul and Marie, of whom she appointed Gustave Arosa guardian when she felt her death approaching (1866). Paul Gauguin, who was then just eighteen, went to live with the Arosa household. After the Commune, the Arosas found employment for their ward in the office of a stockbroker, where he seems to have earned good money. But all the time Gauguin's interest in art was rapidly growing. The Arosas, who also painted, encouraged him, and Gauguin was

given every opportunity to study books with phototype reproductions of Roman, Far Eastern and Neo-Classical art published by Gustave on his own press. Gauguin was encouraged to start painting seriously by Pissarro, and by Emile Schuffenecker, an employee in the same stockbroker's office. Together they went to visit exhibitions and private dealers' galleries, while on Sundays they painted in the environs of Paris. The decisive year in Gauguin's early life was 1879: in that year he exhibited, under Pissarro's sponsorship, a sculpture at the Fourth Impressionist Exhibition; he began to purchase Impressionist paintings; and in summer he was invited to join Pissarro at Pontoise for a painting holiday. Gauguin now met Cézanne, whose work he already admired, as well as Guillaumin, and he was introduced to the Impressionist circle and made contact with Durand-Ruel. Between 1879 and 1883, when the slump on the Bourse caused him to lose his job. Gauguin worked with Pissarro and Cézanne twice more at Pontoise and accumulated, by purchase, gift or exchange, groups of works by Pissaro and Guillaumin, five paintings by Cézanne, and several others by Manet, Degas, Boudin, Renoir, Jongkind and Sisley. Such was the collection which Gauguin took with him when he left Paris for Copenhagen in 1884, and which was to be progressively dispersed in Scandinavia, by his wife Mette, during the following twelve years. Thus Gauguin appears on the scene as a collector of Impressionist paintings before he began to make a name for himself as a Post-Impressionist artist.

These various individuals or groups of friends who bought Impressionist paintings and were friendly with the artists all knew or knew about each other, because they met at Impressionist exhibitions, or competed against each other in the saleroom, or exchanged visits to see each other's collection. Many of them also visited the artists in the small town of Auvers. Daubigny and Daumier lived there, Pissarro lived from 1866 to 1883 at nearby Pontoise, Murer was established there after 1879, while since 1872 Auvers had been the home of Dr Paul Gachet, a homoeopathic doctor, amateur engraver and painter, who frequently played host to the Impressionists and their friends. Gachet (born in 1828) had originally encountered Cézanne as a boy of nineteen when, himself a student, he had called on Cézanne *père* in Aix in 1858. Gachet became friendly with Pissarro in 1865 when he treated his wife and children. During the 1870's he often worked at Auvers with both of these artists, and it was Gachet who instructed them in engraving techniques. Through Pissarro, Gachet met Gauguin in 1879, and it was at Pissarro's suggestion that van Gogh placed himself under Gachet's supervision at Auvers in 1890 for the last three months of his life. Many of Gachet's artist friends painted and drew portraits of him and his daughter, or views of his house; they gave him paintings in exchange for kindnesses received; and on occasion Gachet also bought pictures from his friends. As a result, he became possessed of a fascinating collection of paintings by the artists mentioned, as well as by Daubigny, Guillaumin, Renoir, Monet, Sisley, Desboutins and Goeneutte (Gachet's taste was eclectic) many of which his son ultimately presented to the Louvre.

Another homoeopathic doctor with artistic interests was George de Bellio, a Roumanian, who was a contemporary and friend of Gachet but richer. De Bellio, who worked in Paris, saw the First Impressionist Exhibition, was in contact with Renoir and Cézanne soon thereafter, and began actively buying Impressionist paintings in 1875. He was soon friendly with Monet, Manet, Renoir and Pissarro, some of whom he treated professionally, and de Bellio continued to collect until his

death in the mid-1890's. According to an inventory of his collection made at that time by his son-in-law Donop de Monchy, who subsequently bequeathed much of the collection to the Musée Marmottan in Paris. De Bellio died owning thirty works by Monet, twelve by Pissarro, ten by Renoir, eight by Manet, five by Cézanne, three by Gauguin and four each by Sisley and Morisot. It is perhaps of interest to note that de Bellio stopped buying paintings by Sisley in 1877, when he began buying Manet, and that he ceased buying from Monet in 1881 because he disapproved of his later stylistic innovations. De Bellio is also important for having introduced Impressionist painting to Bucharest: he persuaded his cousin Jean Campineano to commission Manet to paint his daughter Lise's portrait in 1878, while he gave paintings by Monet, Pissarro and Sisley to his brother Alexandre, to his nephew Etienne and also to Campineano. Monet once said of de Bellio, and of the next collector I shall discuss, Victor Chocquet, that they were the only two who seemed to him 'to be true lovers of painting rather than speculators'.

Victor Chocquet (1821-91) was the oldest collector, but one of the most enthusiastic and discriminating, who belonged to the Impressionist circle in the 1870's. He relied on his own taste, bought only for personal pleasure, and having a well-to-do wife was not concerned with personal fame or making a profit. He was the first major collector of paintings by Cézanne. Chocquet was born in Lille, the son of a manufacturer; he, too, was relatively well-off, had an unimportant post in the Customs administration, from which he resigned in 1877, and became a generous patron to those artists whose work he particularly liked, though he was careful about the prices he paid. In the 1860's Chocquet amassed a fine collection of works by Delacroix, and this first love was to colour his taste in works by the Impressionists. Chocquet's great regret was that he had been dissuaded by 'well-meaning friends' from visiting the First Impressionist Exhibition in 1874, for when he viewed the paintings at the Impressionist auction in 1875 he was at once attracted to Renoir's paintings because he saw in them traces of Delacroix's influence. Immediately thereafter Renoir was painting a portrait of Madame Chocquet, a commission which Delacroix had been unable to accept in 1862^ From that moment, Chocquet and Renoir became friends, Renoir took him to Tanguy's shop to look at paintings by Cézanne, and he made his first purchase, then Chocquet met Cézanne and in the spring of 1876 went with him to Argenteuil to meet Monet. Large groups of works by these artists formed the bulk of Chocquet's collection, though he also bought a few paintings by Pissarro and Sisley. He was no less useful to his artist friends, however, as a mouthpiece; Georges Rivière, a great defender of the group, has written that Chocquet 'found eloquent patter and ingenious arguments to convince his listeners. He could also explain the reasons for his predilection with great clarity. Persuasive, vehement and imperious by turns, he was tireless in his persistence, yet never lost that urbanity which made of him the most charming and formidable adversary in any discussion.' Renoir painted three portraits each of Monsieur and Madame Chocquet, while Cézanne painted and drew Chocquet's portrait some six times between 1876 and 1889. Chocquet's period of heavy buying lasted from 1875 to 1882, after which the pace slackened. Yet in 1888 he acquired another Monet, and in the last year of his life another flower painting by Cézanne. When Chocquet's collection was dispersed at auction in 1899, after the death of Madame Chocquet, the lots included some twenty-three paintings by Delacroix, thirty-five by Cézanne, fourteen by Renoir, twelve by Monet and five by Manet.

I have waited till the end of this part of the story to introduce the most famous collector of Impressionist paintings, Gustave Caillebotte. Caillebotte was a rich young man (b. 1848) who lived at Argenteuil on the Seine a few miles outside Paris. He was a boatbuilder by profession, had studied briefly at the Ecole des Beaux Arts and painted in his spare time. Caillebotte seems to have met Monet, Renoir and Manet in 1874-75 while they were all working at Argenteuil and quickly became a close friend and admirer of their works. In 1876 some paintings by Caillebotte were included in the Second Impressionist Exhibition, and he also participated in the three following shows. He was an active buyer of paintings by Monet, Renoir and Pissarro in the mid-1870's, while already in 1876 he made a first Will bequeathing his entire collection to the Louvre. Caillebotte went on buying, however, always with great discrimination, and after his death in 1894 his executors — his brother and Renoir — offered sixty-five paintings to the Musée du Luxembourg, which served as an ante-chamber to the Louvre for works by living artists. But the French art authorities were not prepared at that time to accept such a large gift of contested paintings and eventually proposed to the executors (in defiance of Caillebotte's intention) a mean compromise of accepting forty paintings, and leaving the other twenty-five as assets of the Estate. The Louvre thus sacrificed eight Monets out of sixteen, two Renoirs out of eight, six Sisleys out of nine, three Cézannes out of five, seven Pissarros out of eighteen and one Manet out of three. But it accepted all seven paintings by Degas. The paintings accepted were first publicly shown at the Luxembourg in 1896. After this foolish episode, it is pleasant to record that in 1878 Monsieur Le Coeur, director of the Musée des Beaux Arts in Pau, had purchased for the museum Degas' *A Cotton Exchange in New Orleans* (1873) from a local exhibition, while in 1892 the Luxembourg received Renoir's *Jeunes Filles au Piano,* which had been commissioned by the French State. These were the first Impressionist paintings to enter the French national collections.

By the early 1880's, there were numerous collectors of Impressionist painting in France and for most of the artists the years of privation were over. At that point Durand-Ruel suffered once again a reversal of fortune when his financial backer, the Union Générale, failed. It was 1885-86 before he recovered, and by that time new dealers were coming on the scene — Georges Petit, Goupil, Boussod and Valadon, Knoedler, the Bernheims and eventually Vollard — all of whom were ready to exhibit and handle works by the Impressionists, their friends and successors. But from 1886 on Durand-Ruel made a great come-back. He organised retrospective exhibitions for each of his artists in Paris, as well as major group shows in London, New York and elsewhere, thereby opening up new markets which were soon ready to absorb the paintings of younger artists whose work developed out of Impressionism. I shall not say much about the new collectors who appeared during the 1880's and 1890's because, in France as elsewhere, they tended to start by buying Impressionist paintings and then move on to more recent paintings by younger men. It would be ungenerous, none the less, not to mention a few prominent names — for example Ernest May, Antonin Personnaz, Decap, Octave Mirbeau, Comte Camondo, Ludovic Piette, Charles Ephrussi, Jean Dollfuss, the Prince de Wagram and Jules Strauss — because many of their finest possessions have by now become part of the permanent collections of museums in Europe and America. Except for Manet, who died young in 1883, all the Impressionists enjoyed a critical and material success during their lifetime. The other exception was Cézanne, though both artists and con-

noisseurs competed hotly in the 1890's for his paintings, especially after Vollard's exhibition in 1895. Thus, noteworthy purchases were made by Monet, Degas and Matisse, as well as by Auguste Pellerin and Comte Camondo, while among non-French collectors mention must be made of Egisto Fabbri and Charles Loeser of Florence, as well as of Marczell von Nemesz of Budapest.

The artists who followed the Impressionists — Gauguin, Seurat, van Gogh, Toulouse-Lautrec — never enjoyed any real success while they were alive. Gauguin had great difficulties finding purchasers for his paintings, Seurat sold nothing, Lautrec made a few sales to friends, while van Gogh sold one painting to Anna Boch of Brussels, yet within ten years of their deaths their paintings were eagerly sought after. Two very important collections of works by van Gogh were made in Holland by C. Mouwen of Breda and Hidde Nijland of Dordrecht during the 1890's, while in France Comte A.de la Rochefoucauld (who also owned Gauguins), Olivier Sainsère and Gustave Fayet were buying van Goghs from 1895 on. Before 1900 a few artists had bought paintings by Seurat, for instance Signac, Luce, van Rysselbergh and Henri van Cutsem, a Belgian. But Seurat's most active collector was the Parisian dealer Félix Fénéon. One of Gauguin's chief admirers around 1890 was Degas, who owned several of his paintings, but he had two other steady collectors in Daniel de Monfried and Gustave Fayet, both of Béziers. In the later 1890's, Vollard made a contract to handle Gauguin's last works.

The names of Gauguin, Toulouse-Lautrec, Fénéon and Vollard lead us straight into the world of the Nabis and *La Revue Blanche,* with those attendant spirits the brothers Natanson, Misia Godebska, the dealer Hessel and the theatre managers Antoine and Lugné-Poë. By this time, the official artists of the Salon had lost their former prestige and authority, while in the field of independent art different paths and tastes began to cross. The early collections of Impressionist paintings were mostly sold at auction and re-distributed. Cézanne emerged at last as a significant artist, Gauguin made stylistic innovations which looked forward to the twentieth century, while the painting of the Nabis — Vuillard, Sérusier, Maurice Denis and Bonnard — drew equally on stylistic aspects of the painting of the Impressionists, Gauguin and Cézanne. An amalgam of all these currents resulted in the final flare-up of the Fauves. The new generation of collectors around 1900 in France thus had a broader based taste in modern painting than had their predecessors, although they were less intimately involved, as friends or critics, in the lives of the creating artists.

The interest shown by the art-lovers and collectors of England in Impressionist painting during the early years makes curious reading, for though they were given many chances of seeing fine examples they remained practically unmoved if not actively hostile. Between 1870 and 1875, Durand-Ruel showed several paintings by Manet, Monet, Degas, Renoir, Pissarro and Sisley in exhibitions at his gallery in Bond Street. He organised group exhibitions again in London in 1882 and 1883, helped dealers and artists' societies intermittently to obtain Impressionist paintings for their yearly exhibitions and returned to London in 1905 with a major collection of 315 works.

Against this background we must now consider the following facts about Impressionist paintings known to have been owned in England before 1900. In December 1872, Louis Huth bought Degas' *Maître de Ballet* at Durand-Ruel's fifth exhibition. This was the first purchase made by an English collector, but it was followed between 1874 and 1876 by the acquisition of seven further

paintings by Degas, six ballet scenes and *L'Absinthe,* by Henry Hill of Brighton, a tailor. Next, Constantine Ionides bought *Le Ballet de Robert le Diable* by Degas from Durand-Ruel in 1881. Five more paintings by Degas were bought and briefly owned by the painter Sickert between 1889 and 1899. Samuel Barlow of Stakehill in Lancashire acquired four paintings by Pissarro in the late 1870's or early 1880's, while a Mr Burke of London bought three Pissarros, two Sisleys and one Degas from Durand-Ruel in Paris between 1892 and 1898. Arthur Studd, a disciple of Whistler, bought one of Monet's *Haystacks* in 1892. The publisher Fisher Unwin acquired, during the 1890's, a group of Impressionist works, including three by Degas and a flower still-life by van Gogh, while Esther Sutro bought another painting by van Gogh in 1896. Alexander Reid, a dealer in Glasgow, was also responsible for introducing Impressionist and later paintings into England. Van Gogh painted two portraits of him in Paris in 1887, and one of these hung in Reid's home. Then, after he had opened a new gallery in Glasgow, Reid brought over from Paris a stock of modern French pictures, but the list of his known sales of Impressionist works before 1901 is not long. Andrew Bain bought an early Monet, C. J. Galloway a *Crystal Palace* (1871) by Pissarro, William Burrell a small Manet, and J.J. Cowan of Edinburgh two major oils by Manet. The only other British owners of Impressionist paintings before 1905 seem to have been George Moore (who knew Manet and others before 1880) and two of his friends, Lord Grimthorpe and William Eden, who began to buy in 1896. Moore owned two sketchy works by Manet, a late Monet and a Morisot; Eden owned four Degas and two Morisots; while Lord Grimthorpe had two Manets and one painting each by Degas, Monet and Sisley. From the facts that I have been able to ascertain, I would say, therefore, that before 1905 British collectors had been in possession of some twenty-five paintings by Degas (at least eight had already left the country again), ten by Manet, four by Monet and about fifteen by Renoir, Pissarro, Sisley and van Gogh combined. This is not a spectacular record, especially if one remembers that during this period British collectors were actively buying works by Corot, Courbet, Whistler, the Barbizon School and the genteel artists of The New English Art Club. But in 1905 Hugh Lane began to buy, and he was to be the first serious collector of Impressionist paintings in the British Isles.

Collectors in Germany, America and Russia were more enterprising and courageous. In Germany, three names stand out: those of the painter Max Liebermann and Hugo von Tschudi of Berlin, and Oskar Schmitz of Dresden. Liebermann, one of the first German painters to visit Paris after the Franco-Prussian War, fell under the spell of Impressionist painting in the mid-1870's and, as soon as he could afford it, bought paintings by Manet, Degas, Pissarro and their friends during the 1890's. He transmitted his enthusiasm to the well-to-do Director of the National Galerie in Berlin, von Tschudi, who by 1898 was acquiring for himself works by Manet, Monet, Renoir and Pissarro. These von Tschudi hung in the museum galleries, until the Kaiser was informed, expressed disapproval and demanded von Tschudi's resignation (1909). Von Tschudi was immediately appointed Director in Munich, where he reinstalled his personal collection and began to build up a modern French collection in the Neue Pinakothek, with the help of contributions from his Bavarian friends and admirers. By this means, a splendid still-life by Matisse was bought for the Pinakothek in 1911. Oskar Schmitz, who began to form his important collection in about 1900, had already acquired a considerable group of Impressionist works, as well as some by

Cézanne, Gauguin and van Gogh, before 1905. He continued improving and adding to his collection for several more years. Other German collectors in the period 1895-1907 whose names deserve mention were Graf Harry Kessler, Karl Osthaus, Carl Sternheim and Paul von Mendelssohn-Bartholdy, whose taste ranged from Impressionism to Gauguin, van Gogh, Matisse and Picasso.

The first American purchaser of an Impressionist painting was a girl of twenty, Louisine Waldron Elder of Philadelphia who, on the recommendation of an old family friend, the painter Mary Cassatt, also of Philadelphia, paid $100 in 1874 for a pastel of a ballet rehearsal by Degas, which she admired in a Parisian dealer's window. Fifteen years were to pass before Miss Elder, who in the meantime had become Mrs Havemeyer, the wife of a sugar king, was able to become a major collector of Impressionist paintings. But from 1890 onwards, she and her husband were to assemble one of the greatest collections in America, greatly helped by Mary Cassatt, who continued giving advice from Paris. By the mid-1880's, a considerable group of Americans were already alert to and interested in Impressionist painting, but from the time of Durand-Ruel's great exhibition in New York in 1886 a wave of active buying started. Collectors of that time included Erwin Davis, A. J. Cassatt, W. H. Fuller and Cirus Lawrence, while after 1890 a much larger group became active, in particular P. A. B. Widener, Arthur Pope, Jerome Eddy, Cornelius Bliss, Theodore Davis, W. Church Osborn, the Potter Palmers and Mrs Montgomery Sears of Chicago. Many of these early collections were later to find their way by bequest into American museums, where they can still be seen. Some indication of how pressing was the sudden demand for Impressionist paintings in America is given by the fact that, between 1886 and 1888, Durand-Ruel had to make seven journeys to New York, while in 1889 he opened a branch of his gallery there. It is also worth noting that the Metropolitan Museum of New York accepted two painting by Manet in 1889, a Renoir in 1907 and a Cézanne in 1913.

Many American collectors travelled regularly to Europe in search of paintings, so that as they saw more of modern French art their taste moved forward and Impressionsim became for them a style of the past. For instance, in 1904 two young San Franciscans, Leo Stein and his sister Gertrude, then living in Paris, already owned a group of works by Renoir, Cézanne, Gauguin and Maurice Denis, and during the next twelve months bought others by Manet, Degas, Vuillard, Bonnard and van Gogh. Then in 1905 they and their brother and sister-in-law, Michael and Sarah Stein, 'discovered' Matisse and were soon in competition with Germans and Russians for ownership of his major works. At the same time Leo and Gertrude 'discovered' Picasso and became active collectors of his work too. The Steins fired some of their American friends with their enthusiasm, so that from 1907 on Claribel and Etta Cone of Baltimore, as well as Harriet Levy of San Francisco, joined the ranks of collectors. Thus the bases of American collecting of modern French painting from Impressionism, through the Post-Impressionist generation to the Fauves and Cubists, were well established before 1910, which accounts for the importance in this field of many American museum collections today.

The only other country from which came a small group of great collectors of Impressionist and later paintings was Russia. Three families only were involved — Morosov, Ryabuschinsky and Shchukin — each of them highly cultured and art-oriented, and having a tradition of collecting in

their blood. The brothers Mikhail (1870-1904) and Ivan Morosov (1871-1920) inherited a great fortune made from cotton. Mikhail bought, between 1895 and 1904, a select group of works by Manet, Renoir, Degas, Monet, Gauguin and van Gogh which were presented to the Tretyakov Gallery in Moscow in 1910. Ivan Morosov, who was to acquire a much larger collection, began by buying a landscape by Sisley in 1903, when he moved his home from a country property to Moscow. During the ensuing ten years he bought actively at dealers' exhibitions and auction sales in Paris, or in artists' studios, because he had decided to form a collection which would be truly representative of the best modern French art from 1875 onwards. His approach to collecting was methodical, and he chose each work with special care, so that when his collection was taken over in 1917 the Russian Government found itself in possession of a unique ensemble of some 250 works by Monet, Renoir, Sisley, Pissarro, Degas, Cézanne, van Gogh, Gauguin, Denis, Signac, Vuillard, Bonnard, Marquet, Matisse, Vlaminck, Derain, Picasso and Chagall (bought in 1916). The artists represented by major groups of works were Cézanne, Gauguin, van Gogh, Denis, Valtat, Matisse and Bonnard.

The Ryabuschinsky family were bankers, as well as dealers in cotton and paper. The three brothers were primarily concerned with Russian art in various forms, nevertheless their patronage also extended to contemporary French art in a small degree. Vladimir Ryabuschinsky was a collector of icons; Nicolai, his brother, was predominantly concerned with art publishing, though he owned a few French symbolist paintings and a group of works by Rouault; while Mikhail (1880-1960), the third brother, owned a few paintings by Degas, Pissarro and Renoir but is best known for his backing of Larionov and Gontcharova, and hence for his financial support of the two exhibiting societies The Blue Rose (1907) and The Golden Fleece (1908-10), which brought paintings by Bonnard, Derain, Braque, Gleizes, van Dongen and Matisse to Moscow.

Lastly I come to the most important collector of all, Sergei Shchukin (1851-1936), one of a family of collectors whose wealth came from the manufacture of cloth. Shchukin travelled frequently to Paris on business and was taken to Durand-Ruel's gallery in 1897 to look at paintings by Monet. He liked them and made some purchases right away, following these up during the next five years with a group of works by Renoir, Sisley, Monet, Degas, van Gogh, Cézanne and Gauguin. By 1905 Shchukin had discovered the Nabis and Fauvism, which led him to Matisse, from whom he bought his first painting in 1905. Matisse subsequently introduced Shchukin to Picasso, from whom he began to buy in 1907. In 1909, Shchukin commissioned Matisse to paint two large compositions, Dance and Music, to decorate the stair-well of his house in Moscow, while by 1914 he owned some forty paintings by this artist. During the same years, Shchukin amassed over fifty paintings by Picasso, many of them masterpieces. Other artists who were given prominence in Shchukin's collection were Henri Rousseau, Monet, Gauguin, Derain, Cézanne, and Marquet. He also acquired one painting by Braque, the only one in Russia. In all, Shchukin's collection amounted to over 225 works.

Thus in less than twenty years these three families of Russian collectors were able to put together collections of contemporary French paintings, beginning with Impressionist works, concentrating on Cézanne, Gauguin, van Gogh and the Nabis, and going on through the Fauves and Matisse to Picasso and the Cubists. This was the greatest expression of taste and discriminating

art patronage displayed by any early twentieth-century collector.

My purpose has been to discuss the types of people, in different countries, who not only admired and enjoyed the works of those independent artists who came to dominate the art scene in France between the Franco-Prussian War and the beginning of the First World War, but who as a result of their enjoyment were ready to acquire, and often to write intelligently and well about their work. Some of these people were rich and cultured, others had limited means and were simple people, while others were ready to make personal sacrifices to gratify a new love and help impoverished creators. There was no pattern either in their tastes or in their methods of collecting, except in a few special cases. All of them followed their own likes and dislikes and bought spontaneously for love, without expert guidance or any thought of personal profit. When any one of them was forced to dispose of his collection, either as a result of death or financial difficulties, older collectors or newcomers and dealers were waiting to acquire whatever they could. Thus the circle of admirers and collectors went on growing. Opposition came at first from stiff-necked critics, who had no real artistic formation and could therefore see no merit in unconventional art, and from hidebound museum authorities, whose gaze was fixed on respectability and the past. But, though harmful while it lasted, this opposition was not long-lived. In any case, its effect on the creative artists themselves and on informed taste was less evil than that of today's critics, who see good in everything and make preposterous claims for excellence in a dithyrambic jabberwocky which is beyond human understanding.

The collectors of independent art at the end of the nineteenth century were a new breed: they did not inherit collections, they made them. Almost without exception, they came from the bourgeoisie and were mostly either professional men, fellow artists or writers. But it is thanks to their initiative, taste and discrimination, which has enabled so many masterpieces to be preserved in the public domain, that we can look back today on the half-century between 1870 and 1920 and recognise it as one of the greatest periods of creation in the history of art.

Precursors of Impressionism

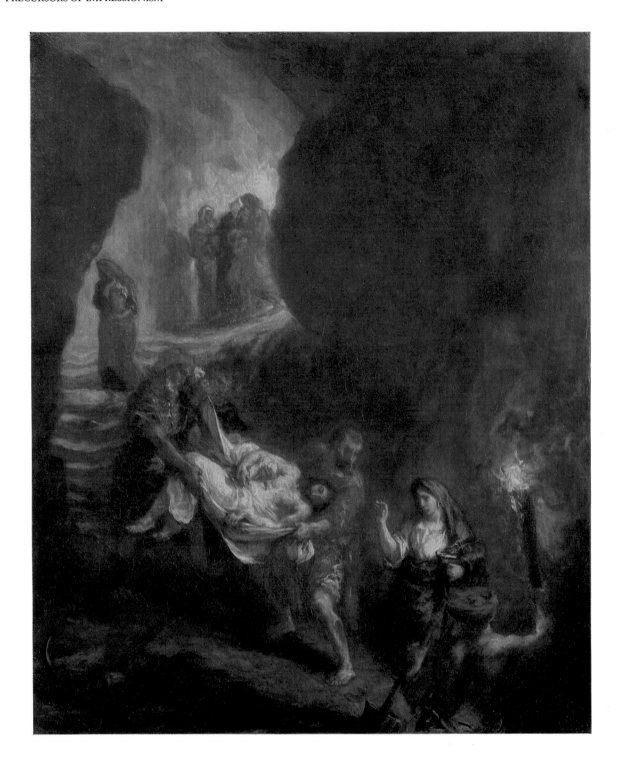

EUGENE DELACROIX *Christ descendu au Tombeau*
Signed and dated 1859 21½in by 17¾in

This is a project for the mural suggested in 1847 for L'Eglise de St Sulpice. When Delacroix received the commission in 1849 he believed, through a misunderstanding, that the *Christ descendu au Tombeau* and other subjects were destined for La Chapelle des Fonts-Baptismaux. These works were created specifically for that chapel and it was only a few years later that the painter discovered that the commission was in fact for La Chapelle des Saints-Anges. Delacroix therefore had to change his first ideas and the commissioned work was not completed until 1861 with the inauguration in 1861 of *L'Archange Saint Michel Terrassant le Démon* on the ceiling and *Heliodore chassé du Temple* and *La Lutte de Jacob avec l'Ange* on the walls.

Baudelaire wrote about this painting as follows: 'Dites-moi si vous vites jamais mieux exprimée la solennité nécessaire de la mise au tombeau. Croyez-vous sincèrement que Titien eût invente cela? Il eut conçu, il a conçu la chose autrement; mais je préfère cette manière-ci. Le décor, c'est la caveau lui-même, emblème de la vie souterraine que doit mener longtemps la religion nouvelle! Au dehors, l'air et la lumière qui glisse en rampant dans la spirale. La Mère va s'évanouir, elle se soutient à peine.' *(Le Salon de 1859).*

London £65,000 ($156,000) 2.IV.74

JOHAN BARTHOLD JONGKIND
*Nôtre-Dame de Paris, prise du
Pont de L'Archevêché* Signed and
dated Paris 1849 13in by 23¾in

New York $80,000 (£33,333)
28.XI.73
From the collection of Arthur Sachs
and Marian François-Poncet, of Paris

STANISLAS LEPINE
Le Pont des Arts, Paris Signed
Painted *c.* 1875 13in by 18in

London £15,000 ($36,000) 5.XII.73

JEAN-BAPTISTE-CAMILLE COROT *Jeune Italienne de Papigno
avec sa Quenouille* With stamped signature
Painted *c.* 1826-1827 12in by 8in

New York $105,000 (£43,750) 17.X.73 From the collection of
the late Edwin C Vogel

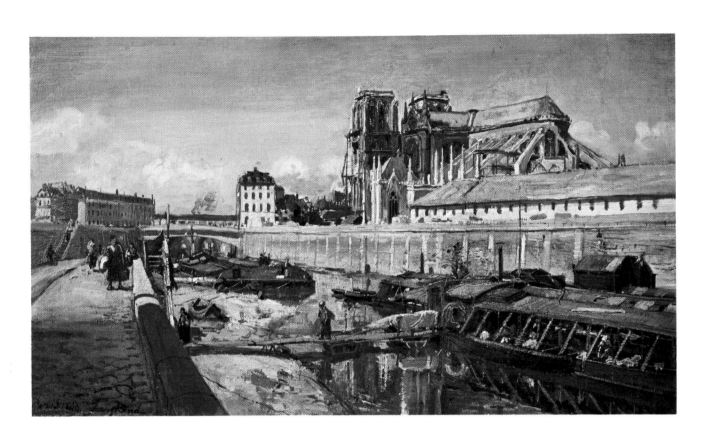

5

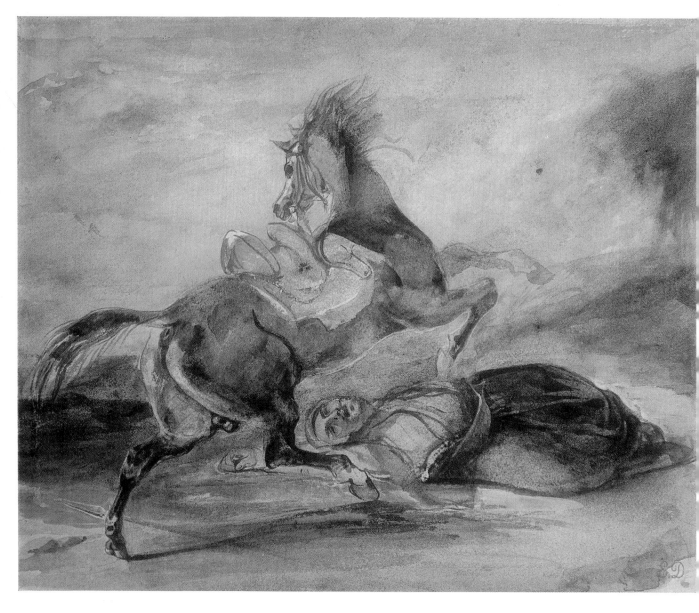

EUGENE DELACROIX *Arabe blessé au Pied de son Cheval* Watercolour Stamped with the
atelier mark 10in by 13½in

London £30,000 ($72,000) 2.IV.74
From the collection of the Norton Simon Inc, Museum of Art, Los Angeles

HONORE DAUMIER *Avant l'Audience—L'Avocat et son Client*
Watercolour, gouache and pencil 7in by 8½in

London £60,000 ($144,000) 2.IV.74

EUGENE BOUDIN *Plage à Trouville* On panel Signed and dated *Trouville* 7-84 8¼in by 16⅝in

New York $105,000 (£43,750) 17.X.73 From the collection of the late Edwin C Vogel, of New York

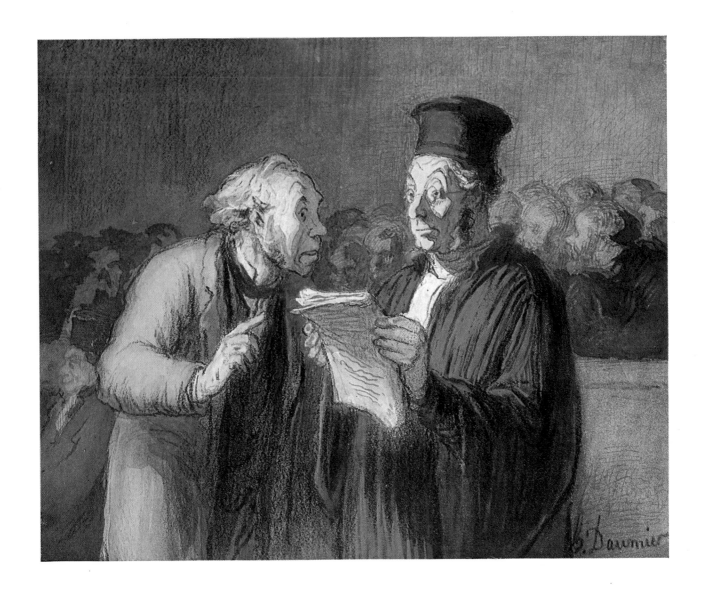

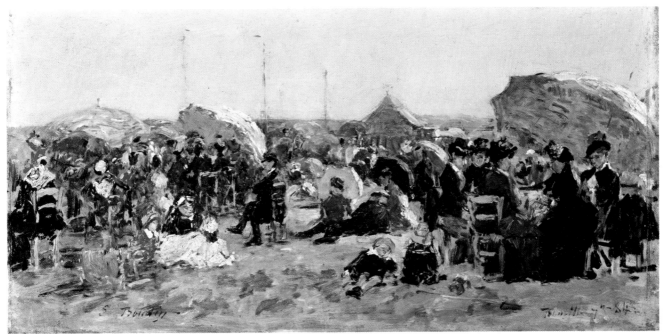

JEAN-BAPTISTE-CAMILLE COROT *Rome-Monte Pinco. La Trinité des Monts, vue prise des Jardins de l'Académie de France* Signed Painted between 1840 and 1850 10¼in by 15¾in

London £38,000 ($91,200) 5.XII.73

EUGENE BOUDIN *Pêcheuses de Crevettes à Kerhor* Signed and dated '70 18in by 25in

London £25,500 ($62,400) 2.VII.74

JEAN-FRANCOIS MILLET *Le Ramasseur de Fagots, Soleil couchant* Pastel Signed Executed *c.* 1867
16 in by 19¼in

London £14,500 ($34,800) 3.VII.74 From the collection of the heirs of Felix Somary, of Zurich

GUSTAVE COURBET *Chevreuils dans la Neige* Signed Painted *c.* 1866 20¼in by 24¼in

New York $67,500 (£28,125) 17.X.73 From the collection of The Metropolitan Museum of Art, New York

JEAN-BAPTISTE-CAMILLE COROT
Corot par lui-même Cliché-verre, 1858

London £1,100 ($2,640) 23.IV.74 From
the collection of the late Dr Felix Somary

HONORE DAUMIER *Le Ventre Législatif*
Lithograph printed on Chine appliqué
Executed in 1834 11in by 17in

New York $5,250 (£2,187) 13.II.74
From the collection of the late R Sturgis
Ingersoll, of Philadelphia

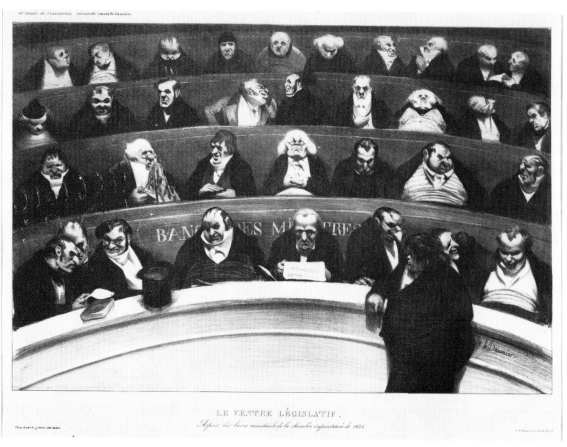

LE VENTRE LÉGISLATIF.

Impressionism

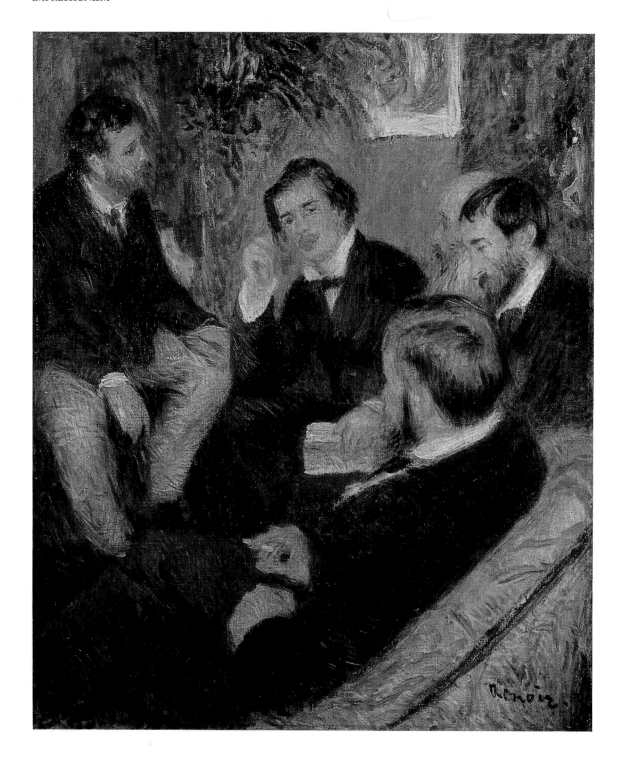

PIERRE-AUGUSTE RENOIR *L'Atelier du Peintre, Rue Saint-Georges*

Signed Painted in 1876 in Renoir's studio 17$\frac{3}{4}$in by 14$\frac{1}{2}$in

Renoir's friends depicted in his studio are from left to right: Pierre Franc-Lamy, Georges Rivière, Camille Pissarro, Eugène Lestrinquez and Ernest-Jean Cabaner. One of the first of the great Impressionist collectors, Eugène Murer, bought this picture soon after it was painted. Murer, who owned a pastry shop in the Boulevard Voltaire, met the Impressionists in the 1870s, and in his apartment behind the shop gave dinner-parties every Wednesday to which Renoir and his other friends in *L'Atelier* were often invited. In 1877 Renoir painted portraits of Murer, his half-sister, Marie Meunier Murer, and his son, Paul (Daulte, numbers 246, 247 and 249).
Murer had the habit of buying pictures in lots, taking advantage of any financial difficulties the painters might be suffering. Thus it was that he bought *L'Atelier* with other works at a time when Renoir needed money to pay the rent.

London £150,000 ($360,000) 2.IV.74

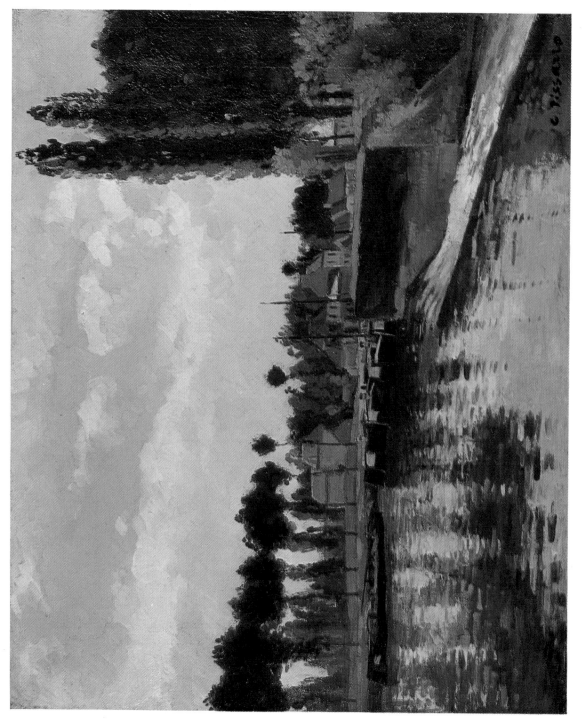

CAMILLE PISSARRO *L'Ecluse à Pontoise* Signed Painted *c* 1869 23in by 28¼in

London £106,000 ($254,400) 2.IV.74

PAUL CEZANNE *Paysage d'Ile-de-France* Painted *c* 1879-1880 23½in by 28¾in

New York $500,000 (£208,333) 2.V.74

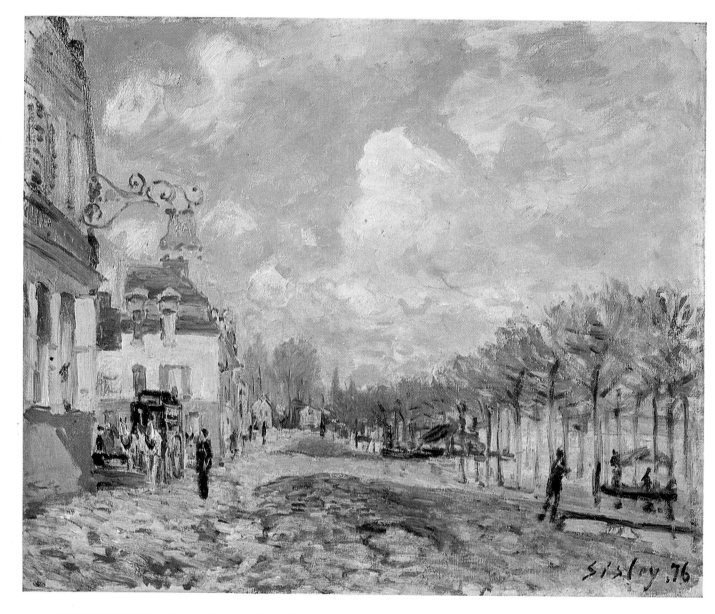

ALFRED SISLEY *L'Inondation à Port-Marly* Signed and dated '76 19¾in by 24in

London £111,000 ($266,400) 2.IV.74

JEAN-BAPTISTE-ARMAND GUILLAUMIN *Nature Morte* Signed and dated '69 19¼in by 23½in

London £29,000 ($69,600) 2.IV.74

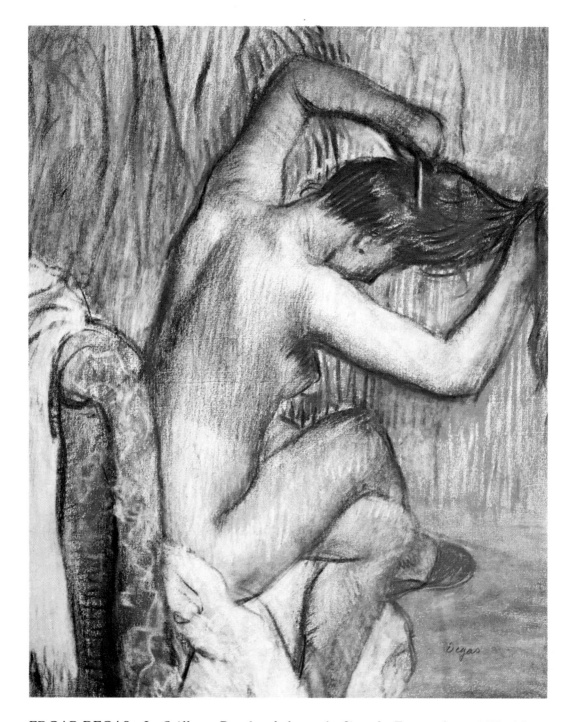

EDGAR DEGAS *La Coiffure* Pastel and charcoal Signed Executed *c.* 1887-1890
23¼in by 18½in

New York $180,000 (£75,000) 17.X.73
From the collection of the late Edwin C Vogel, of New York

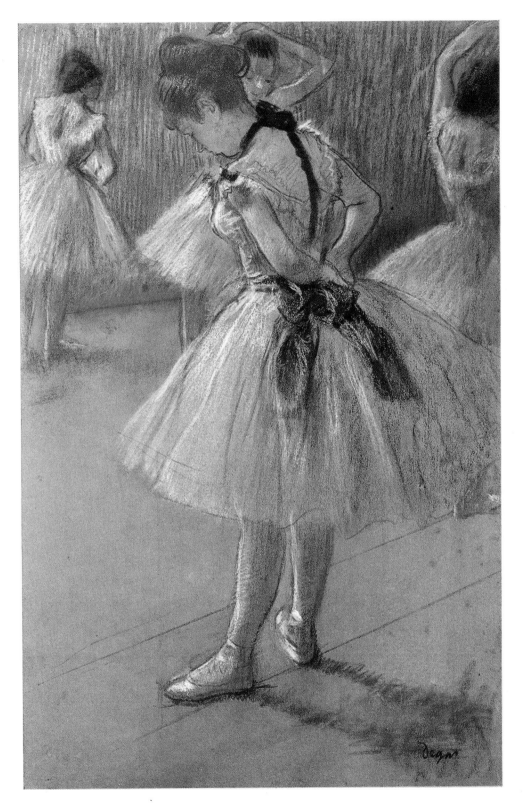

EDGAR DEGAS *Salle de Danse* Pastel and charcoal Signed Executed *c.* 1878
19¼in by 12½in

London £142,000 ($340,800) 2.IV.74

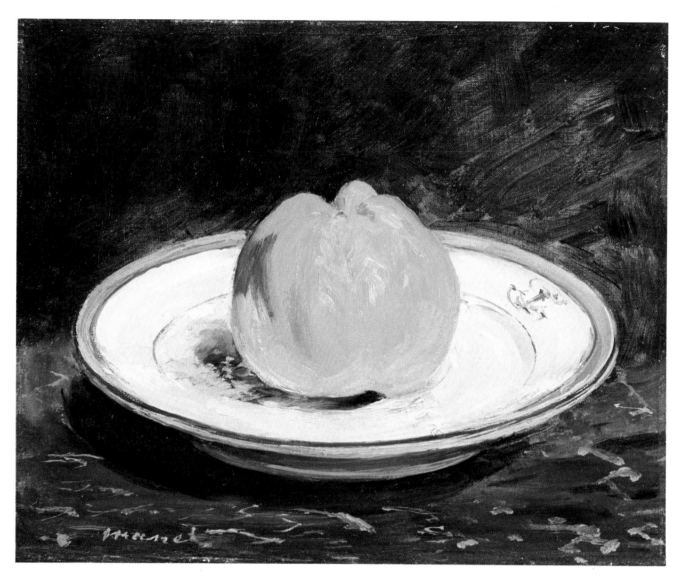

EDOUARD MANET *L'Assiette avec la Pomme* Signed Painted *c.* 1882 8½in by 10¾in

New York $155,000 (£64,583) 17.X.73 From the collection of the late Edwin C Vogel, of New York

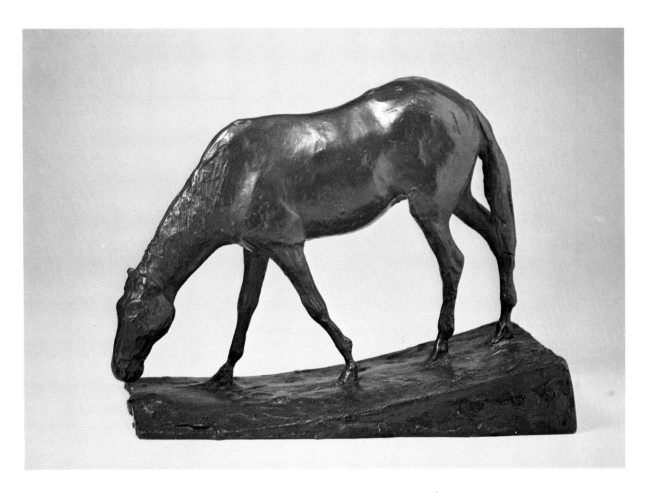

EDGAR DEGAS *Cheval à l'Abreuvoir* Bronze Signed Height 6½in

New York $45,000 (£18,750) 17.X.73

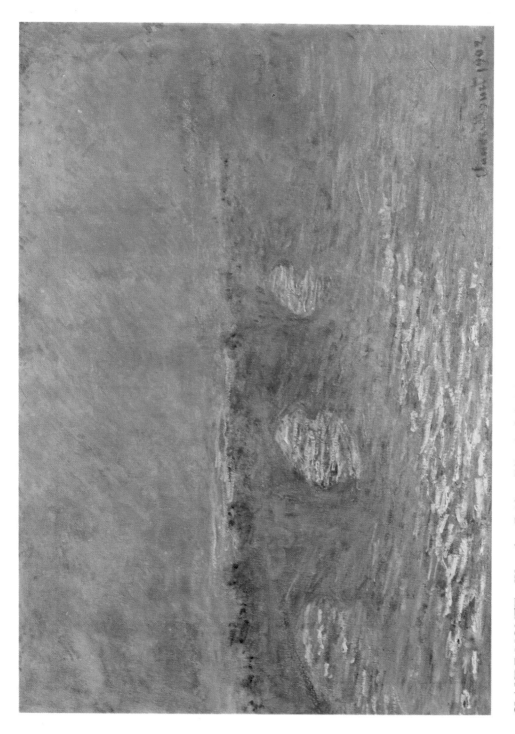

CLAUDE MONET *Waterloo Bridge, Effet de Soleil dans la Brume* Signed and dated 1902 26in by 36¼in
New York $220,000 (£91,667) 2.V.74 From the collection of Mrs Mahlon B Wallace, Jr, of St Louis

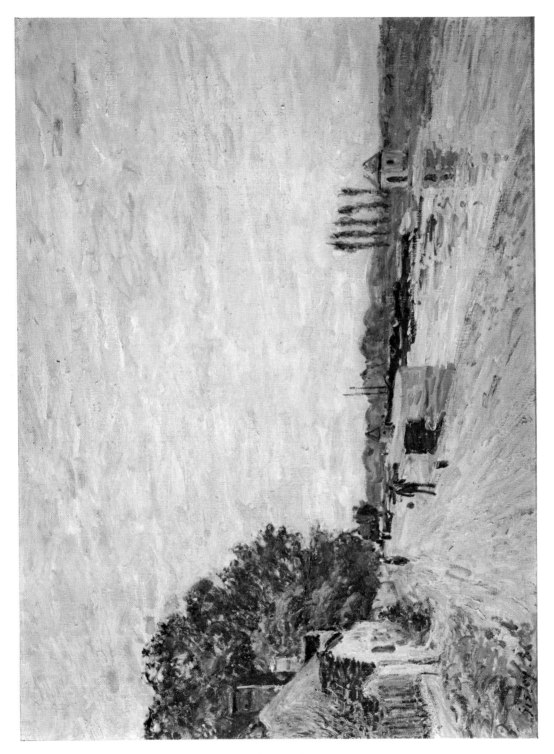

ALFRED SISLEY *Le Barrage du Loing à St Mammès* Signed and dated '86 21¼in by 29in

London £75,000 ($180,000) 5.XII.73

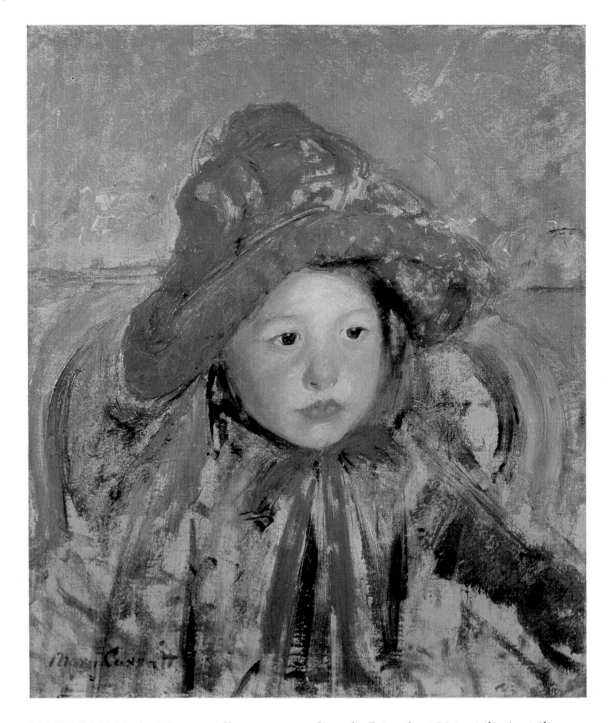

MARY CASSATT *Fillette au Chapeau rouge* Signed Painted *c* 1881 16½in by 14¼in

London £56,000 ($134,400) 2.IV.74

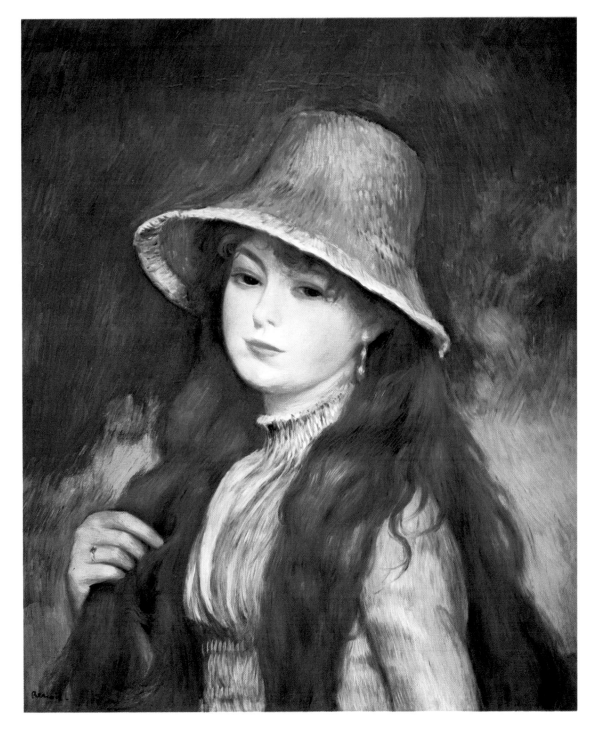

PIERRE-AUGUSTE RENOIR *Jeune Fille au Chapeau de Paille* Signed Painted in 1884
22in by 18¼in

New York $525,000 (£218,750) 17.X.73 From the collection of the late Edwin C Vogel,
of New York

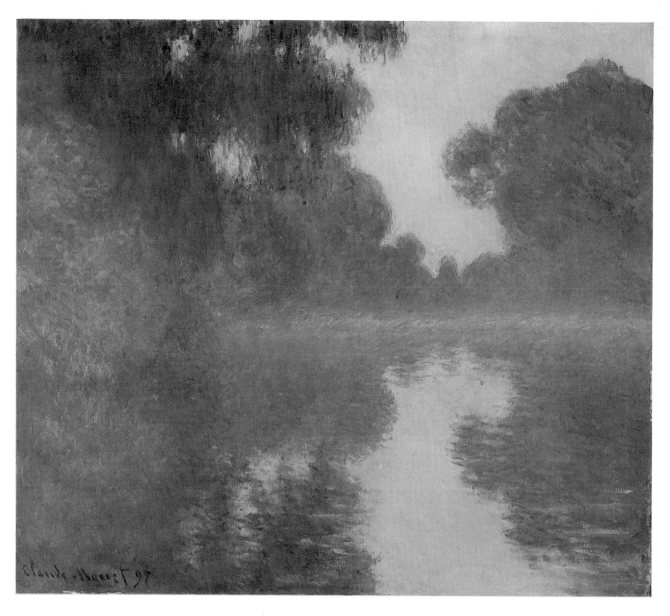

CLAUDE MONET *Matinée sur la Seine (Bras de la Seine près Giverny)* Signed and dated '97
32¼in by 36¾in

London £120,000 ($288,000) 2.VII.74

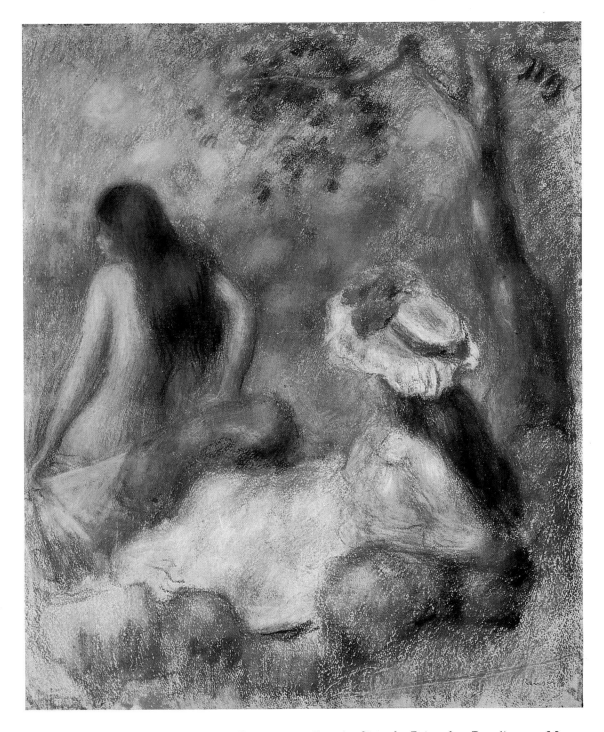

PIERRE-AUGUSTE RENOIR *Les Baigneuses* Pastel Signed Painted at Beaulieu-sur-Mer in 1894 18¾in by 15¾in

London £72,000 ($172,800) 5.XII.73

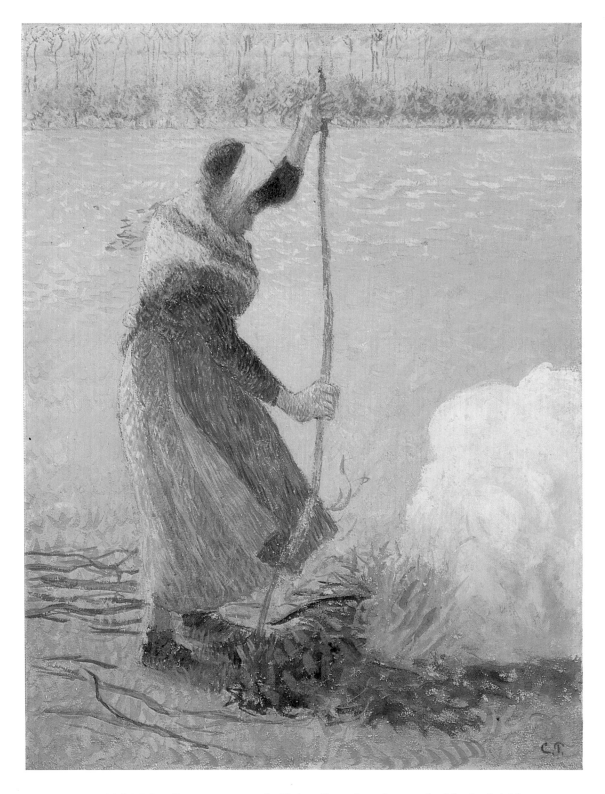

CAMILLE PISSARRO *Femme cassant du Bois* Gouache Stamped with the initials
Executed *c* 1890 23¼in by 18¼in

London £45,000 ($108,000) 3.IV.74 From the collection of the Norton Simon Foundation,
of Beverly Hills

CAMILLE PISSARRO *Mendiantes* Etching with drypoint,
printed in colours Executed *c.* 1894 The total number of
impressions pulled was 8 or 9, only 4 or 5 of which were in
colour 7⅞in by 5⅞in

New York $6,750 (£2,812) 8.XI.73

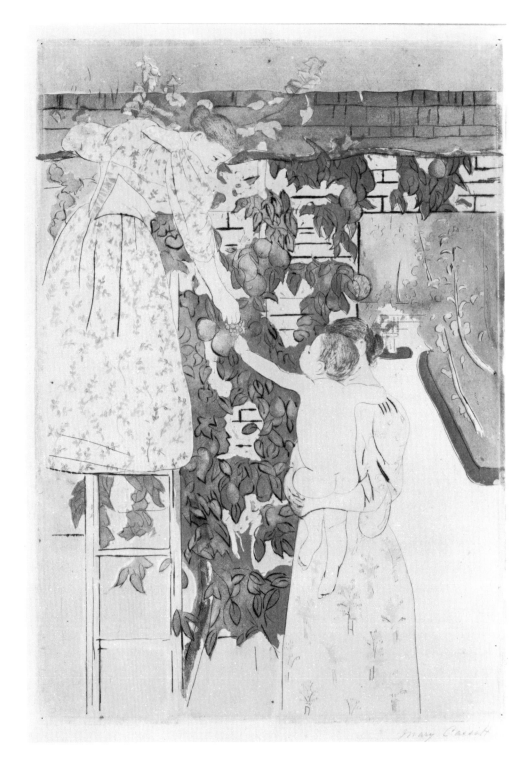

MARY CASSATT *Gathering Fruit (L'Espalier* or *Le Potager)* Drypoint and aquatint printed in colours Signed in pencil Executed *c.* 1895 16⅞in by 11⅞in

New York $16,000 (£6,666) 14.V.74

Post-Impressionism

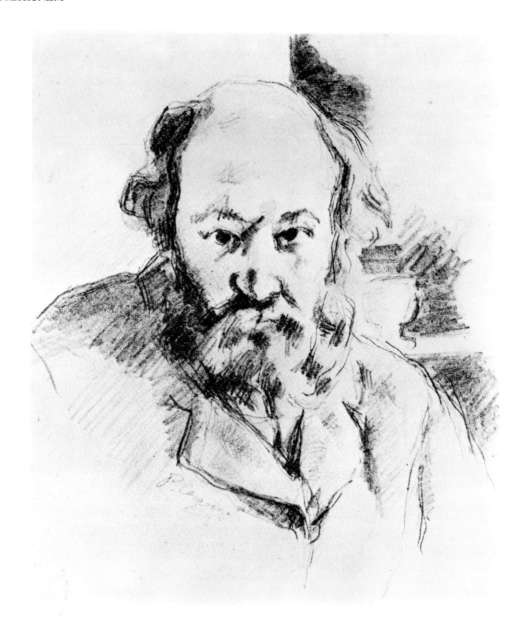

PAUL CEZANNE *Portrait de Lui-même* Black crayon Signed
Drawn *c* 1875 6in by 5in

London £42,000 ($100,800) 2.IV.74 From the collection of the
Norton Simon Foundation, of Beverly Hills

GEORGES SEURAT *Broderie- la Lecture de Grand'Mère* Black *conté* crayon
Drawn *c* 1883 11¾in by 9¼in

London £24,000 ($57,600) 2.IV.74 From the collection of the Norton Simon, Inc.,
Museum of Art, Beverly Hills

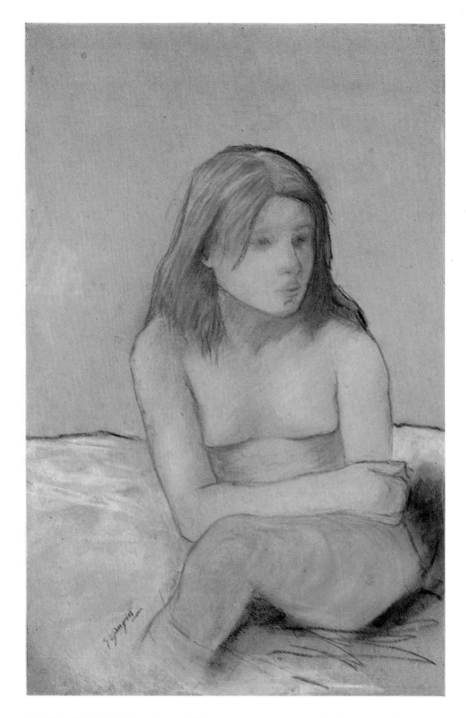

PAUL GAUGUIN *Jeune Fille nue, assise au bord d'un Lit* Pastel
Signed Executed *c* 1885-86 19¼in by 12½in

London £55,000 ($132,000) 2.IV.74

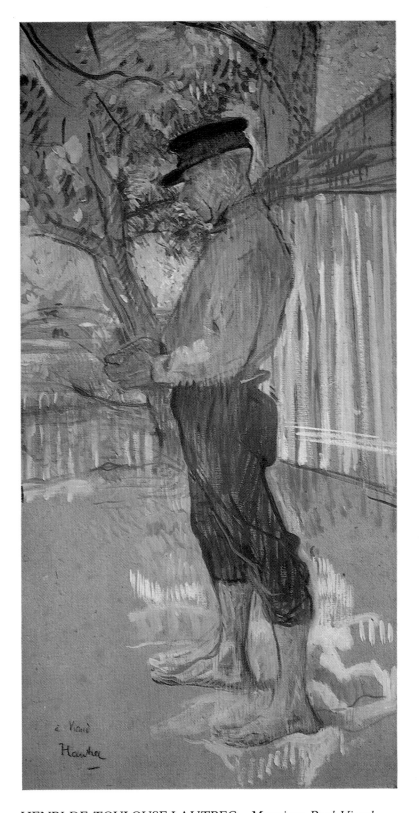

HENRI DE TOULOUSE-LAUTREC *Monsieur Paul Viaud,*
Taussat, Arcachon On board, signed and dedicated *à Viaud*
31in by 15½in
Painted in the summer of 1900 at Arcachon where he usually
spent his holidays with his great friend Paul Viaud. From
1899 onwards Lautrec was ill and his constant companion was
Paul Viaud.

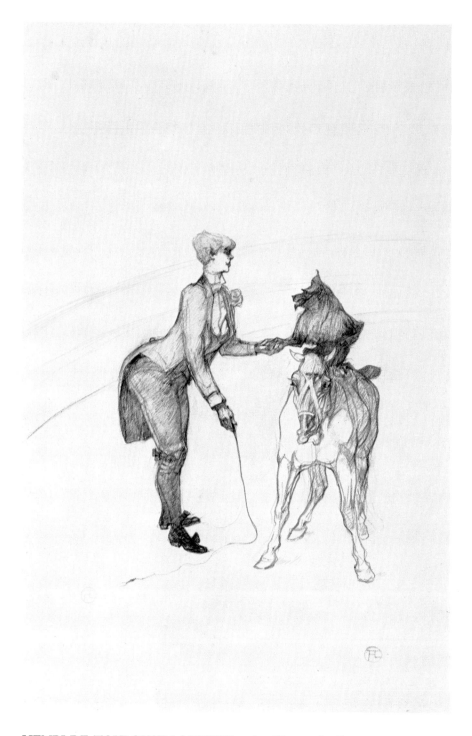

HENRI DE TOULOUSE-LAUTREC *Au Cirque: La Dresseuse d'Animaux* Pencil and coloured crayons Signed with the monogram Executed in 1899 20in by 13in

New York $95,000 (£39,583) 17.X.73 From the collection of the late Edwin C Vogel, of New York

HENRI DE TOULOUSE-LAUTREC *Yvette Guilbert* Gouache and
charcoal Signed with the monogram Executed in 1893
21½in by 15in

London £53,000 ($127,200) 2.IV.74

HENRI DE TOULOUSE-LAUTREC *Au Cirque Fernando, Ecuyère sur un Cheval blanc* Pastel and gouache on board
Signed Painted in 1888 23½in by 31¼in

London £210,000 ($505,000) 2.IV.74

VINCENT VAN GOGH *Le Parc de L'Institut Saint Paul à Saint Rémy*
Black chalk, reed pen and ink Drawn in 1889 18½in by 24in

London £67,000 ($160,800) 2.IV.74 From the collection of the Norton Simon Foundation, Beverly Hills

41

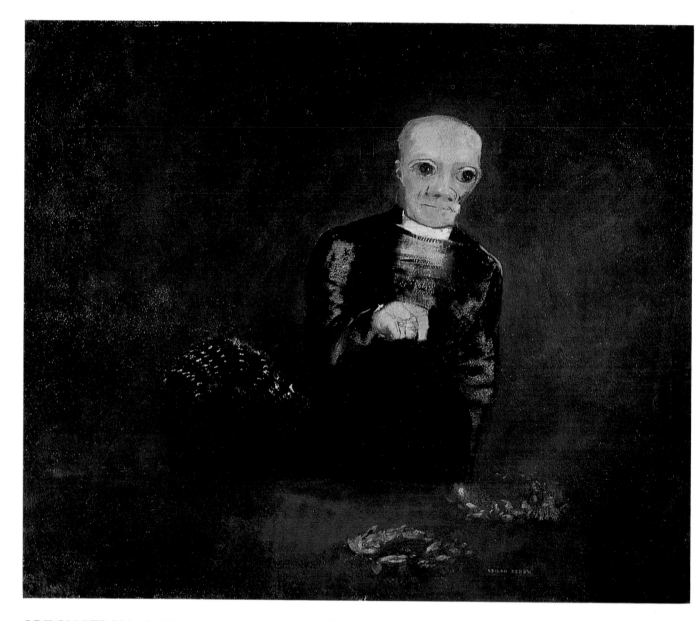

ODILON REDON *Le Distributeur de Couronnes* Signed Painted *c* 1870 16½in by 19½in

London £34,000 ($81,600) 5.XII.73

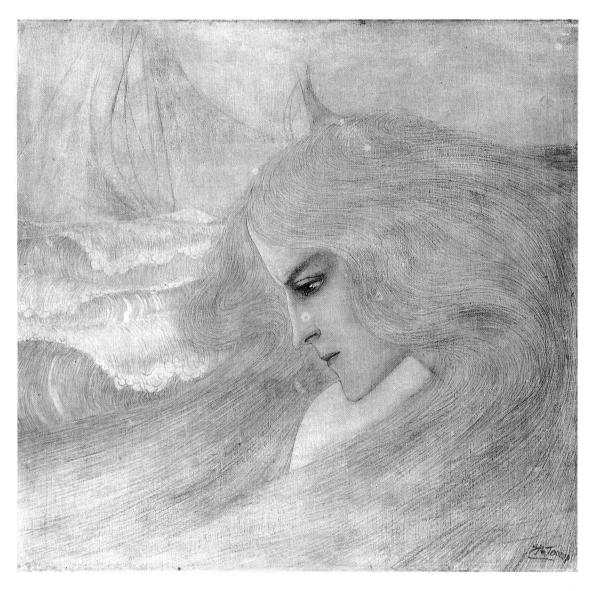

JAN TOOROP *Océanide* Mixed media and pencil Signed Painted *c.* 1893 21¼in by 32½in

London £9,500 ($22,800) 3.IV.74

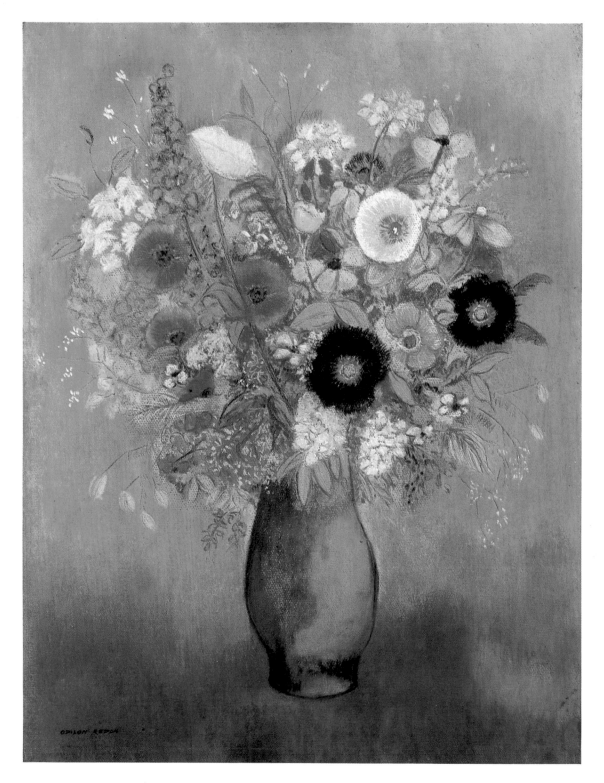

ODILON REDON *Fleurs dans un Vase bleu* Pastel Signed 23½in by 18½in

London £63,000 ($151,200) 3.IV.74

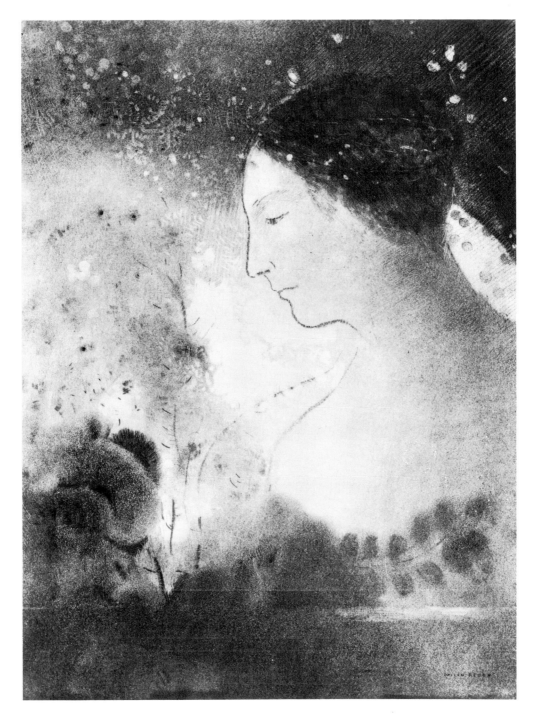

ODILON REDON *Profil de Femme aux Fleurs* Black chalk Signed Drawn *c.* 1895
19¼ by 14in

New York $46,000 (£19,167) 2.V.74 From the collection of the late R Sturgis
Ingersoll, of Philadelphia

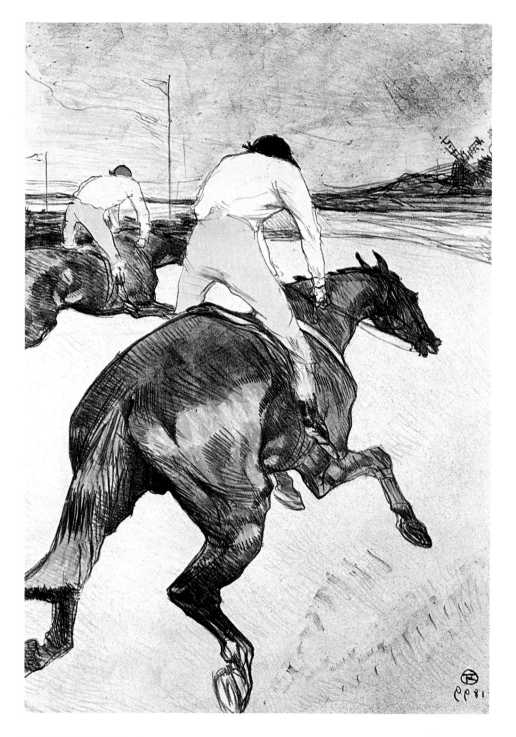

HENRI DE TOULOUSE-LAUTREC *Le Jockey* Lithograph printed in colours
Executed in 1899 One of an edition of 100 20¼in by 14⅛in

New York $40,000 (£16,666) 14.II.74

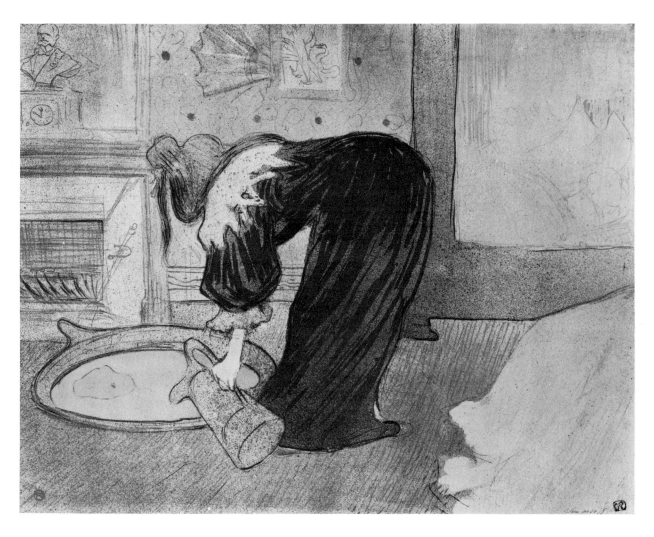

HENRI DE TOULOUSE-LAUTREC *Femme au Tub* Lithograph printed in colours Executed in
1896 Plate 4 of the *Elles* Series 15¾in by 20½in

New York $20,000 (£8,333) 14.II.74
The complete set of the plates of the *Elles* series sold for $105,200 (£43,833)

HENRI DE TOULOUSE-LAUTREC *Invitation à une Tasse de Lait* Lithograph, 1900, only state Signed in pencil and inscribed *à Stern* 26.5cm by 20cm

London £2,100 ($5,040) 20.XI.73

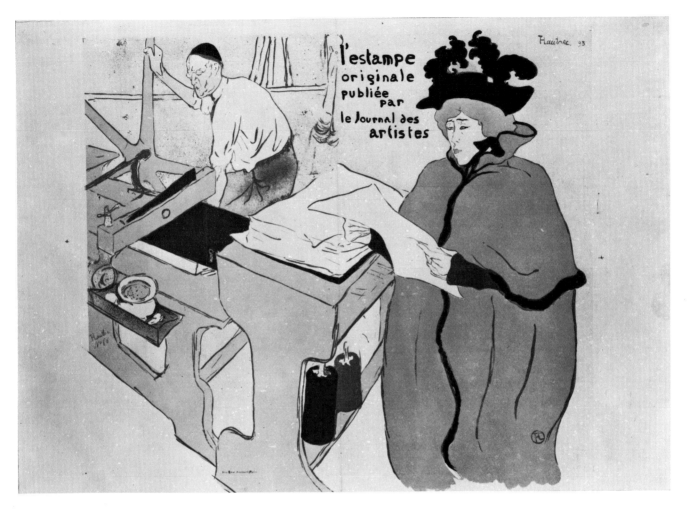

HENRI DE TOULOUSE-LAUTREC *Couverture de l'Estampe originale* Lithograph printed in colours Signed in pencil and numbered 66 Executed in 1893 22¼in by 25¾in

London £2,700 ($6,480) 16.VII.74

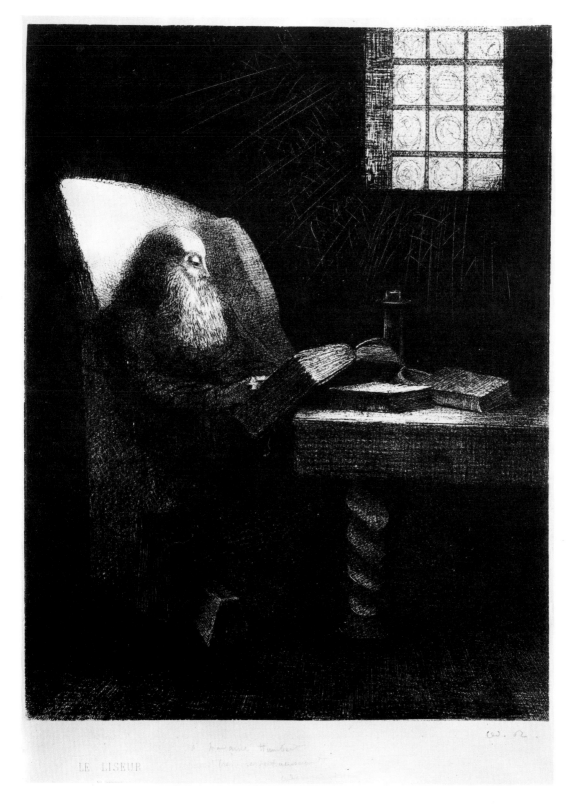

LE LISEUR

ODILON REDON *Le Liseur* Lithograph Initialled in pencil and dedicated
'à Madame Humbert très respectueusement Odilon Redon' Executed in 1892
One of an edition of 50 12¼in by 9⅜in

New York $7,750 (£3,229) 14.II.74

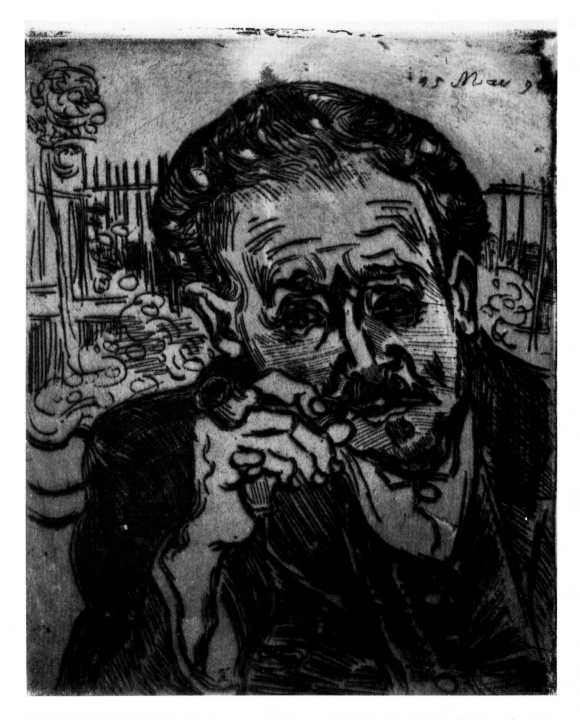

VINCENT VAN GOGH *Le Fumeur—L'Homme à la Pipe: Portrait du Docteur Gachet*
Etching 7⅛in by 5⅞in

New York $16,000 (£6,875) 8.XI.73

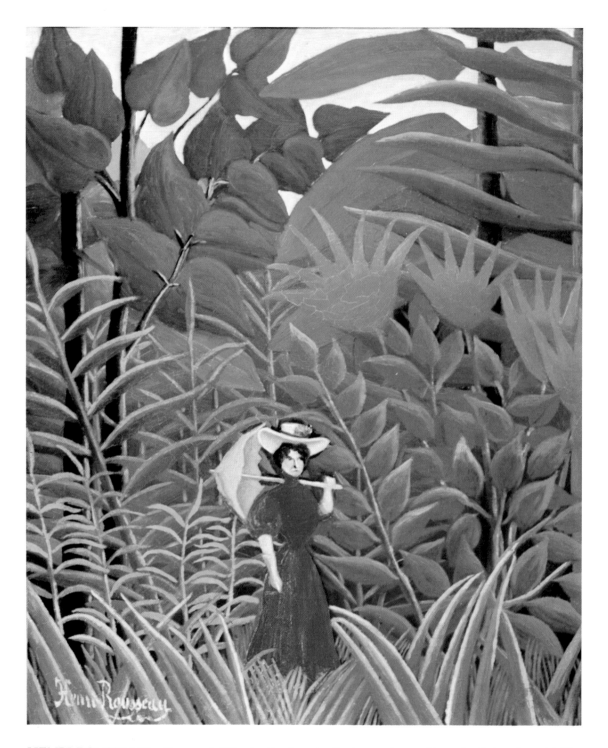

HENRI ROUSSEAU *Femme à l'Ombrelle dans la Forêt exotique* Signed Painted *c.* 1907
28¾in by 23½in

New York $325,000 (£135,416) 2.V.74

School of Paris 1900-1914

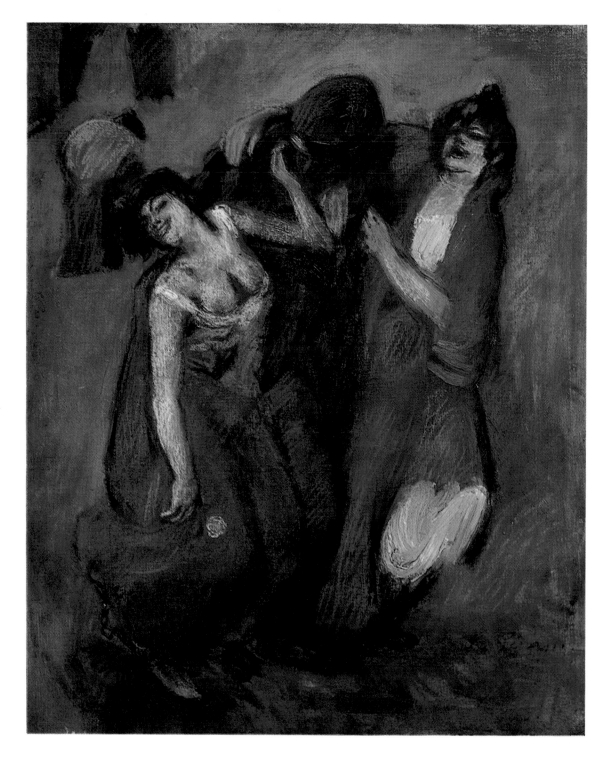

PABLO PICASSO *Les Morphinomanes* Oil and pastel Signed Painted in 1900
22½in by 18in

London £120,000 ($288,000) 2.IV.74

PABLO PICASSO *Femme et jeune Garçon pres d'un Voilier* Pen and indian ink and brown wash Signed and dated 1903 11in by 7¼in

London £34,000 ($81,600) 3.IV.74

PABLO PICASSO *Portrait de l'Artiste*
Charcoal Signed Drawn in Madrid in 1900
13¾in by 6in

New York $65,000 (£27,083) 28.XI.73
From the collection of Arthur Sachs and Marian
François-Poncet, of Paris

PABLO PICASSO *Jeune Homme au Bouquet* Gouache on board Signed; also signed later and dated 1904 or 5 on the reverse Executed in 1905 27¼in by 21¼in

New York $720,000 (£300,000) 17.X.73 From the collection of Bernice McIlhenny Wintersteen, of Pennsylvania

RAOUL DUFY *Fête nautique* Signed and dated 1905 23⅞in by 28¾in

New York $140,000 (£58,333) 17.X.73 From the collection of Evert D Weeks, of Des Moines, Iowa

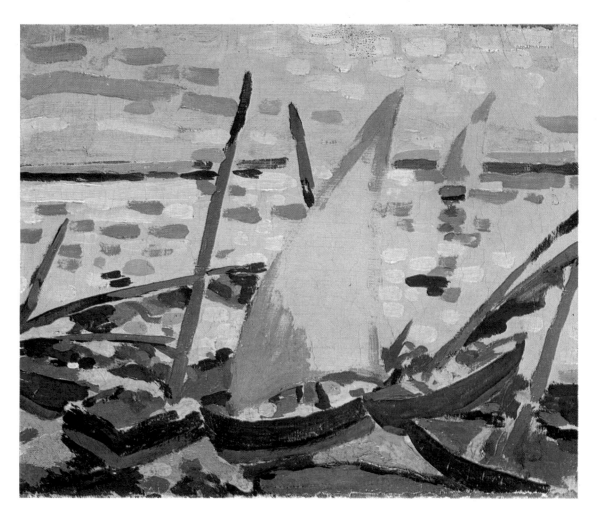

ANDRE DERAIN *Bateaux sur la Plage à Collioure* Signed Painted in 1905 7½in by 9¼in

London £33,000 ($79,200) 3.VII.74

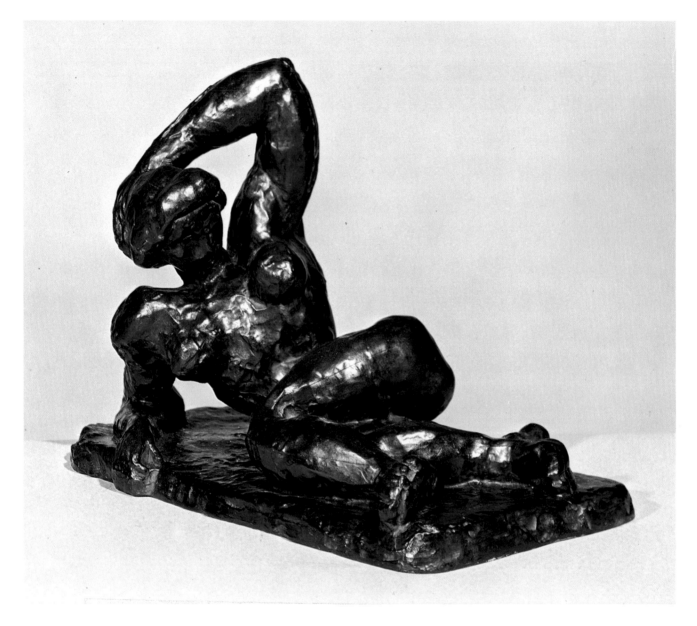

HENRI MATISSE *Nu Couché I* Bronze Signed One of an edition of ten
Executed in 1907 Length 19½in

New York $360,000 (£150,000) 17.X.73

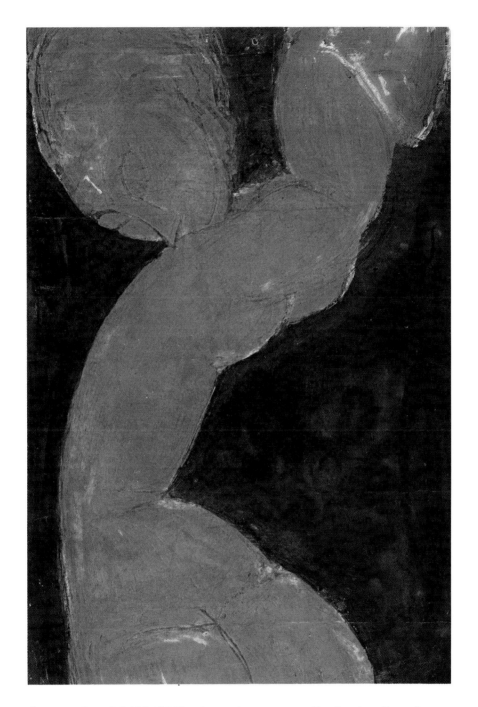

AMEDEO MODIGLIANI *Cariatide rouge sur Fond noir* Gouache
Executed in 1914 24½in by 16½in

New York $70,000 (£29,167) 2.V.74

Expressionism

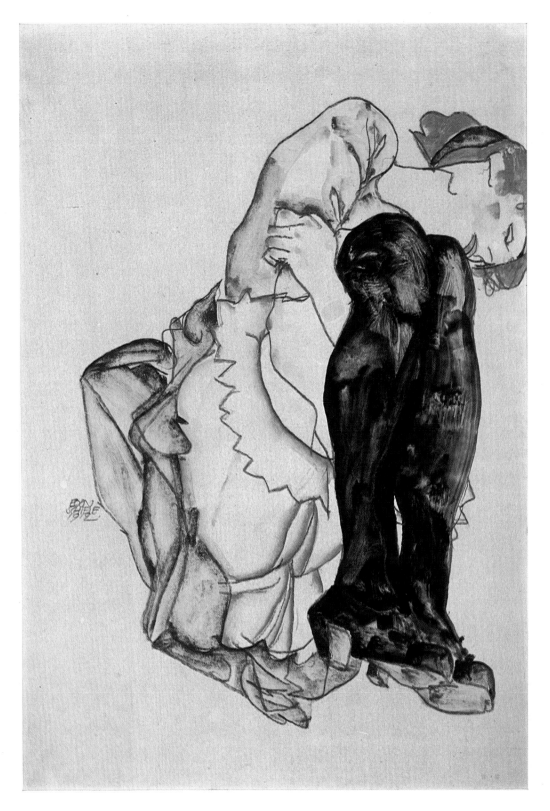

EGON SCHIELE *Frau mit blauen Strümpfen* Gouache Signed and dated 1912
17¼in by 12½in

London £25,000 ($60,000) 3.IV.74

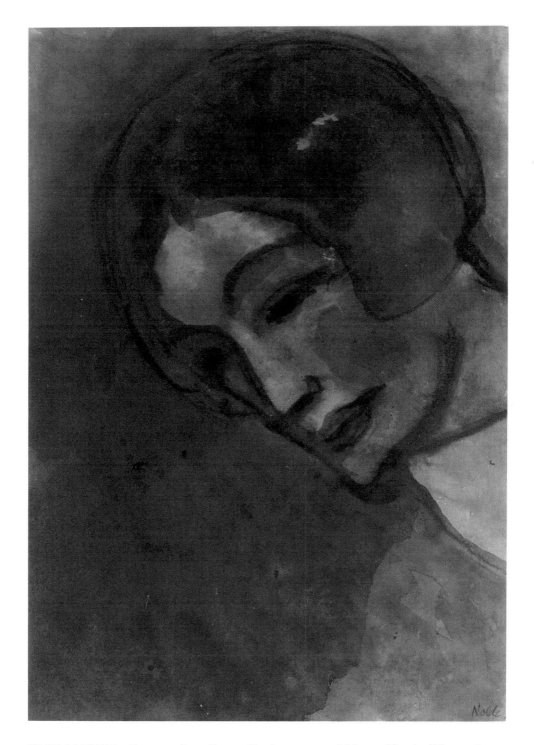

EMIL NOLDE *Porträt einer Dame (Rotbraunes und blaues Haar)* Watercolour
Signed Executed *c.* 1920-25 18¾in by 13¾in

New York $38,000 (£15,833) 2.V.74 From the collection of the
Norton Simon, Inc, Museum of Art, Beverly Hills

EMIL NOLDE *Landschaft mit Bauernhäuser* Watercolour Signed Executed *c.* 1935 8¾in by 10¾in

London £10,500 ($25,200) 2.IV.74. From the collection of the Norton Simon Inc, Museum of Art, Beverly Hills

EMIL NOLDE *Rote Schlafmohne* Watercolour Signed Executed *c.* 1925-30

London £11,000 ($26,400) 3.VII.74 From the collection of the Norton Simon Inc. Museum of Art, Beverly Hills

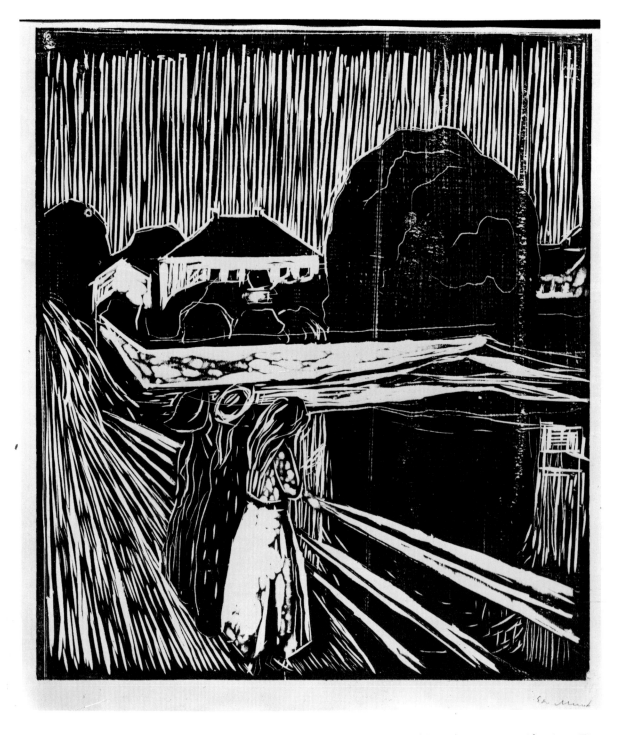

EDVARD MUNCH *Mädchen auf der Brücke* Woodcut Executed *c.* 1919-20 19½in by 17in

New York $21,000 (£8,750) 8.XI.73

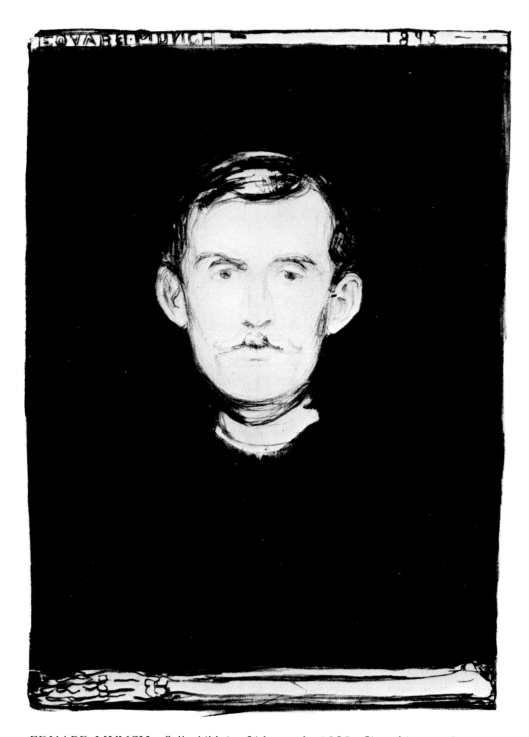

EDVARD MUNCH *Selbstbildnis* Lithograph, 1895 Signed in pencil
18¼in by 12½in

London £4,500 ($10,800) 23.IV.74

ALEXEJ JAWLENSKY *Nemesis* Signed with the initials Painted in 1917
14¼in by 10¾in

London £15,000 ($36,000) 3.VII.74

Cubism

PABLO PICASSO *Tête* Gouache on brown paper Executed *c.* 1906-07
12¼in by 9½in

London £35,000 ($84,000) 3.VII.74

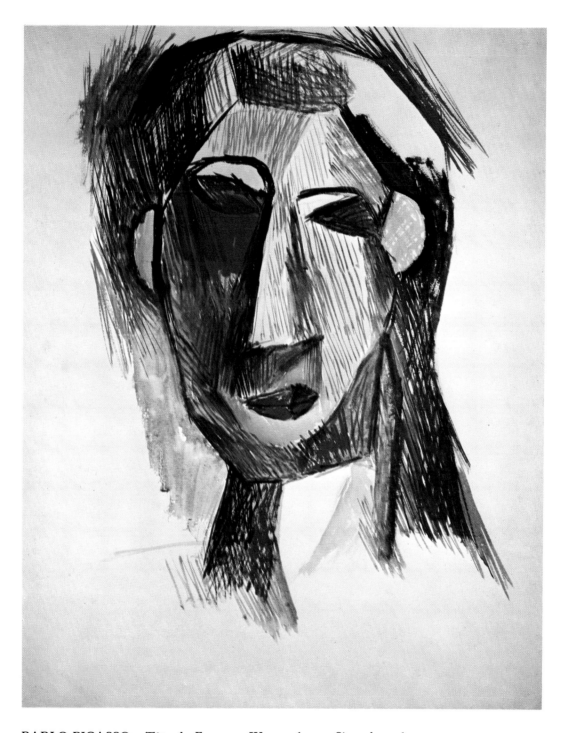

PABLO PICASSO *Tête de Femme* Watercolour Signed on the reverse
Executed *c.* 1908 23¾in by 18¾in

New York $190,000 (£79,167) 17.X.73 From the collection of Bernice McIlhenny
Wintersteen, of Pennsylvania

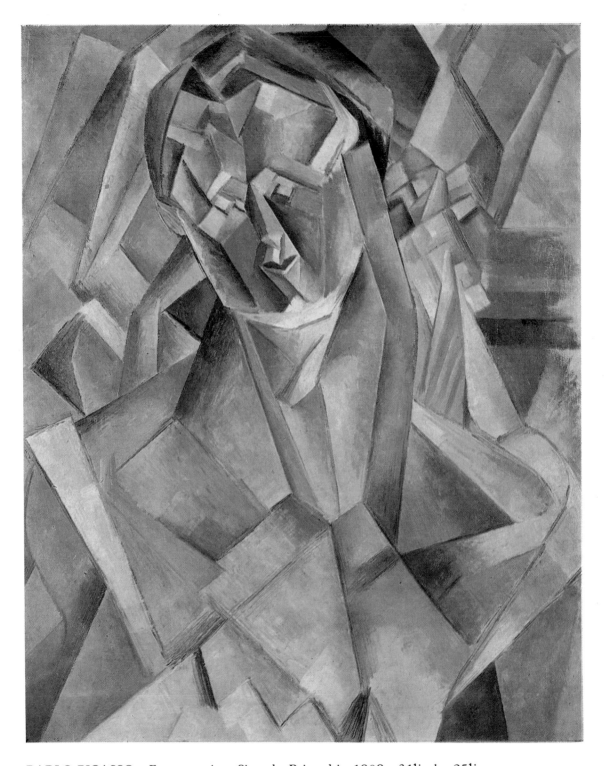

PABLO PICASSO *Femme assise* Signed Painted in 1909 31½in by 25½in

London £340,000 ($816,000) 5.XII.73

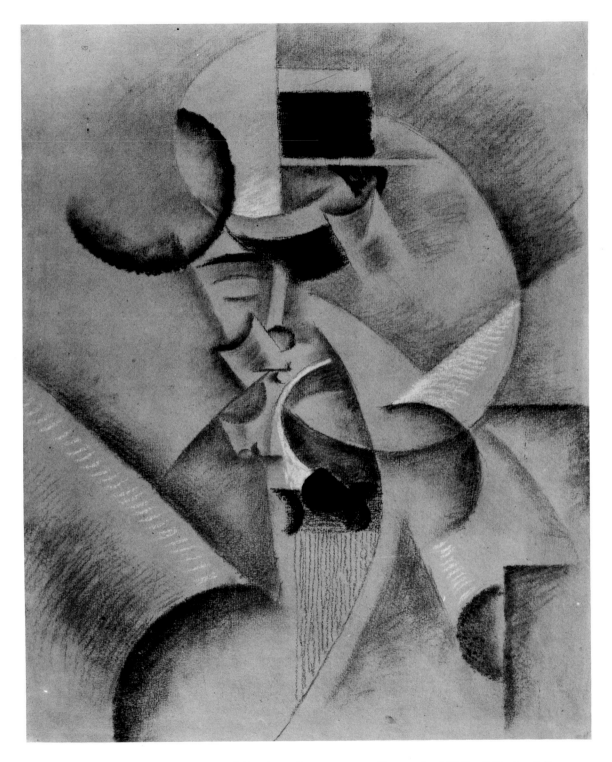

GINO SEVERINI *Mon Portrait* Mixed media on paper Drawn in 1913 26in by 24in

New York $40,000 (£16,667) 1.V.74 From the collection of Arnold H Maremont

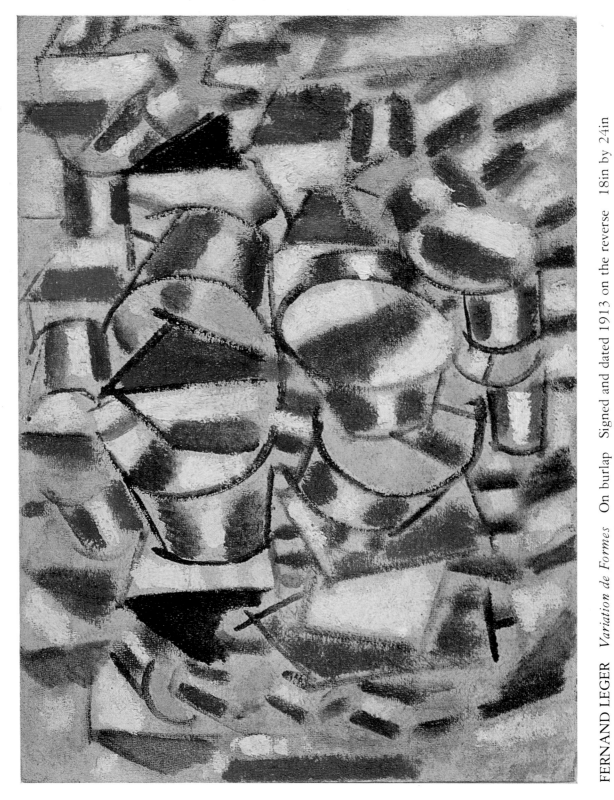

FERNAND LEGER *Variation de Formes* On burlap Signed and dated 1913 on the reverse 18in by 24in

London £79,000 ($189,600) 3.VII.74 From the collection of the Solomon R Guggenheim Foundation, New York

ROGER DE LA FRESNAYE *Portrait d'Homme* Pen and indian ink Stamped with the signature Drawn *c.* 1913-14 11¼in by 8¼in

London £3,000 ($7,200) 3.IV.74

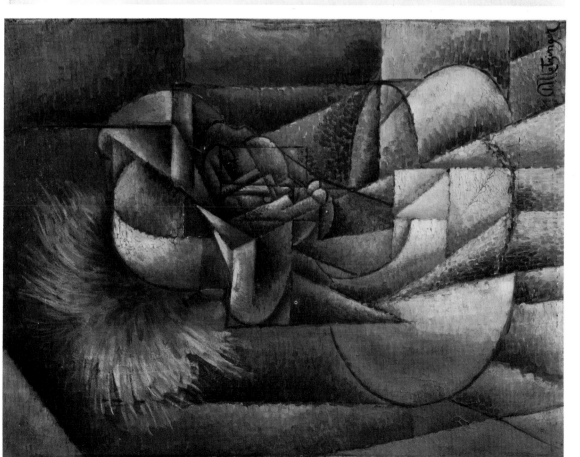

JEAN METZINGER *La Plume jaune* Signed Painted *c* 1913 28in by 20½in

New York $34,000 (£14,167) 3.V.74 From the collection of the late R Sturgis Ingersoll, of Philadelphia

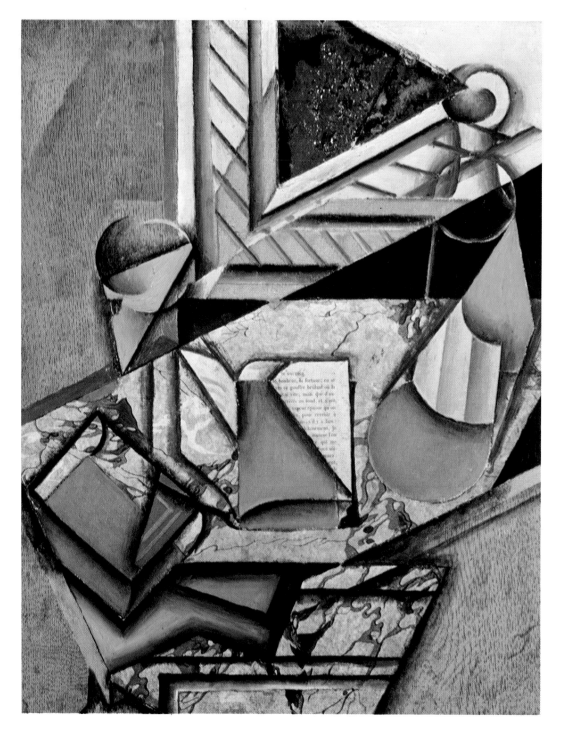

JUAN GRIS *La Console de Marbre* Oil and collage with mirror on canvas Painted *c.* 1914 24in by 19¾in

New York $250,000 (£104,167) 1.V.74 From the collection of Arnold H Maremont

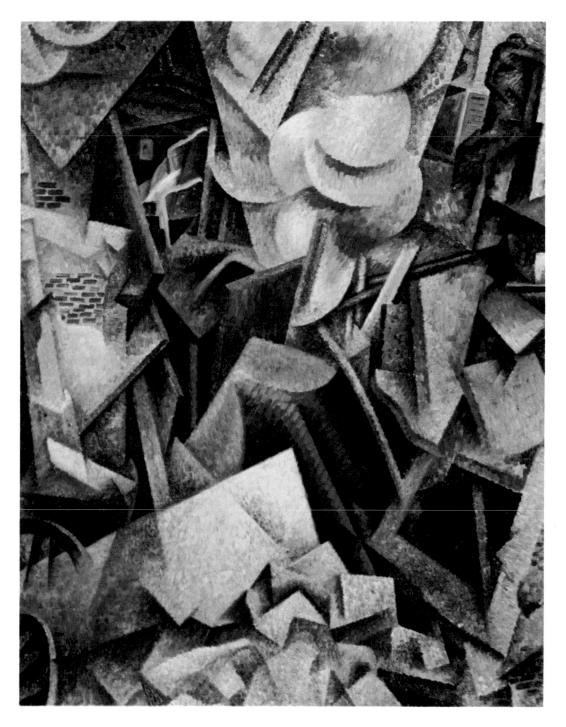

GINO SEVERINI *Crash* Signed Painted in 1915 36¼in by 28¾in

New York $175,000 (£72,917) 1.V.74 From the collection of Arnold H Maremont

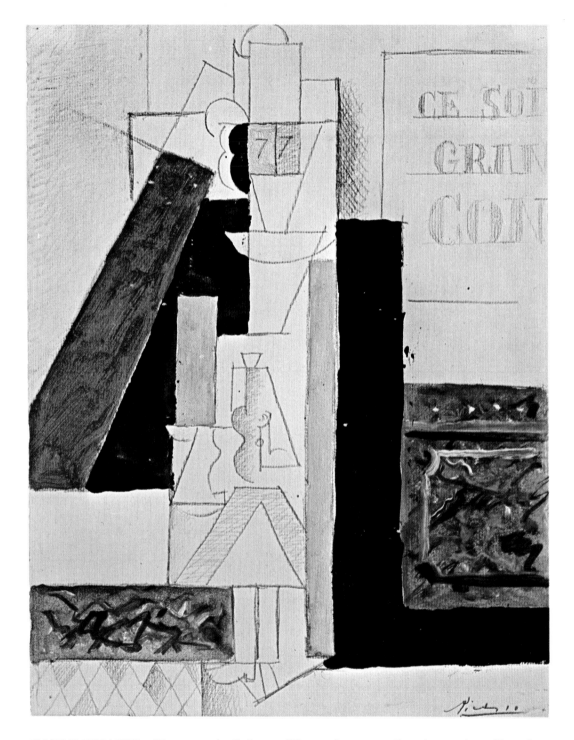

PABLO PICASSO *Homme à la Guitare* Watercolour, pencil and gouache Signed
Executed during the winter of 1912-13 12in by 9½in

New York $70,000 (£29,167) 2.V.74

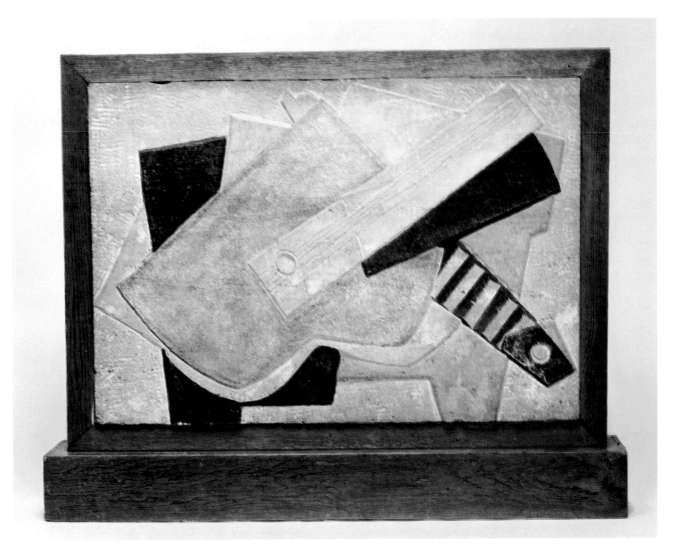

HENRI LAURENS *Instruments de Musique* Painted stone Signed and dated 1919 19in by 28½in

New York $42,500 (£17,708) 1.V.74 From the collection of Arnold H Maremont

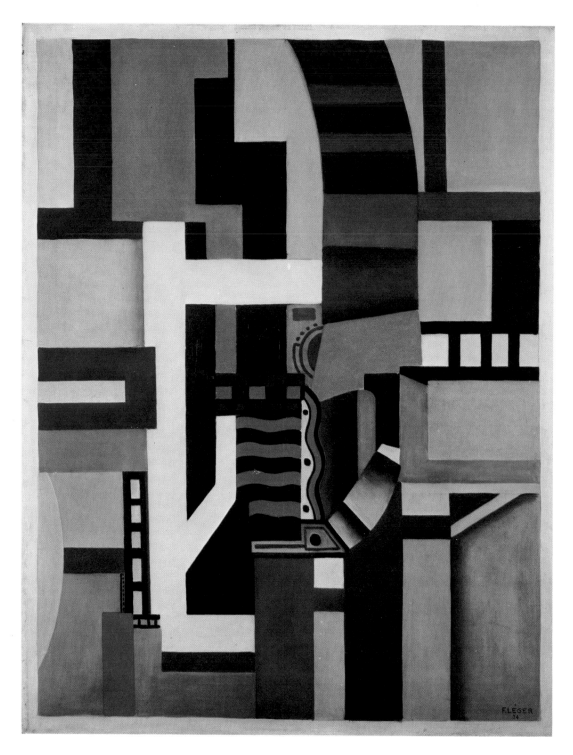

FERNAND LEGER *Composition* Signed and dated '24 52in by 39¾in

New York $265,000 (£110,417) 2.V.74

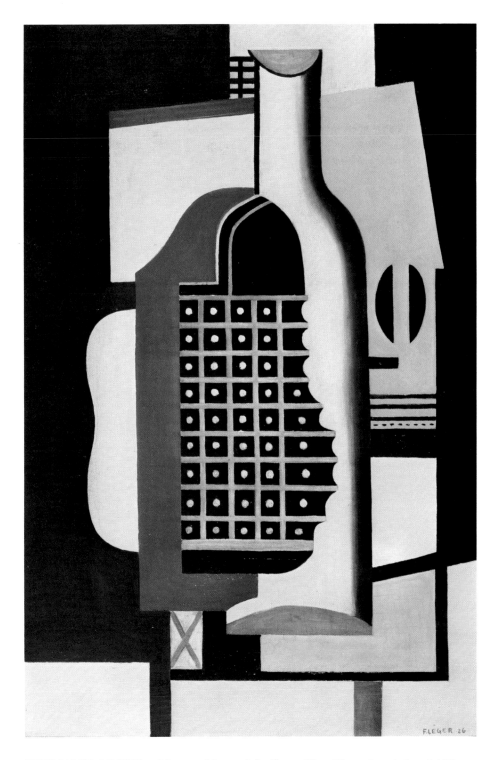

FERNAND LEGER *Nature Morte à la Bouteille* Signed and dated '26
36in by 23¾in

New York $150,000 (£62,500) 1.V.74 From the collection of
Arnold H Maremont

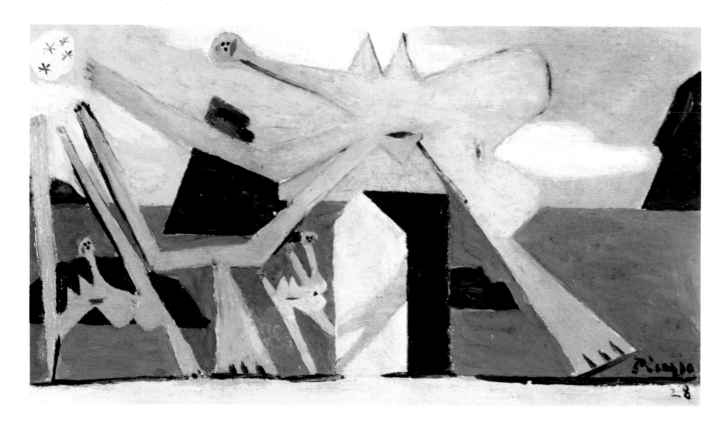

PABLO PICASSO *Baigneuses au Ballon* Signed and dated '28 Painted in Dinard on August 19th, 1928
7½in by 13in

New York $130,000 (£54,167) 2.V.74 From the collection of the late R Sturgis Ingersoll, of Philadelphia

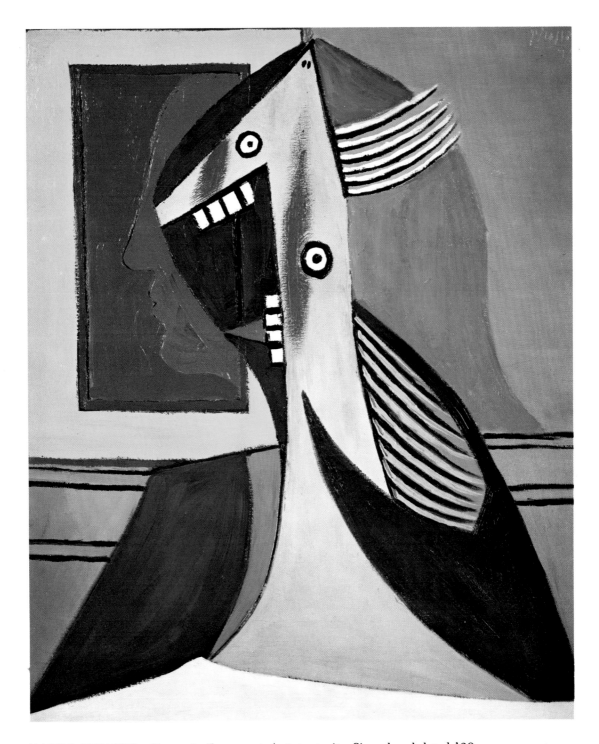

PABLO PICASSO *Buste de Femme et Autoportrait* Signed and dated '29
28in by 23¾in

New York $260,000 (£108,333) 17.X.73 From the collection of Bernice McIlhenny
Wintersteen, of Pennsylvania

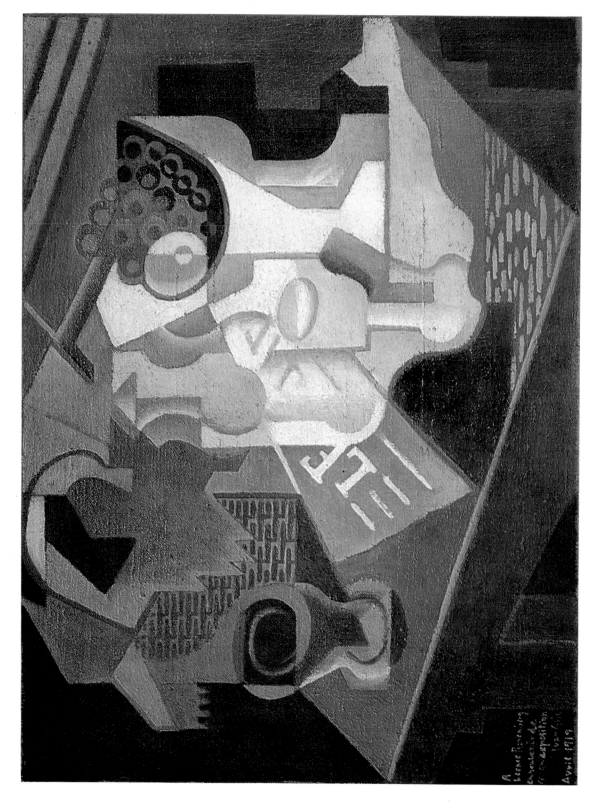

JUAN GRIS *La Table devant le Batiment* Signed and dedicated *à Léonce Rosenberg en souvenir de mon exposition, Juan Gris Avril '1919* Painted in 1918 24¾in by 32in

London £86,000 ($206,400) 3.VII.74

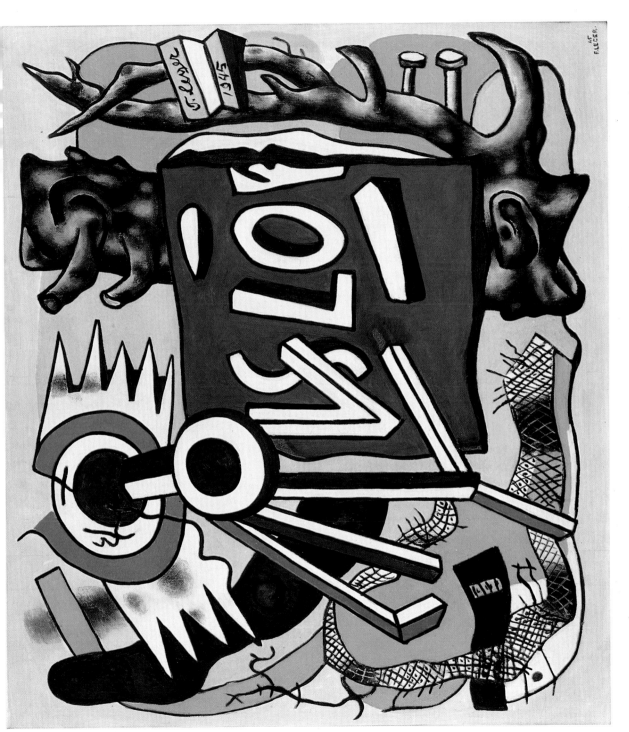

FERNAND LEGER *Tronc d'Arbre sur Fond jaune* Signed and dated 1945 Painted in America in 1945
50in by 44in

London £52,000 ($124,800) 5.XII.73

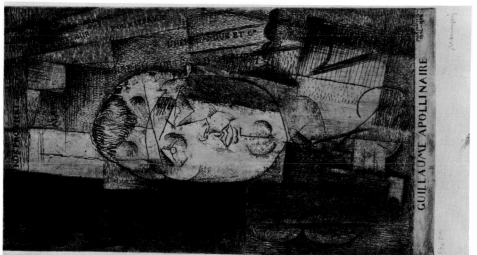

LOUIS MARCOUSSIS *Guillaume Apollinaire* Etching, aquatint and drypoint Signed and initialled in pencil and numbered 16/30 49.5cm by 28 cm

London £3,000 ($7,200) 23.IV.74

MARC CHAGALL *Selbstbildnis mit dem Verzierten Hut* Drypoint Signed in pencil 21cm by 14.5cm One of sixty

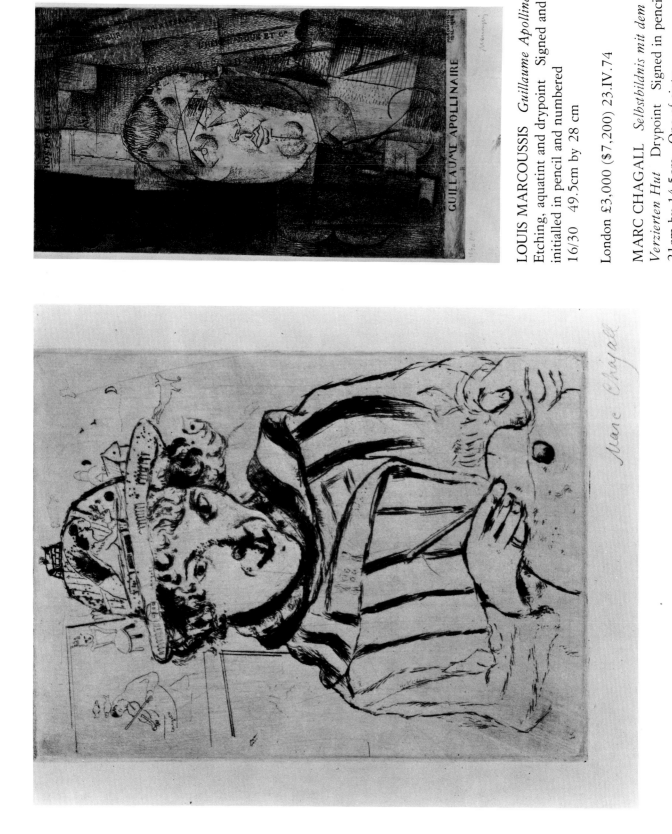

Russian Avant Garde 1900-1930

ALEXANDRA EXTER *Cubist Nude* Signed on the reverse
Painted *c.* 1914-15 57in by 44in

London £1,600 ($3,840) 4.VII.74 From the collection of
Simon Lissim, of New York

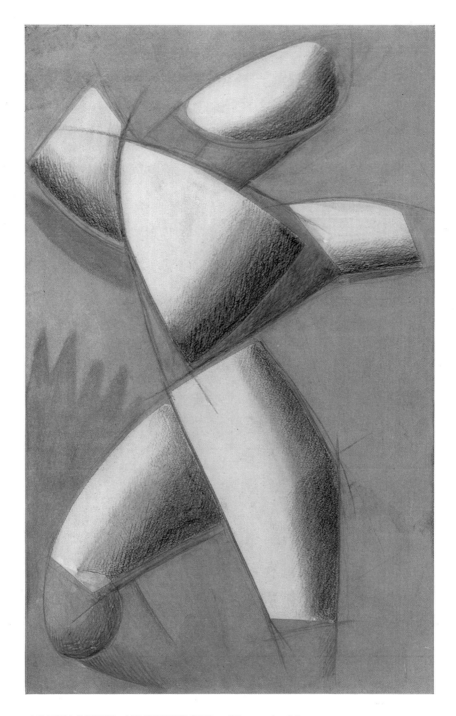

ALEXANDER ARCHIPENKO *Figure in Movement*
Collage and chalk Executed *c.* 1913 19¼in by 12¼in

London £4,500 ($10,800) 4.VII.74

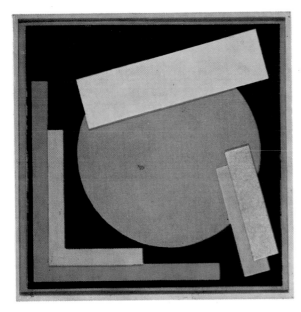

VASSILY ERMILOV *Suprematist Composition*
Painted wood relief on panel Executed *c.* 1919-21
18¾in by 18¾in

London £3,200 ($7,680) 4.VII.74

EL LISSITZKY *Proun 5 A* Charcoal, indian ink
and gouache Signed on the mount
Executed in 1919 11¼in by 10¾in

London £10,000 ($24,000) 4.VII.74

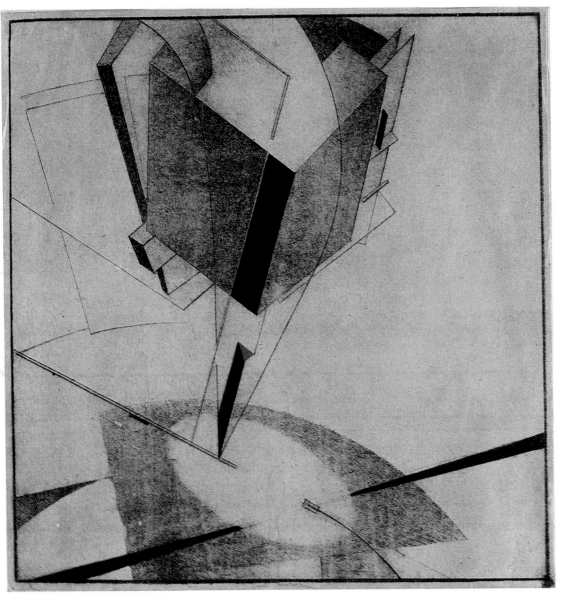

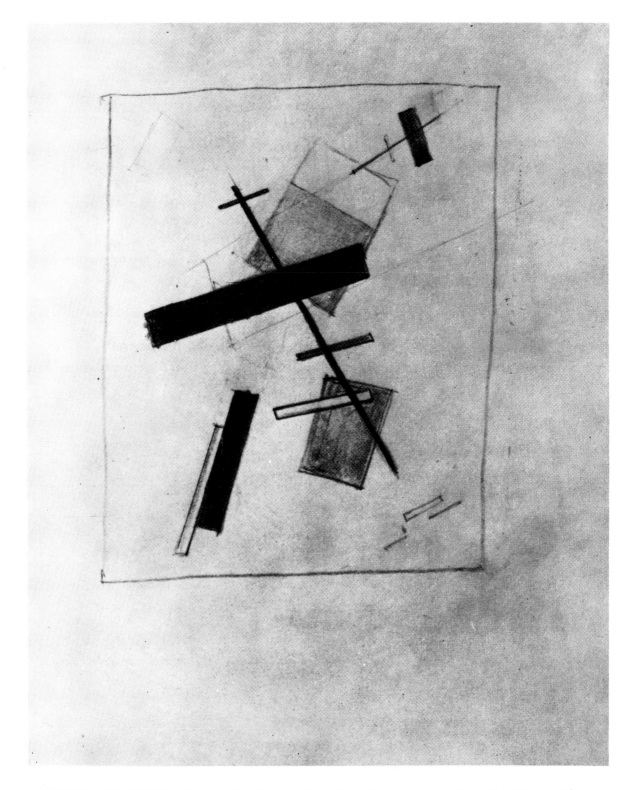

KASIMIR MALEVICH *Suprematist Composition* Pencil Drawn *c.* 1915-16 10in by 8¾in

London £2,500 ($6,000) 4.VII.74

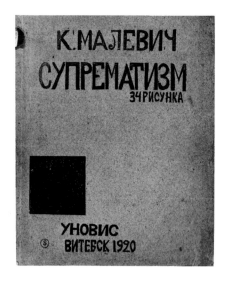
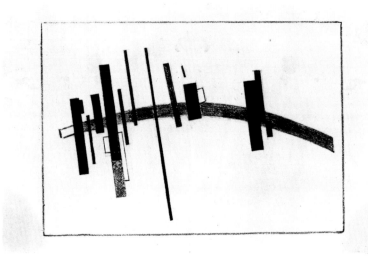

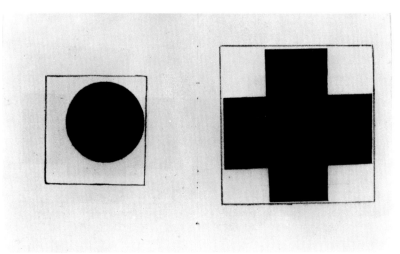

KASIMIR MALEVICH *'Suprematism'* Book lithographed by the Vitebsk Art Workshops, headed by Lissitsky. Four pages of Malevich's autograph text reproduced in capitals, with erasures and brackets, Malevich's signature in cursive hand, and dated Vitebsk, 15 December 1920
This book, with 34 lithographs, was 'probably prepared . . . when the big retrospective exhibition of Malevich's work was held in Moscow in 1920.' (Troels Andersen, Stedelijk Museum Catalogue, *Malevich,* 1970)

London £3,100 ($7,480) 4.VII.74

KASIMIR MALEVICH *'On New Systems in Art'* Lithographic facsimile of Malevich's autograph in cursive hand and capitals, decorated with circles and black rectangles. With 3 full page 'lithographs based on analytical drawings' Signed in facsimile 3 times, dated Nemchinovka, 15 July 1919, Vitebsk, 15 November 1919

'On New Systems in Art is the most important among Malevich's early writings . . . (He) discussed the movements in modern art that played a formative role in his painting . . . The book was printed in the lithographic workshop of the Vitebsk School . . . headed by Lissitzky. The text is written in block letters and corrections are made as small squares, rectangles, etc. The front cover is made as a woodcut . . .'. (Troels Andersen, Stedelijk Museum Catalogue, *Malevich,* 1970, p. 149, no. 38)

London £2,100 ($5,040) 4.VII.74

IVAN PUNI (POUGNY) *Man with a Bowler Hat*
Pencil Stamped twice with the signature Drawn in Berlin
in 1921 7¼in by 4⅜in

London £1,000 ($2,400) 4.VII.74

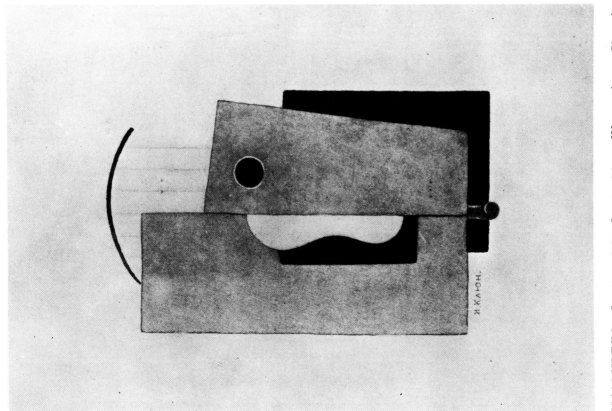

IVAN KLIUN *Constructivist Composition* Watercolour Signed
Executed *c.* 1920 11¼in by 7¾in

London £2,600 ($6,240) 4.VII.74

Klee, Kandinsky and Feininger

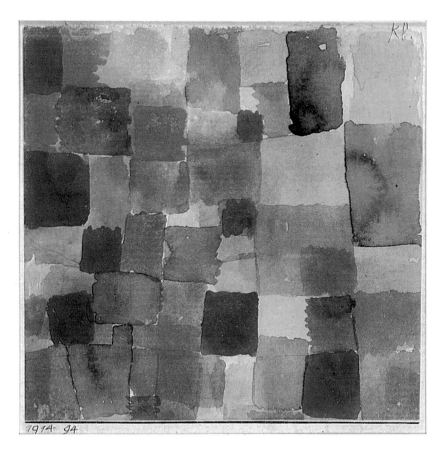

PAUL KLEE *Aquarell, Deutsches Bütten* Watercolour
Signed; dated 1914 94 on the mount 4¼in by 4½in

London £9,200 ($22,080) 3.VII.74

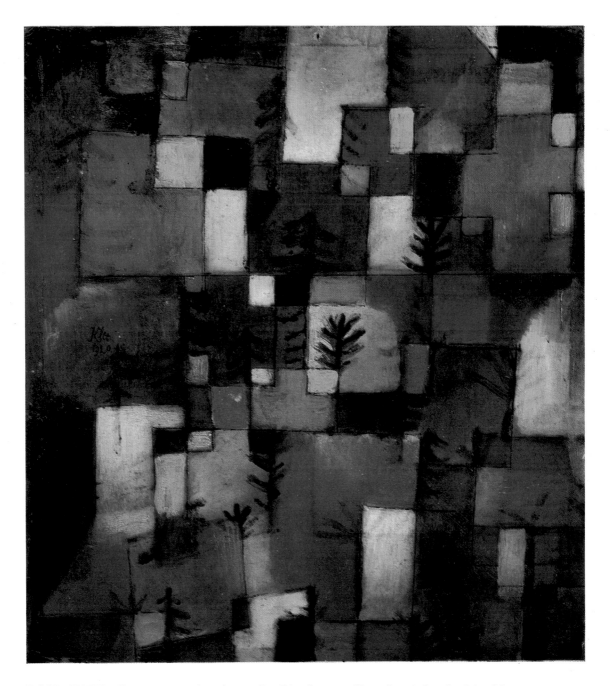

PAUL KLEE *Rotgrüne und violett-gelbe Rhythmen* Signed and dated 1920 38
14¾in by 13¼in

London £76,000 ($182,400) 3.VII.74

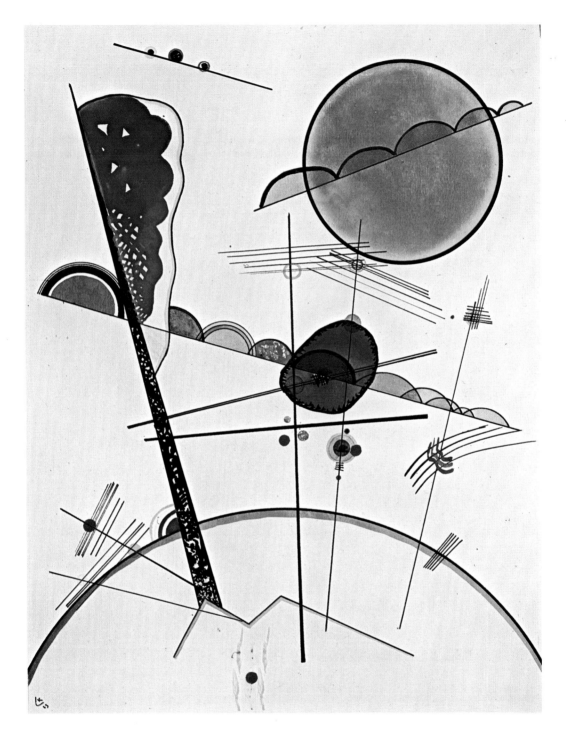

WASSILY KANDINSKY *Wachsen* Indian ink and watercolour Signed with the initials and dated '23 15½in by 12in

New York $57,500 (£23,958) 2.V.74

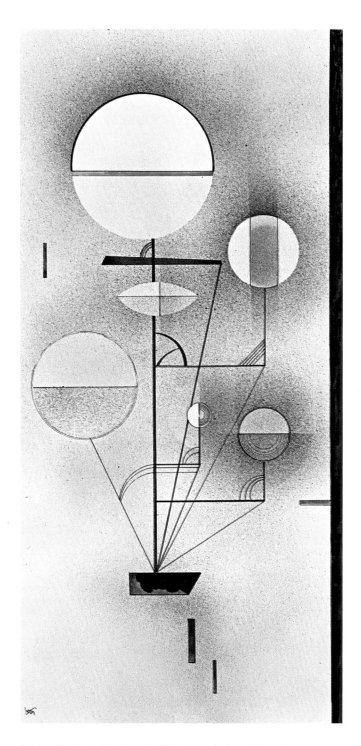

WASSILY KANDINSKY *Machtlose Fesseln*
Watercolour Signed with the monogram and dated '29
26¼in by 13in

New York $60,000 (£25,000) 2.V.74

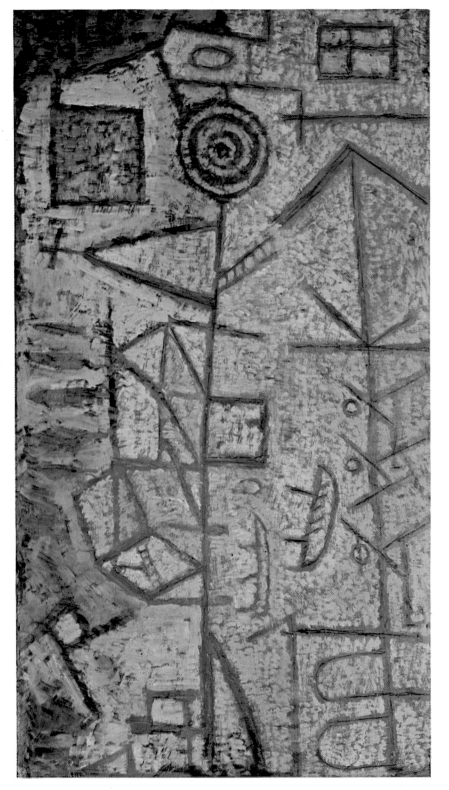

PAUL KLEE *Kleiner See-hafen* Signed; titled and dated 1937 q-14 on the reverse 14½in by 24½in

London £70,000 ($168,000) 5.XII.73 From the collection of Richard K Weil, of St Louis

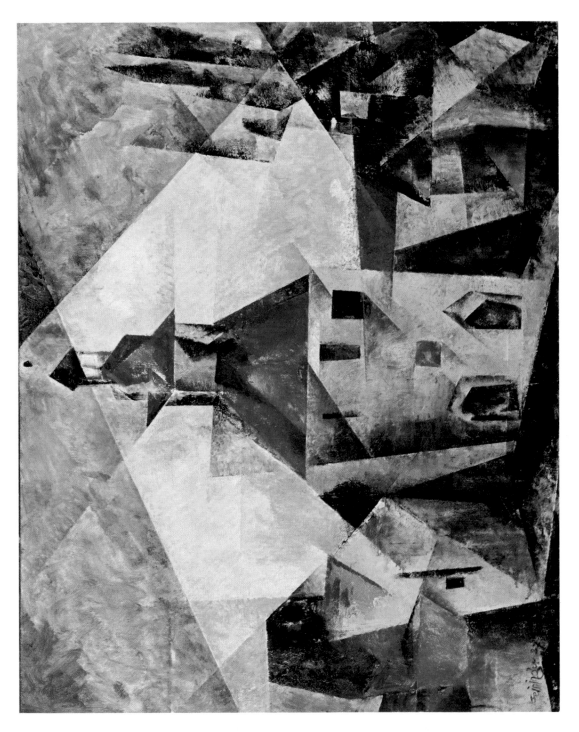

LYONEL FEININGER *Town Hall II, Zottelstedt* Signed and dated '27 31½in by 39½in

New York $140,000 (£58,333) 2.V.74

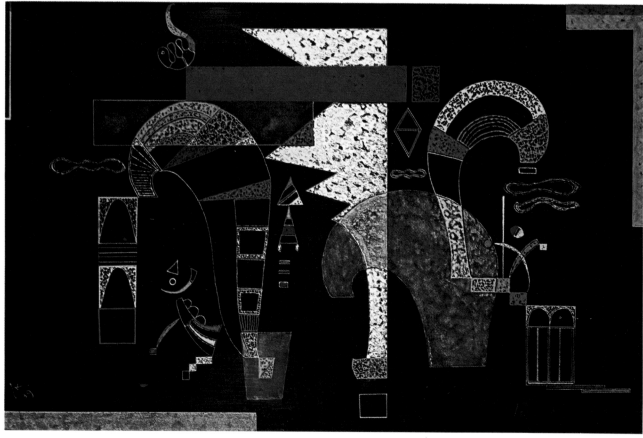

104

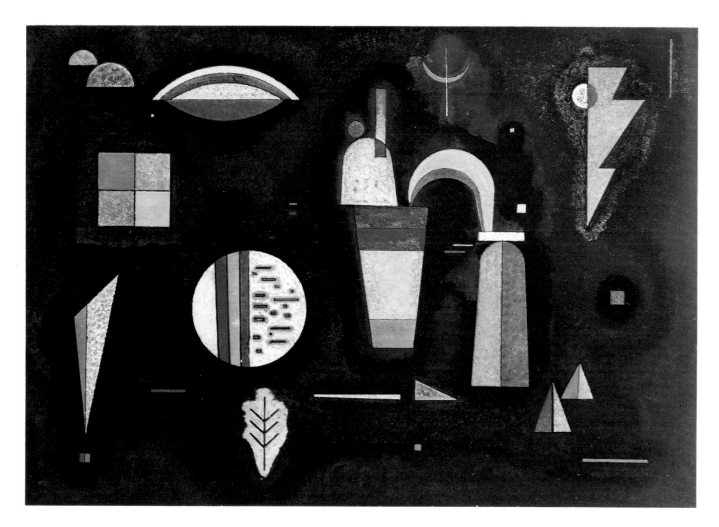

WASSILY KANDINSKY *Gelber Bogen* Signed with the monogram and dated '30 19in by 27½in

New York $160,000 (£66,667) 2.V.74 From the collection of the Estate of the late E Weyhe,

LYONEL FEININGER *Ship with yellow Sails* Watercolour, pen and ink on brown paper Signed
Executed *c.* 1938 7¾in by 10½in

New York $12,500 (£5,208) 18.X.73 From the Kortheuer Collection

WASSILY KANDINSKY *La Forme blanche* Watercolour and gouache on black paper
Signed with the initials and dated '39 12½in by 19¼in

New York $62,500 (£26,042) 2.V.74

PAUL KLEE *Flotille* Tempera on paper Signed, titled and dated 1925 1 14in by 19½in

London £30,000 ($72,000) 3.VII.74

LYONEL FEININGER *Mondlicht auf den Dünen* Signed Painted in 1944 24in by 36in

London £43,000 ($103,200) 3.VII.74

PAUL KLEE *Jungfrau im Baum
(Jungfrau träumend)* Etching
Signed in pencil, titled, dated 1903
and numbered 24/30, with the
work number 2 9¼in by 11¾in

New York $21,000 (£8,750)
14.V.74

GEORG GROSZ *Die Räuber*
Title page and the complete set of
nine lithographs Signed in pencil
Published in Berlin in 1922
27½in by 11½in

New York $5,000 (£2,083)
8.XI.73

Non-Objective Art

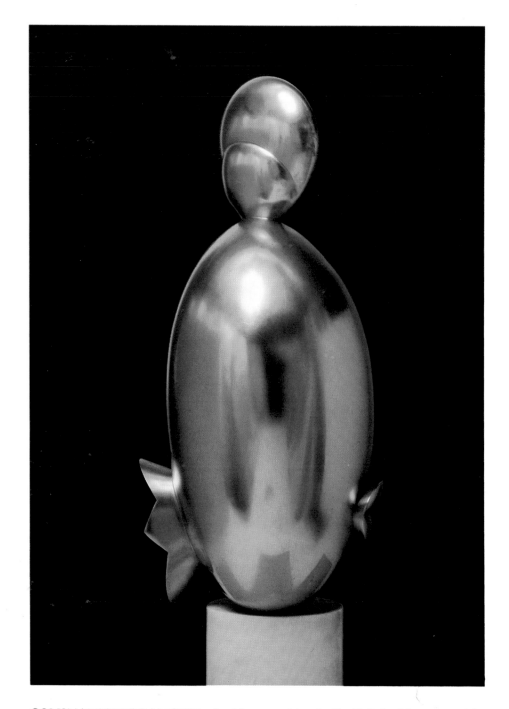

CONSTANTIN BRANCUSI *La Negresse blonde II* Polished bronze; with two bases of marble and limestone Signed and dated 1926 Height without base 15¼in

New York $750,000 (£312,500) 1.V.74 From the collection of Arnold H Maremont

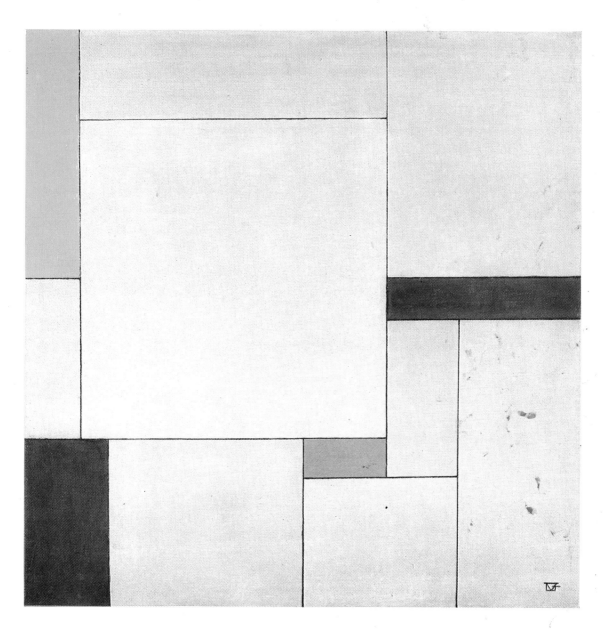

GEORGES VANTONGERLOO *Composition dans le Carré inscrit et circonscrit d'un Cercle*
Signed with the initials Painted in 1930 20in by 20in

London £23,000 ($55,200) 3.VII.74 Sold at Sotheby's in November 1962 for
£800 ($2,240)

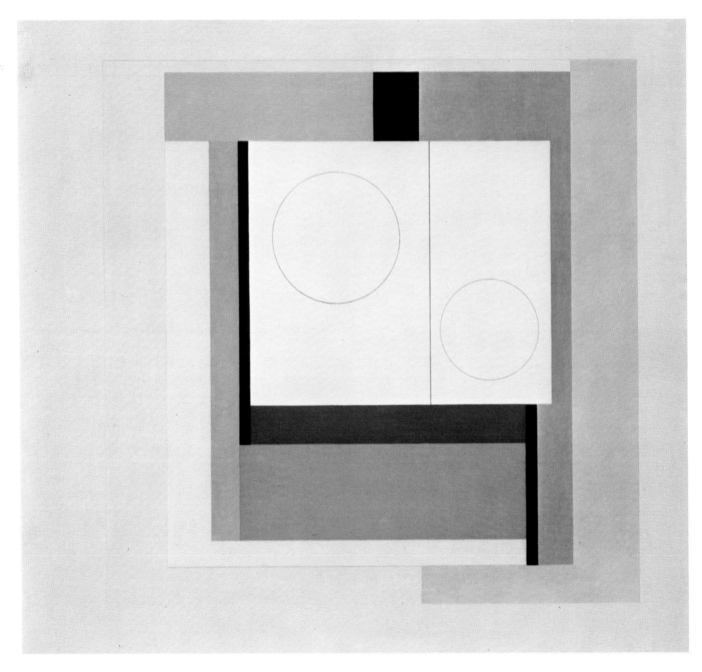

BEN NICHOLSON, O.M. *Painting, Version I* Painted in 1944-1945 36in by 33¾in

New York $85,000 (£35,417) 2.V.74

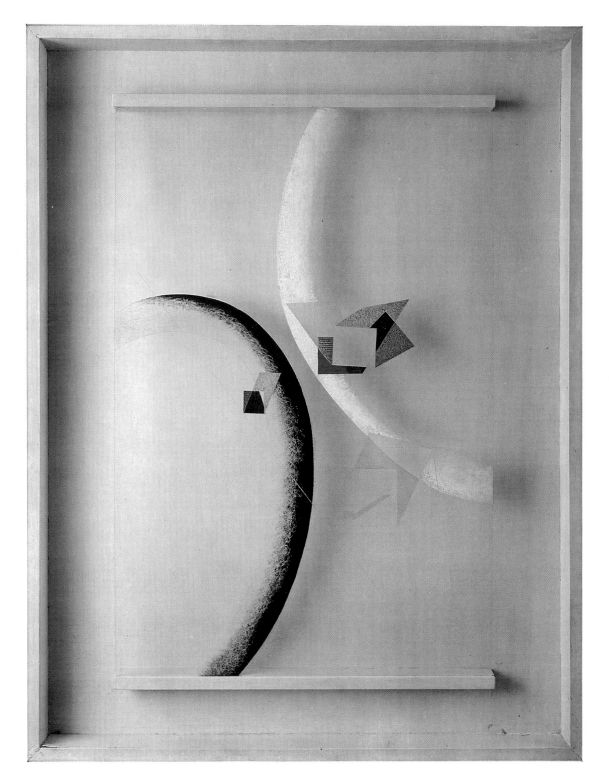

LASZLO MOHOLY-NAGY *Space Modulator CHPII* Oil on plexiglass in a shallow
painted box Signed, inscribed and dated '40 45½in by 35¼in

London £15,500 ($37,200) 3.IV.74

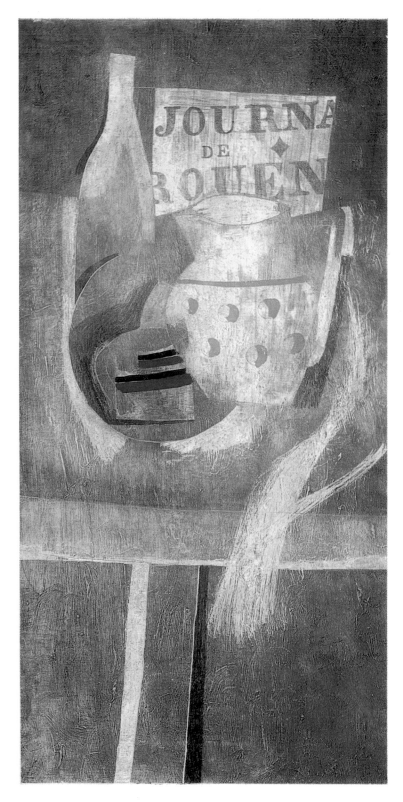

BEN NICHOLSON, O.M. *Journal de Rouen* Signed and
dated on the reverse Painted in 1932 35½in by 17¾in

London £28,000 ($67,200) 13.III.74

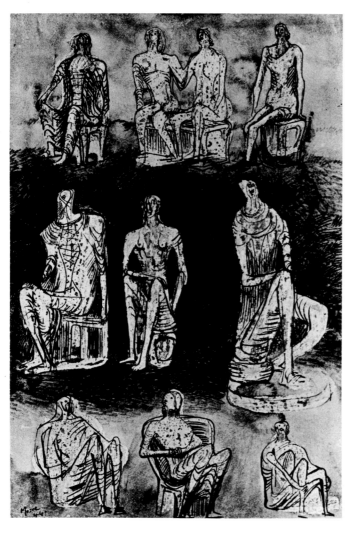

HENRY MOORE, O.M., C.H. *Study for Sculpture: seated Figures* Pen and ink, watercolour and crayon Signed and dated '44 21½in by 14½in

New York $26,000 (£10,833) 2.V.74
From the collection of the Norton Simon Foundation, of Beverly Hills

HENRY MOORE, O.M., C.H. *Shelter Drawing* Pen and ink, coloured chalks and watercolour, heightened with bodycolour Signed and dated '41

London £8,000 ($19,200) 21.XI.73
From the collection of Peter Bellew, of Paris

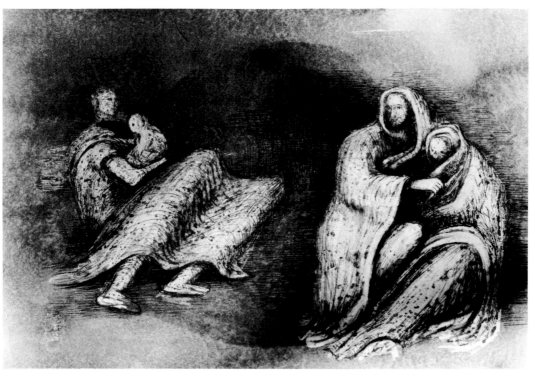

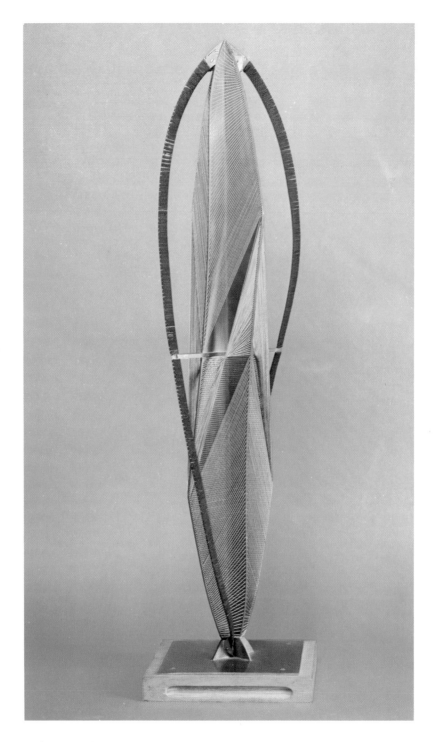

NAUM GABO *Vertical Construction No. 1* Phosphor-bronze,
with stainless steel strings Signed Executed in 1964-65
Height 49½in

New York $95,000 (£39,583) 2.V.74

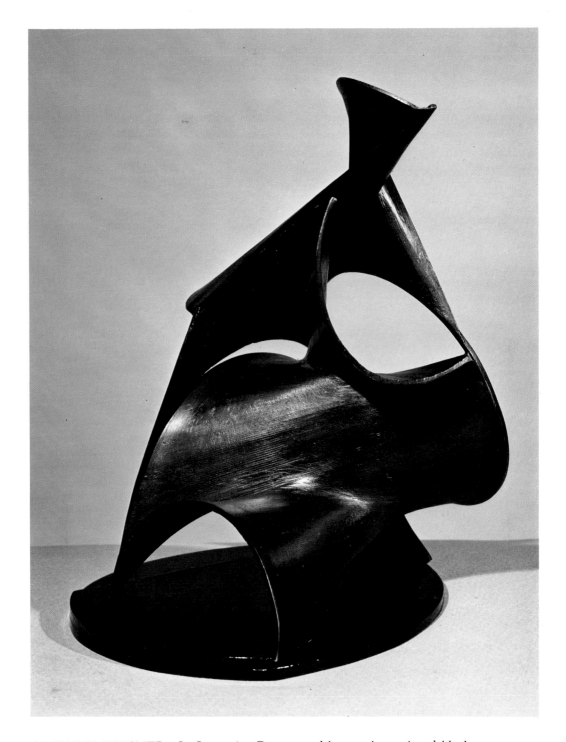

ANTOINE PEVSNER *Le Lys noir* Bronze and brass wire, painted black.
Copper base, painted black Signed Height 20½in Length 16¾in

New York $70,000 (£29,167) 17.X.73

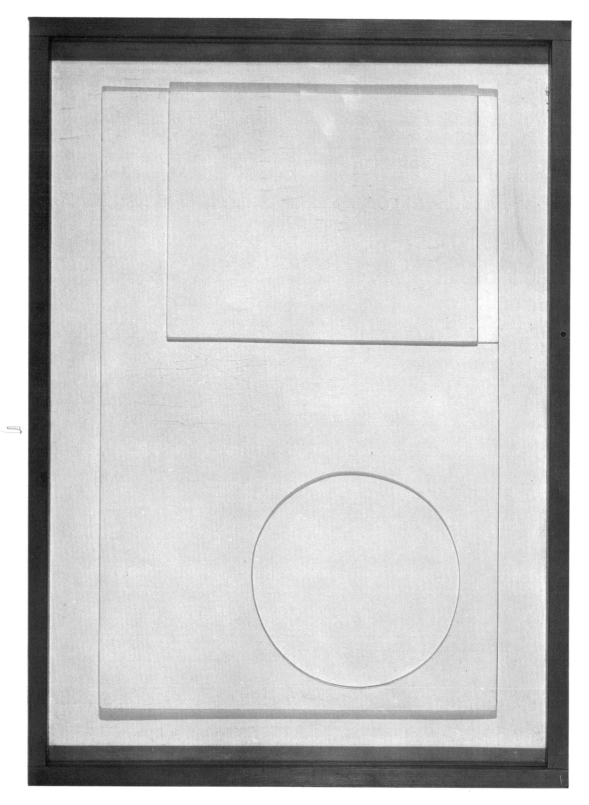

BEN NICHOLSON, O.M. *White Relief* Painted in 1935 20½in by 29in

London £30,000 ($72,000) 19.VI.74

School of Paris
1918-1945

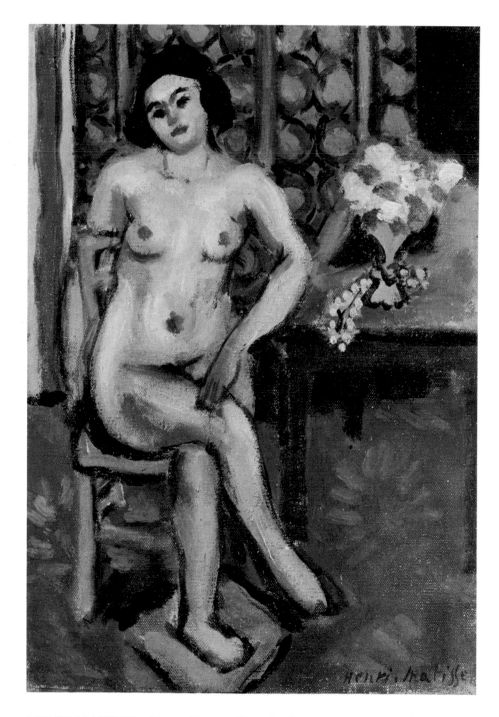

HENRI MATISSE *Nu au Fleurs* Signed Painted *c.* 1922 10¾in by 7⅝in

New York $145,000 (£60,417) 2.V.74 From the collection of the
late R Sturgis Ingersoll, of Philadelphia

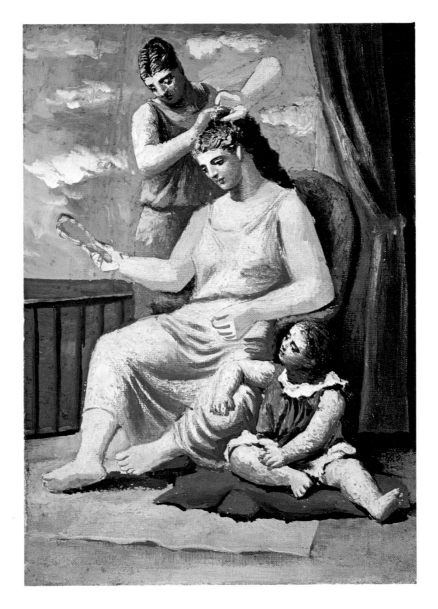

PABLO PICASSO *La Coiffure*
Inscribed and dated *Dinard* 1922 on the stretcher 8⅝in by 6¼in

New York $250,000 (£104,167) 17.X.73 Formerly in the
collection of Paul Hyde Bonner, sold at Sotheby's in October
1963 for £13,000 ($36,400) From the collection of Bernice
McIlhenny Wintersteen, of Pennsylvania

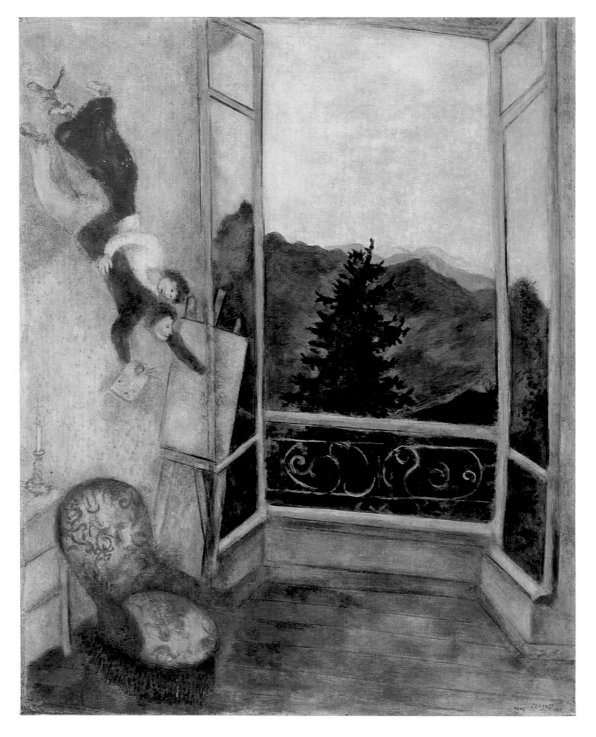

MARC CHAGALL *Le Fauteuil rose* Signed and dated 1930 28¼in by 23¼in

London £63,000 ($151,200) 3.VII.74 From the collection of the Solomon R Guggenheim Foundation, New York

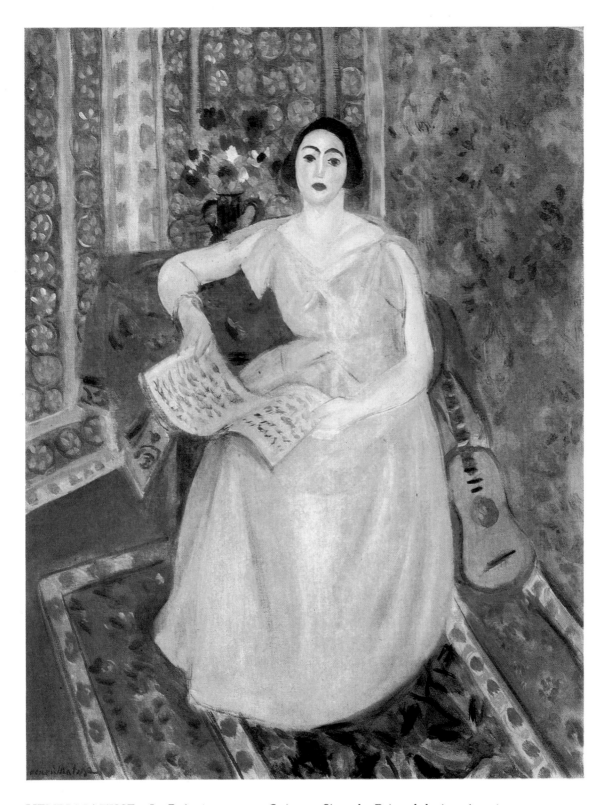

HENRI MATISSE *La Robe jaune avec Guitare* Signed Painted during the winter of 1922-23 25½in by 19¾in

London £120,000 ($288,000) 2.VII.74

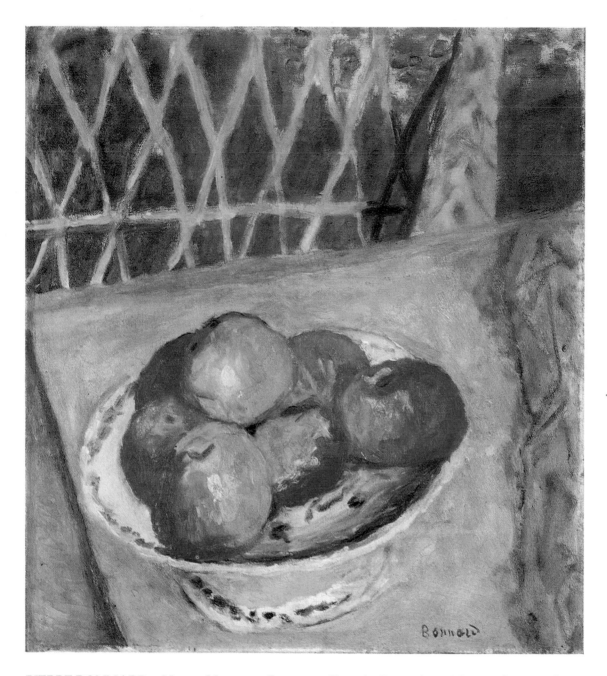

PIERRE BONNARD *Nature Morte aux Pommes* Signed Painted in 1930 13¾in by 12½in

London £60,000 ($144,000) 2.IV.74

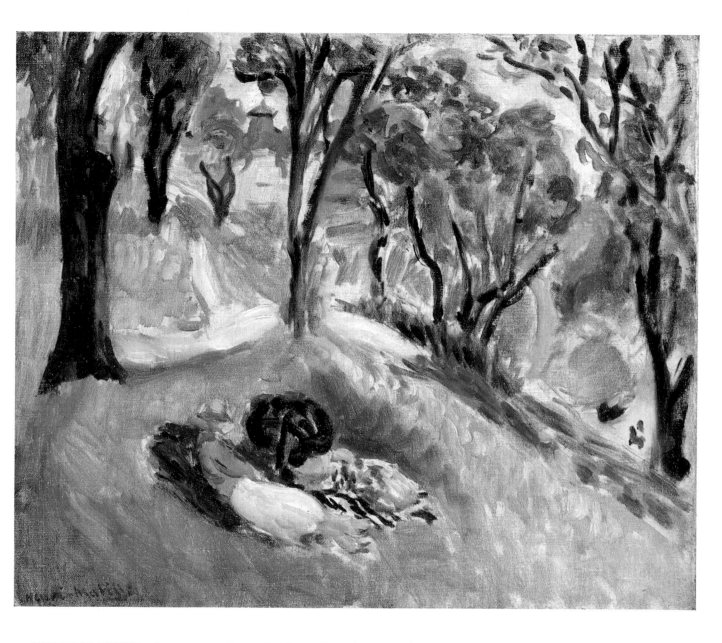

HENRI MATISSE *Paysage, environs de Nice* Signed Painted *c.* 1918 at La Mantegnia 14½in by 17¾in

London £38,000 ($91,200) 3.IV.74

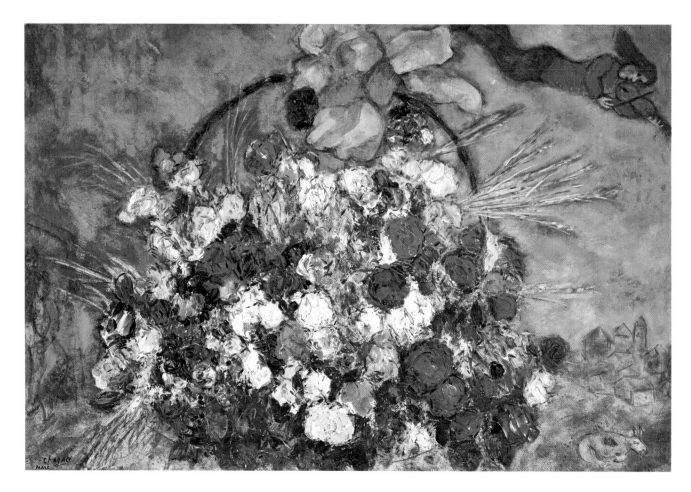

MARC CHAGALL *Panier de Fleurs* Signed Painted *c.* 1925 21½in by 32in

New York $250,000 (£104,167) 17.X.73

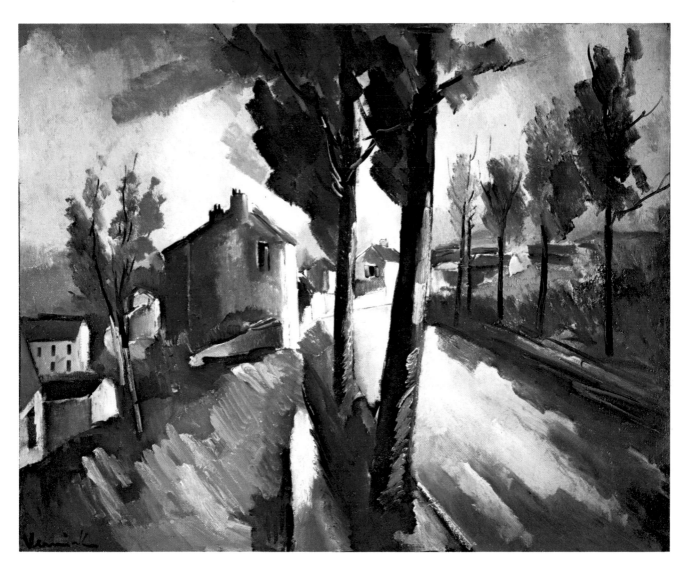

MAURICE DE VLAMINCK *La Carouge Valmondois* Signed Painted *c.* 1917 29in by 36in

New York $55,000 (£22,917) 17.X.73

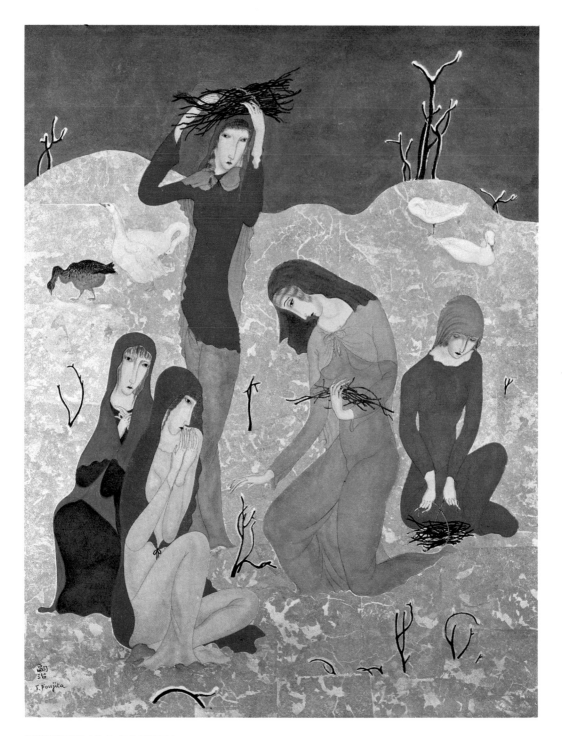

TSUGUHARO FOUJITA *Cinq Grâces dans un Paysage d'Hiver*
Gouache on silver leaf Signed Executed in 1917 17¼in by 13in

New York $33,000 (£13,750) 18.X.73

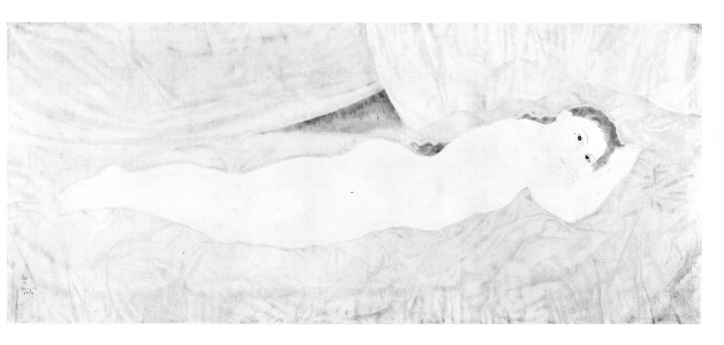

TSUGUHARO FOUJITA *Femme allongée sur un Divan* Signed and dated 1924 27¾in by 63¼in

New York $120,000 (£50,000) 17.X.73

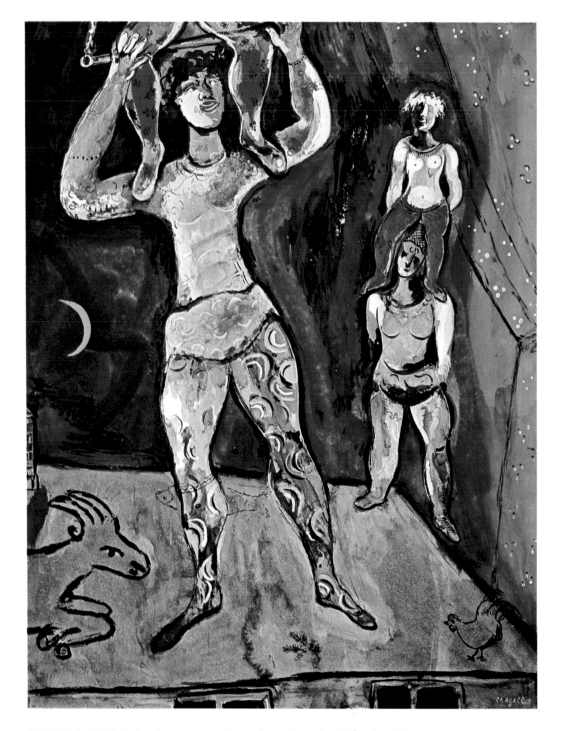

MARC CHAGALL *Le Cirque* Gouache Signed 25½in by 20in

New York $70,000 (£29,166) 2.V.74

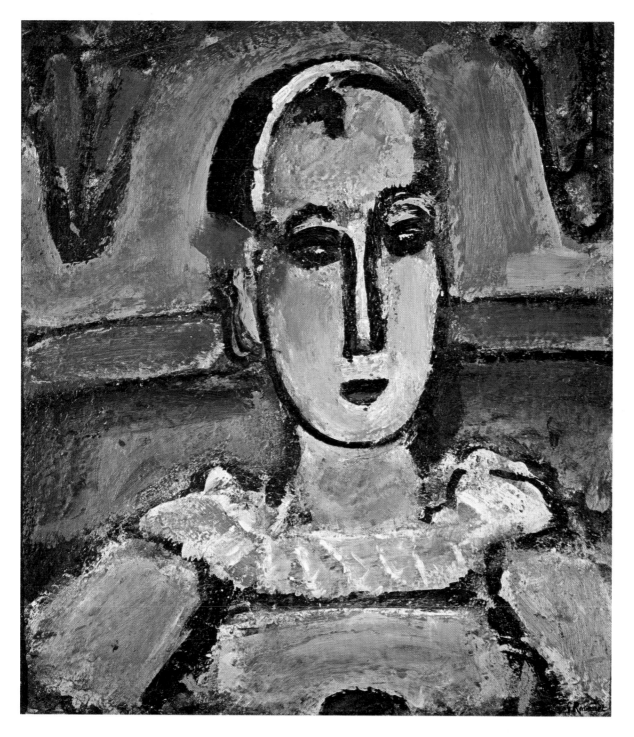

GEORGES ROUAULT *Pierrot* On board Signed; dated '43 on the reverse 24½in by 22in

New York $150,000 (£62,500) 17.X.73

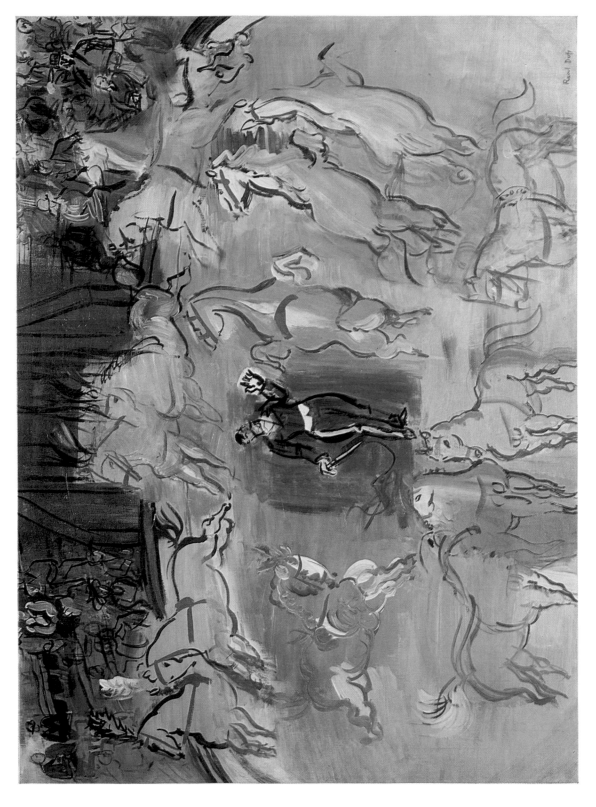

RAOUL DUFY *Le Cirque* Signed Painted *c.* 1925 35in by 45½in

London £24,000 ($57,600) 2.VII.74 From the collection of Mr and Mrs Gregory Peck, of Brentwood, Los Angeles

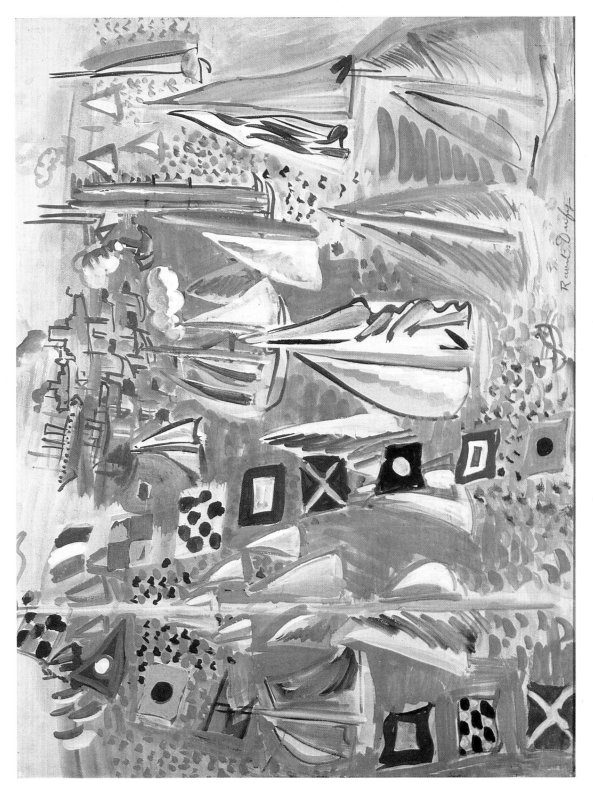

RAOUL DUFY *La Régatte au Havre* Gouache Signed 19¾ins by 25½in

London £13,000 ($31,200) 5.XII.73

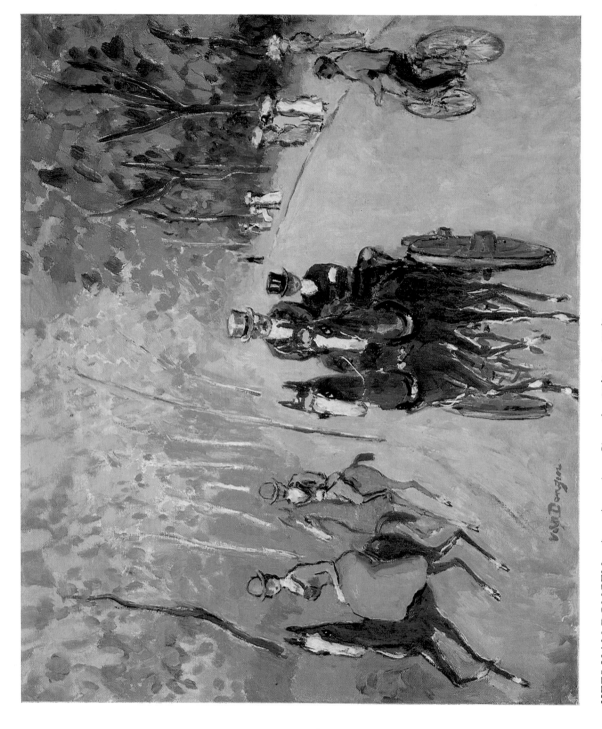

KEES VAN DONGEN *Aux Accacias* Signed 21¼in by 25¾in

London £20,500 ($49,200) 2.VII.74

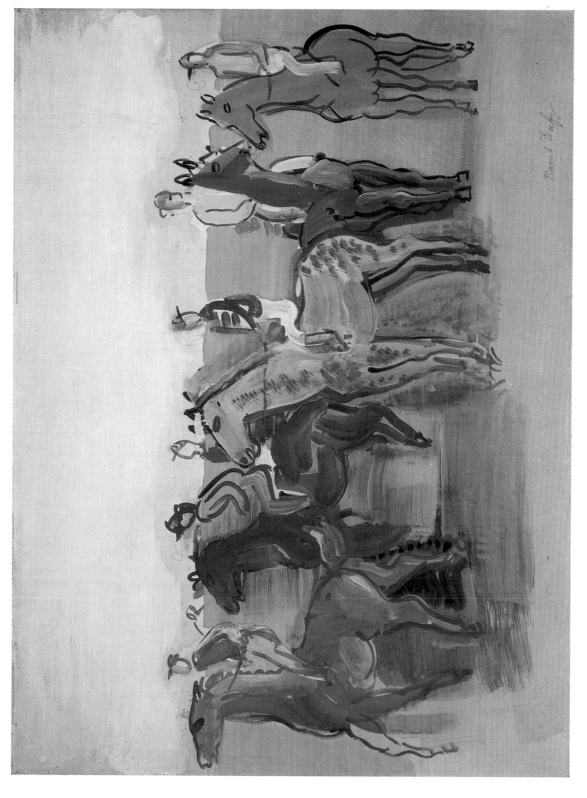

RAOUL DUFY *Chevaux de Course* Watercolour Signed 19¼in by 25¼in

London £15,000 ($36,000) 3.IV.74

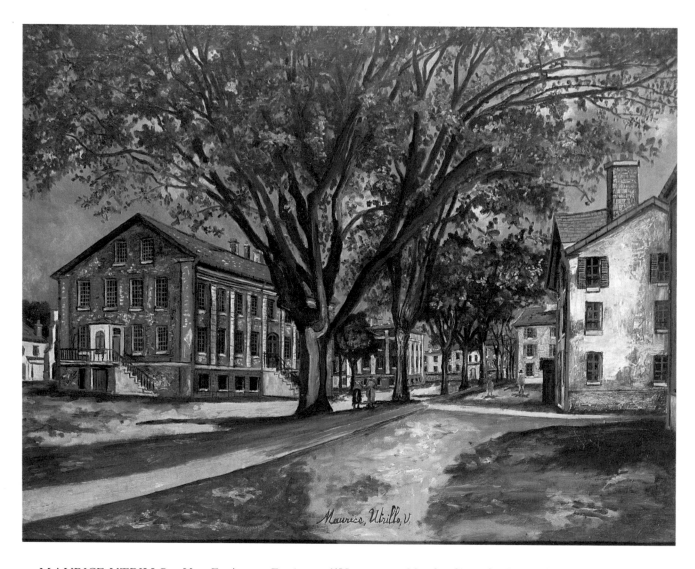

MAURICE UTRILLO *Une Ecole aux Environs d'Hautmont (Nord)* Signed Painted *c.* 1926
20in by 26in

Los Angeles $37,500 (£15,625) 25.II.74

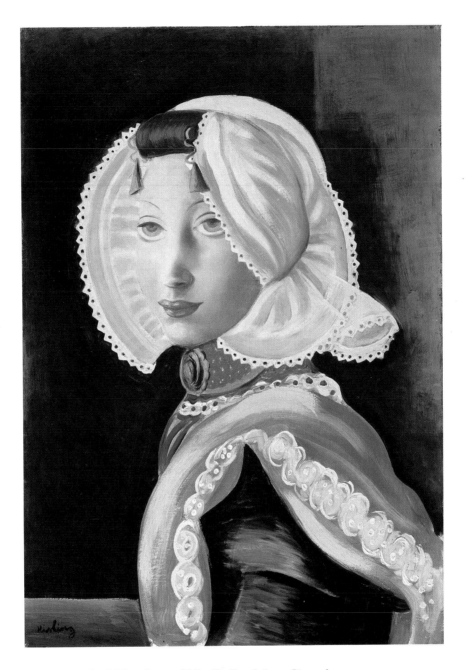

MOISE KISLING *Jeune Fille Hollandaise* Signed
Painted in 1928 21¾in by 15in

Los Angeles $21,000 (£8,750) 25.II.74 From the Estate of the late
Jacqueline D Hodgson, of Greenwich, Connecticut

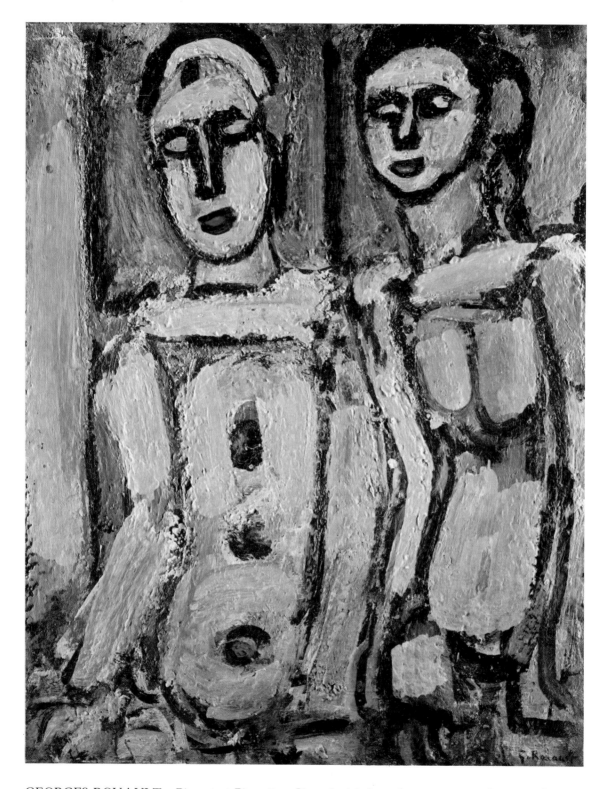

GEORGES ROUAULT *Pierrot et Pierrette* Signed, titled on the reverse 28½in by 22½in

London £65,000 ($156,000) 2.VII.74

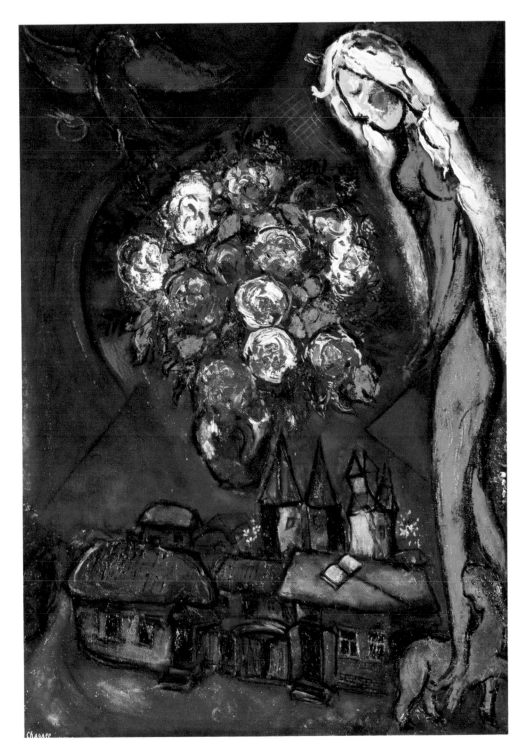

MARC CHAGALL *Femme au-dessus de la Ville* Signed and dated 1955-56
51in by 38in

New York $235,000 (£97,917) 2.V.74

GEORGES ROUAULT *Les trois Juges* Titled on the stretcher Painted in 1925 25in by 38½in

London £73,000 ($175,200) 5.XII.73

HENRI MATISSE *Femme endormie* Pen and indian ink Signed and dated '41 19¾in by 14¾in

London £12,600 ($30,240) 3.IV.74

PABLO PICASSO *Tête de Minotaure* Brush, pen and indian ink Signed and dated 26 juin '44 14½in by 11in

London £12,000 ($28,800) 3.VII.74

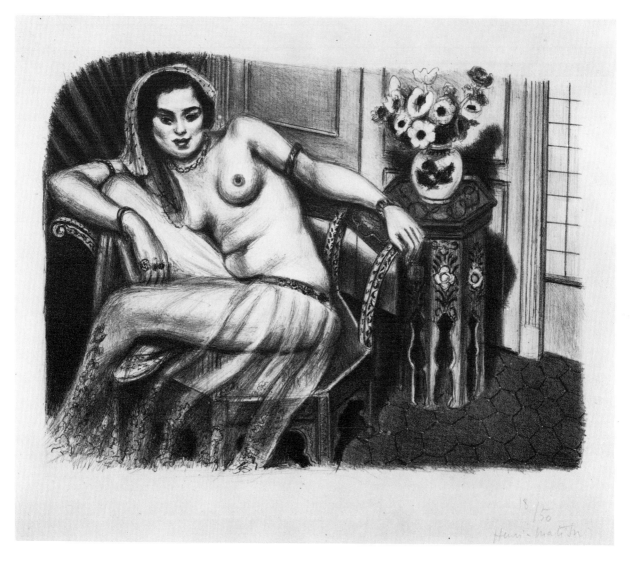

HENRI MATISSE *Odalisque assise, Jupe de Tulle* Lithograph Signed in pencil and numbered
35/50 28.5cm by 37.5cm

London £3,800 ($9,120) 20.XI.73

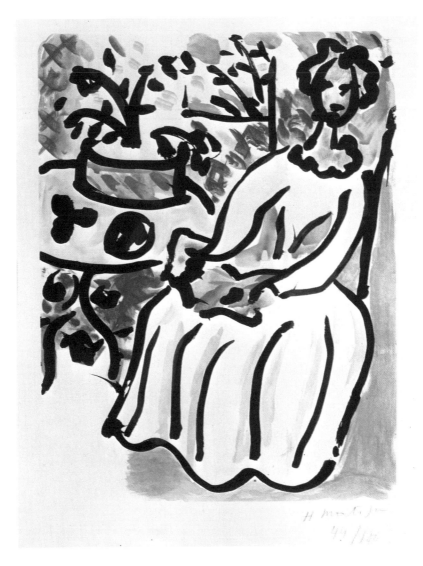

HENRI MATISSE *Marie José en Robe jaune* Aquatint printed
in colours, signed in pencil and numbered 44/100 This is the
artist's only colour print 21in by 16¼in

New York $9,500 (£3,958) 14.5.74

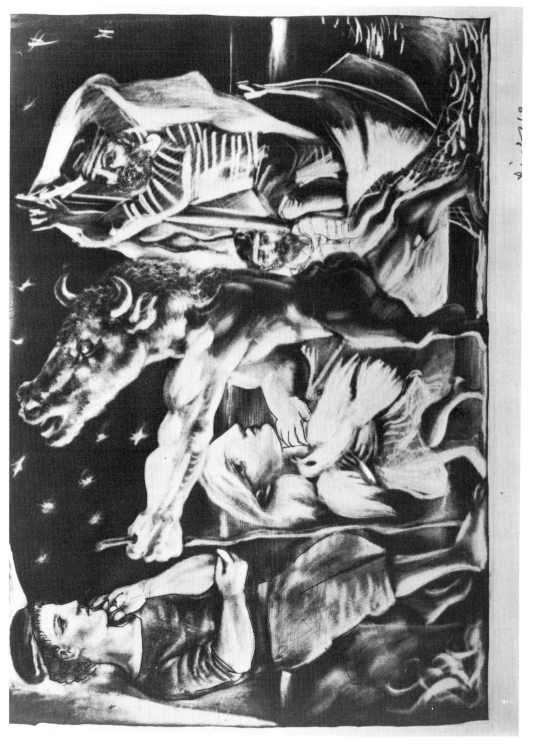

PABLO PICASSO *Minotaure aveugle guidé par une Fillette dans la Nuit* Drypoint and aquatint from the Vollard Suite Signed in pencil Executed in 1933 9¼in by 13¼in

London £3,500 ($8,400) 16.VII.74

Surrealism

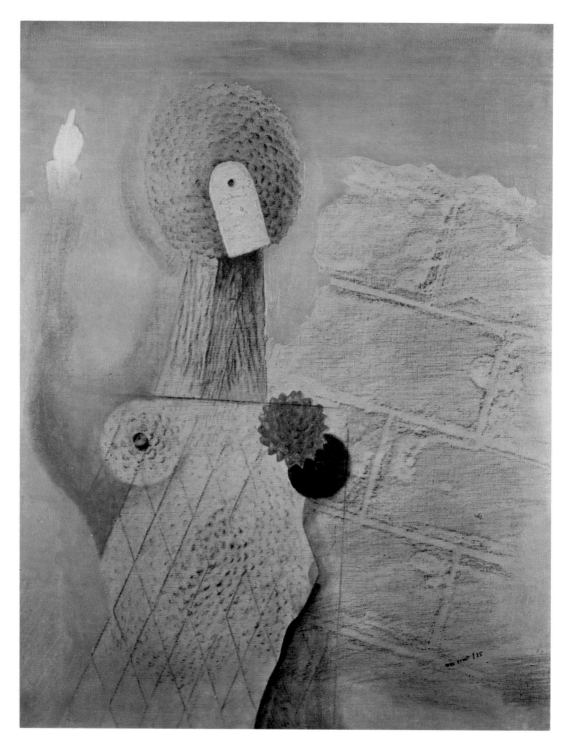

MAX ERNST *La Fleur du Désert* Mixed media and frottage Signed and dated '25
$29\frac{5}{8}$in by $23\frac{1}{4}$in

New York $220,000 (£91,667) 2.V.74

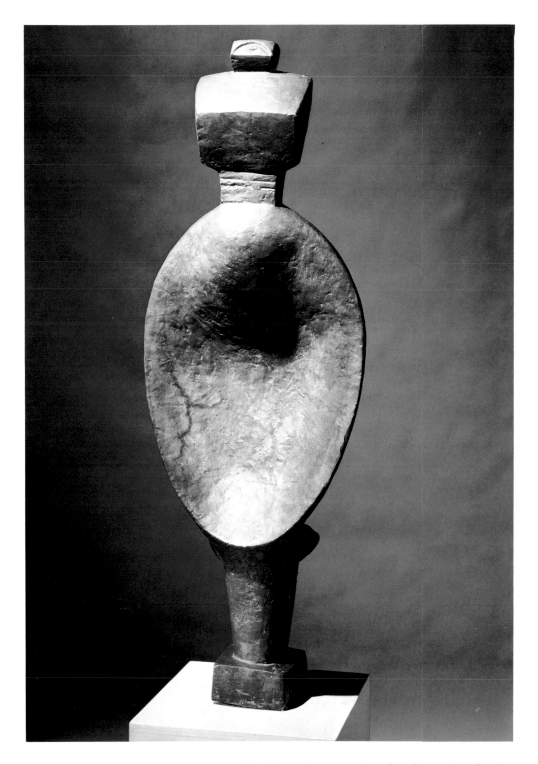

ALBERTO GIACOMETTI *Femme-Cuillère* Bronze, signed and numbered 5/6
Height 56½in

New York $165,000 (£68,750) 1.V.74 From the collection of Arnold H Maremont

JEAN ARP *Portrait de Tzara* Painted wood relief Executed in 1916 Height 15½in

New York $47,500 (£19,792) 1.V.74 From the collection of Arnold H Maremont

JOAN MIRO *Femme nue* Signed, dated 8.32.,
and titled on the reverse 13in by 7¾in

New York $110,000 (£45,833) 2.V.74 From the collection of
the late R Sturgis Ingersoll, of Philadelphia

FRANCIS PICABIA *La Ville de New York apercue à travers le Corps* Watercolour and pencil Signed, titled and dated 1912 21¾in by 29¾in

New York $67,500 (£28,125) 2.V.74

MAX ERNST *Cactus* Pencil frottage Signed
Drawn in 1925 17in by 10in

London £19,000 ($45,600) 3.IV.74

GIORGIO DE CHIRICO *Costruzione Metafisica* Pencil Signed and
dated '17 12¼in by 9¾in

New York $20,000 (£8,333) 1.V.74 From the collection of
Arnold H Maremont

JOAN MIRO *Peinture 1933* Signed and dated 22.4.33 on the reverse 50¾in by 63¾in

London £100.000 ($240.000) 3.VII.74

MAX ERNST *Couple étroitement enlacé dans les Flammes* Signed Painted in 1927 31½in by 39¼in

New York $230,000 (£95,833) 2.V.74

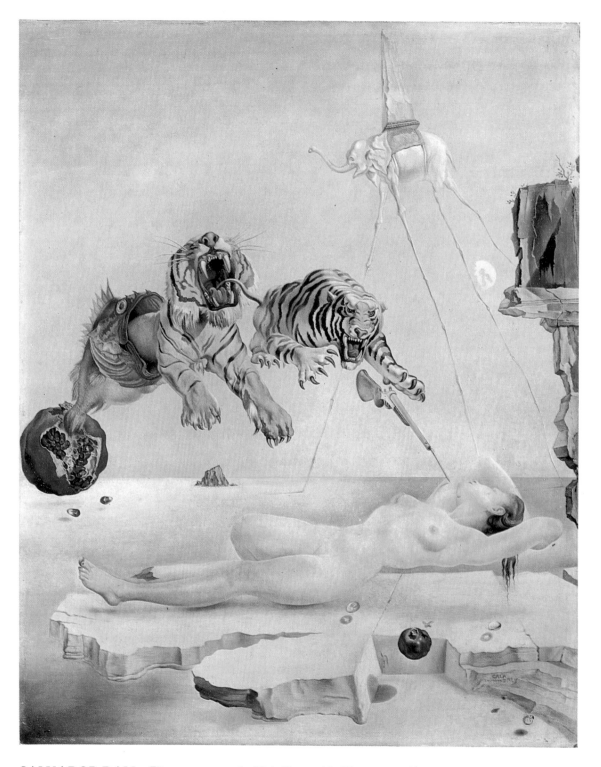

SALVADOR DALI *Rêve causé par le Vol d'une Abeille autour d'une Pommegrenade une Seconde avant l'Eveil* On panel Signed and inscribed *Gala* Painted in 1944 20in by 16in

London £70,000 ($168,000) 3.VII.74

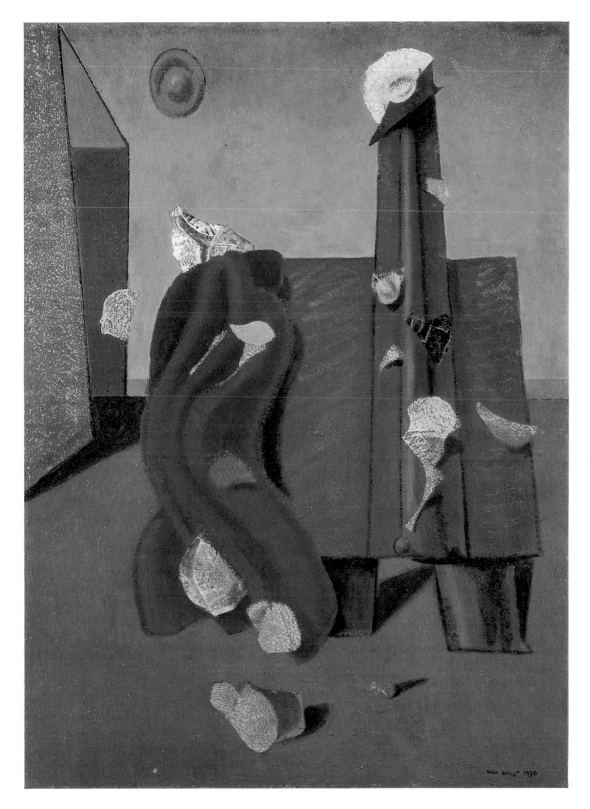

MAX ERNST *Le Toréador* Signed and dated 31¼in by 23½in

London £90,000 ($216,000) 5.XII.73

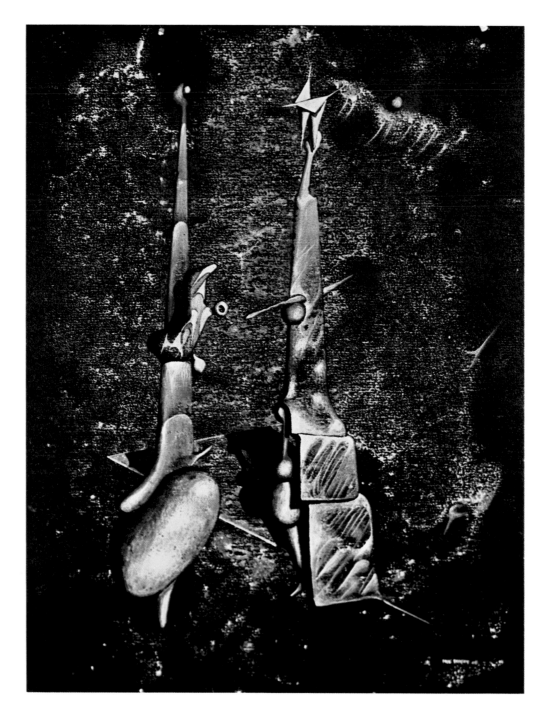

YVES TANGUY *Les Causeurs* Gouache on black paper Signed and dated '45
14¼in by 11in

New York $30,000 (£12,500) 18.X.73

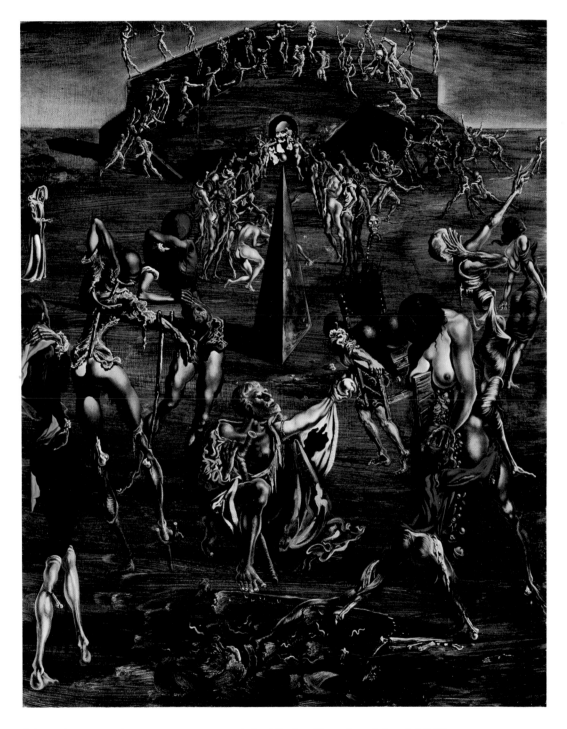

SALVADOR DALI *Resurrection of the Flesh* Signed and dated 1945
36¼in by 28¾in

New York $245,000 (£102,083) 2.V.74

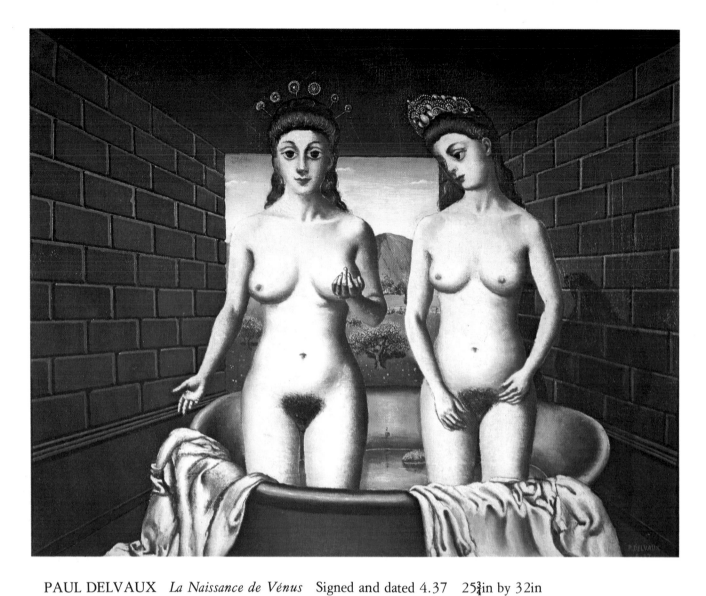

PAUL DELVAUX *La Naissance de Vénus* Signed and dated 4.37 25¾in by 32in

New York $130,000 (£54.167) 17.X.73 From the collection of the California Institute of the Arts, San Francisco

OSĆAR DOMINGUEZ *Le Chasseur* Signed and dated 1933 24in by 19¾in

New York $28,000 (£11,667) 2.V.74

ANDRE MASSON *Le Coq et la Sauterelle* Signed on the reverse Executed *c.* 1935 15½in by 23in

London £10,000 ($24,000) 3.IV.74

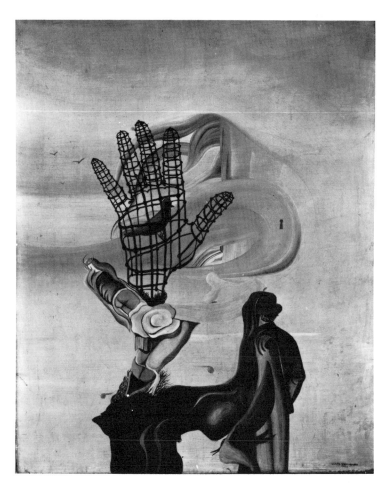

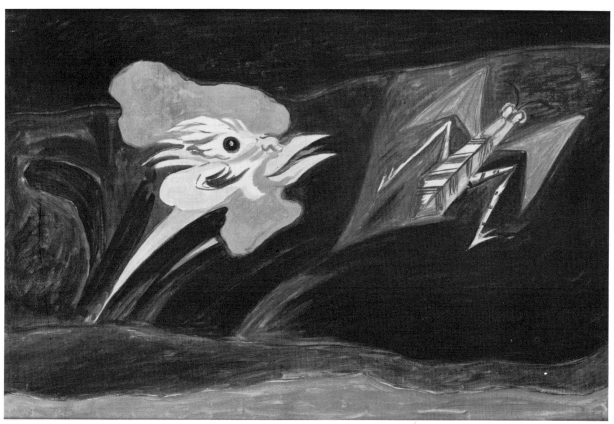

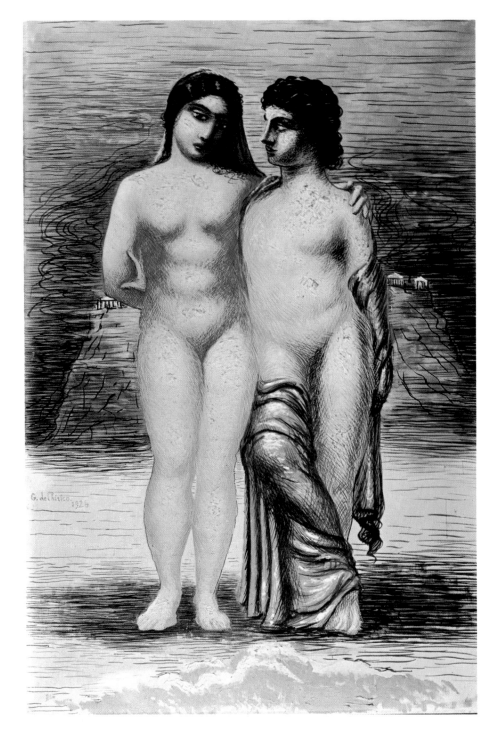

GIORGIO DE CHIRICO *Les deux Nus* Signed and dated 1926
51¼in by 35in

New York $90,000 (£37,500) 2.V.74 From the collection of the
late R Sturgis Ingersoll, of Philadelphia

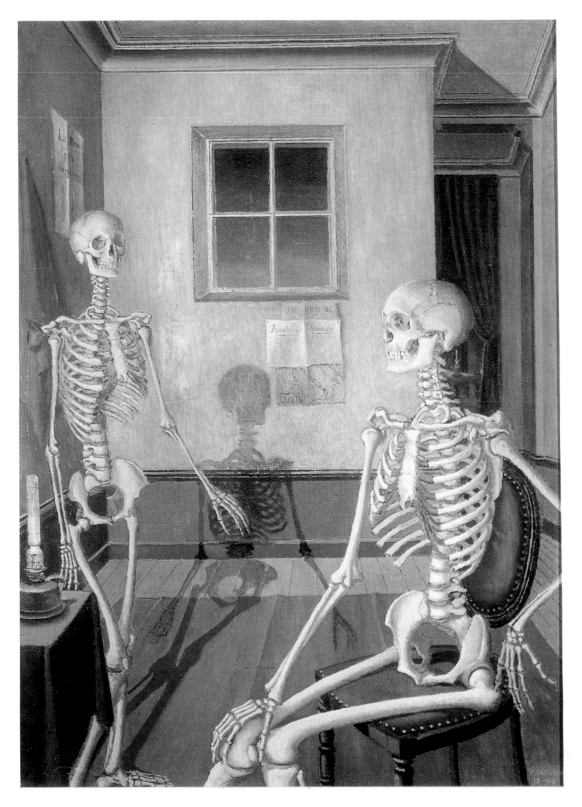

PAUL DELVAUX *Squelettes en Conversation* Signed and dated 12-'44 43¼in by 31½in

London £56,000 ($134,400) 3.VII.74

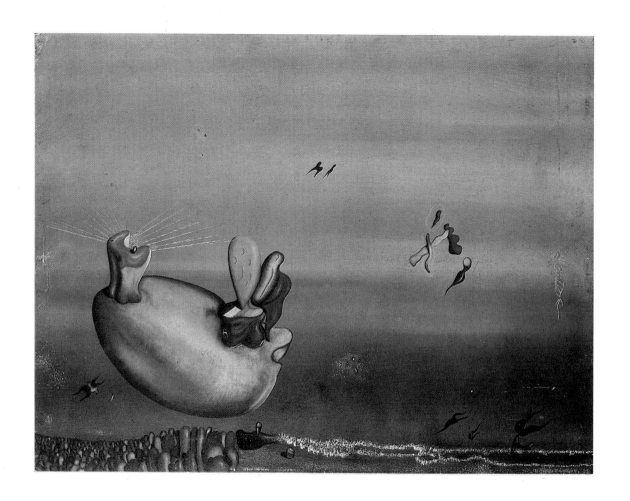

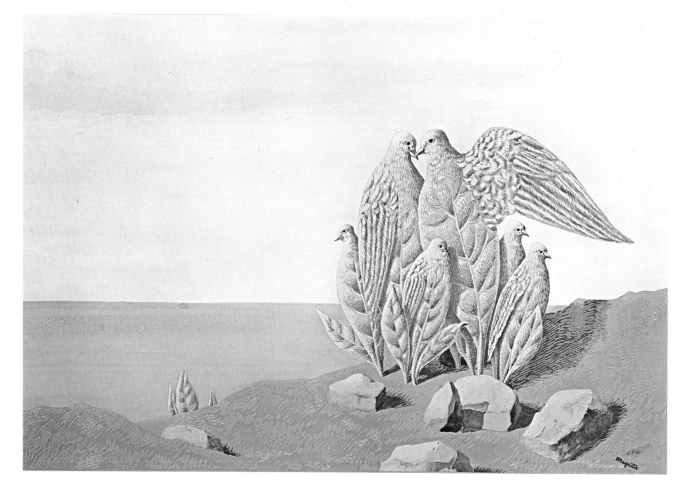

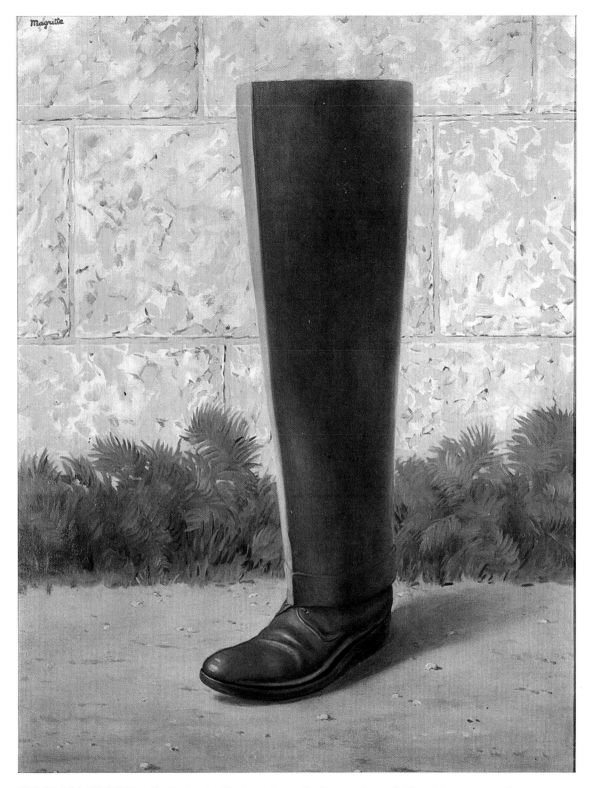

RENE MAGRITTE *Le Puits de Verité* Signed Painted in 1963 (Magritte made a bronze of this subject in 1967) 31in by 23¼in
London £36,000 ($86,400) 5.XII.73

YVES TANGUY *Roux en Hiver* On panel Signed and dated '32 10½in by 13¾in
London £35,000 ($84,000) 3.VII.74

RENE MAGRITTE *L'île au Tresor* Gouache Signed Executed *c.* 1942 17¾in by 24½in
New York $54,000 (£22,500) 2.V.74

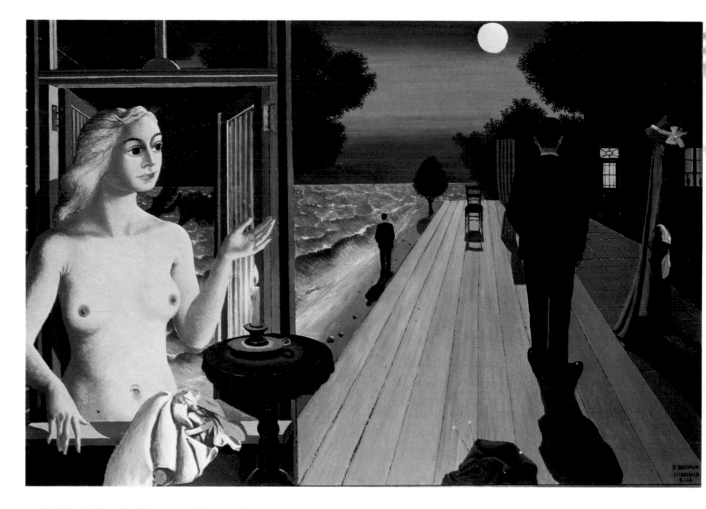

PAUL DELVAUX *Les Adieux* Signed and dated 9-64 48in by 72in

New York $160,000 (£66,667) 2.V.74

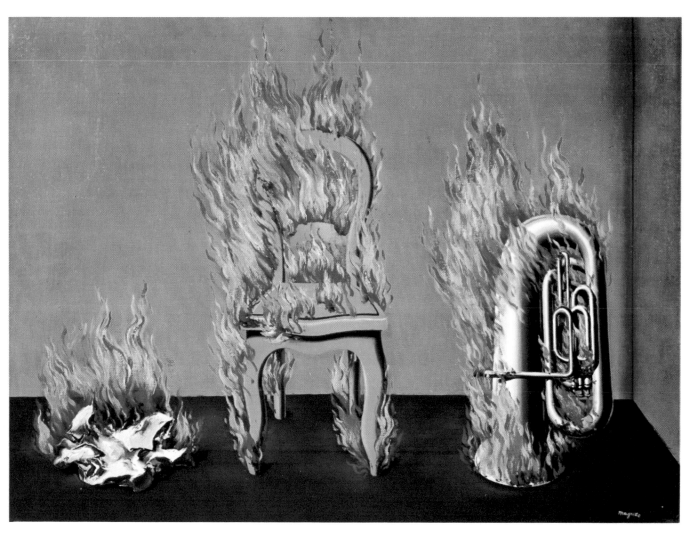

RENE MAGRITTE *L'Echelle de Feu,I* Signed Painted in 1933 21¼in by 28¾in

New York $100,000 (£41,667) 2.V.74 Sold at Sotheby's in 1970 for £15,000 ($36,000)

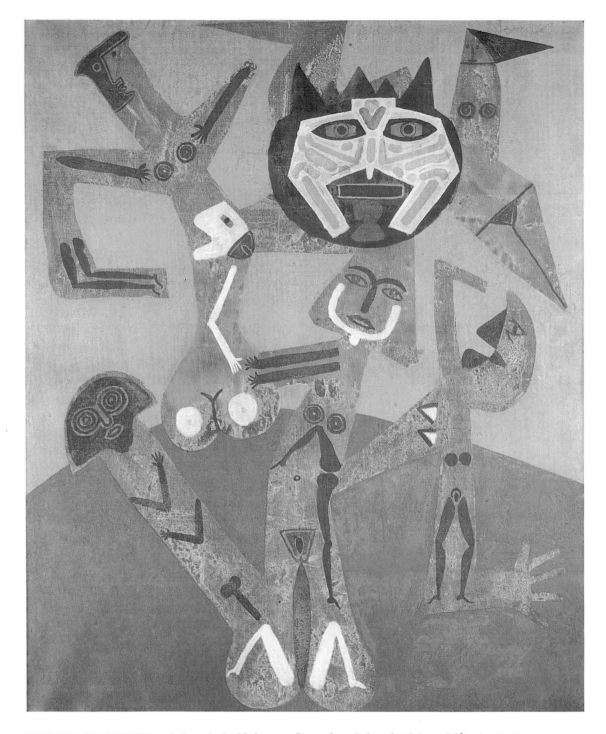

VICTOR BRAUNER *Arbre de la Volupté* Signed and dated 1961 39¼in by 32in

London £29,000 ($69,600) 3.IV.74

Post-War Art

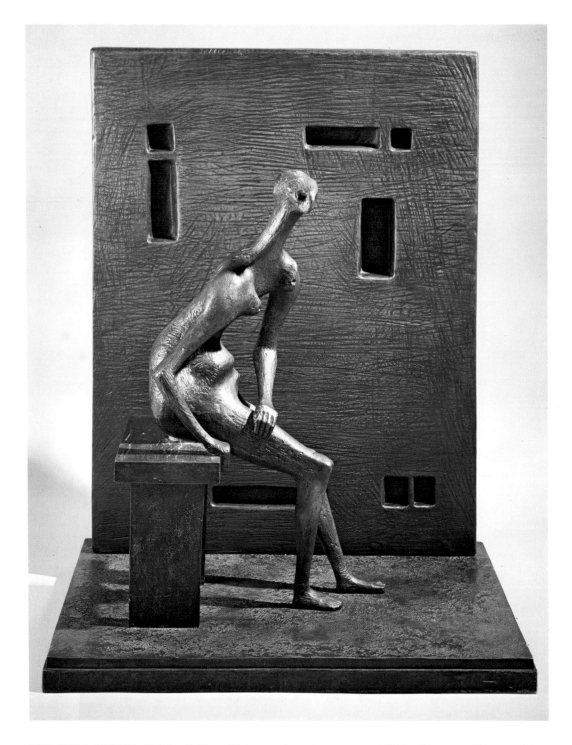

HENRY MOORE, O.M., C.H. *Girl seated against square Wall* Bronze Executed in 1957-58, one of an edition of twelve

New York $90,000 (£37,500) 17.X.73 From the collection of Mrs Cecile Marcoux Baillargeon, of Montreal

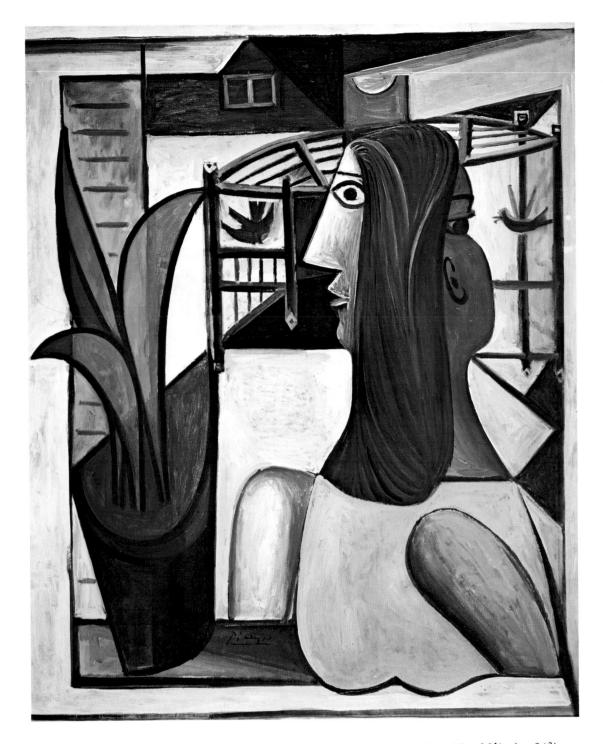

PABLO PICASSO *Buste devant la Fenêtre* Signed Painted *c* 1941-42 39¼in by 31¾in

New York $375,000 (£156,250) 17.X.73 From the collection of
Bernice McIlhenny Wintersteen, of Pennsylvania

NICOLAS DE STAEL *Fleurs grises* Signed Painted in 1952 51½in by 35½in

New York $150,000 (£62,500) 28.XI.73 From the Estate of the
late Barbara McFadden Willcox

BEN NICHOLSON, O.M. *Blue Trevose* Signed, titled and dated
Dec. 1957 on the reverse 46¾in by 29¾in

New York $105,000 (£43,750) 1.V.74 From the collection of
Arnold H Maremont

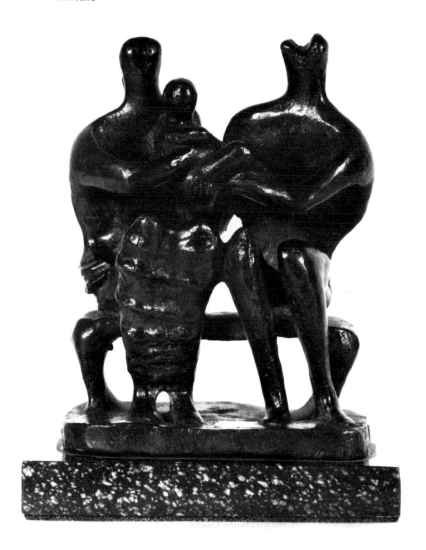

HENRY MOORE, O.M., C.H.
Maquette for Family Group, 1945
Bronze, one of an edition of seven
Height 5in

London £17,500 ($42,000)
19.VI.74

HENRY MOORE, O.M., C.H.
Reclining Figure No. 5 Bronze
Executed in 1952, one of an edition
of nine Length 8½in

London £8,000 ($19,200)
21.XI.73

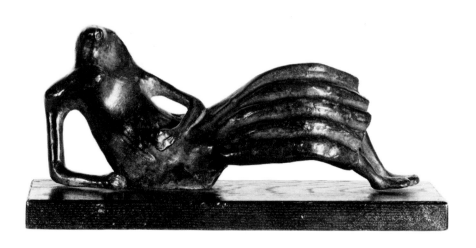

HENRY MOORE, O.M., C.H.
*Madonna and Child, a maquette,
1943* Bronze, one of an edition of
seven Height 6in

London £15,000 ($36,000)
19.VI.74

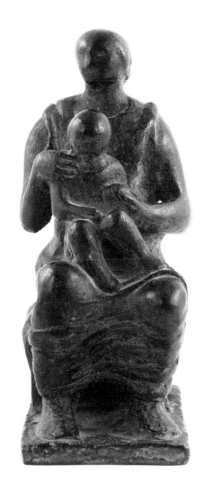

HENRY MOORE, O.M., C.H.
Reclining Figure Bronze
Executed *c.* 1945 Length 6in

New York $27,000 (£11,250)
3.V.74 From the collection of the
late R Sturgis Ingersoll, of
Philadelphia

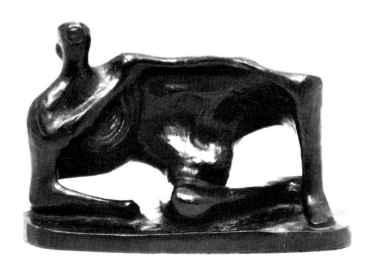

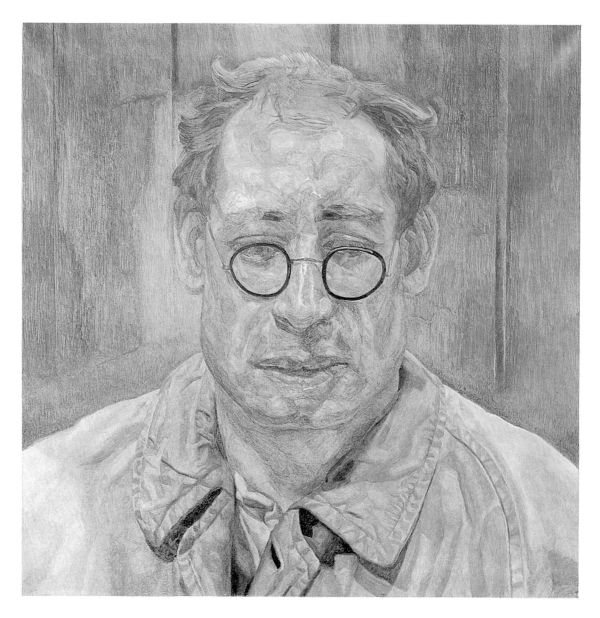

LUCIAN FREUD *Portrait of a Man* Painted *c.* 1957-58 23½in by 23½in

London £15,000 ($36,000) 19.VI.74

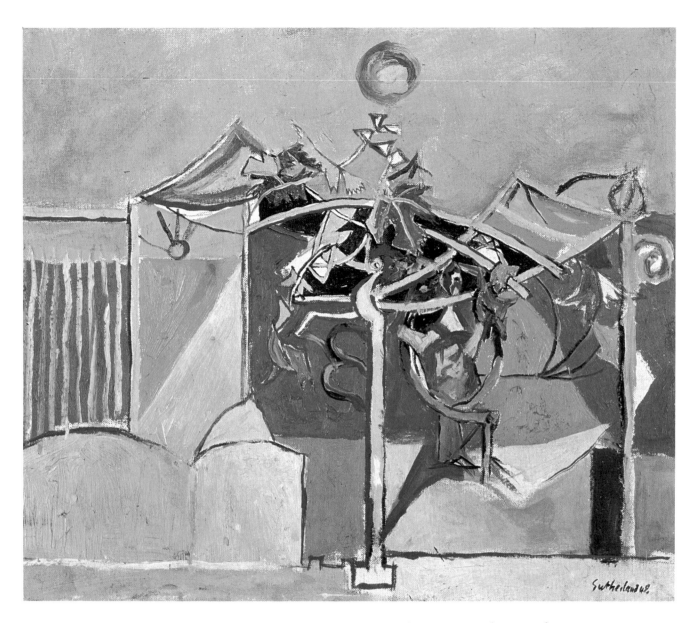

GRAHAM SUTHERLAND, O.M. *Vine Pergola* Painted in 1948 18¼in by 21¾in

London £11,000 ($26,400) 19.VI.74

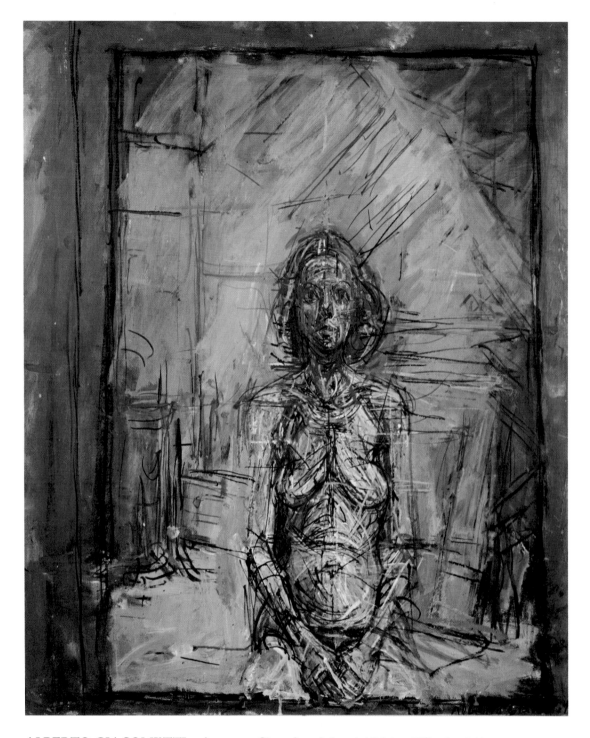

ALBERTO GIACOMETTI *Annette* Signed and dated 1954 25¼in by 21in

New York $160,000 (£66,667) 1.V.74 From the collection of Arnold H Maremont

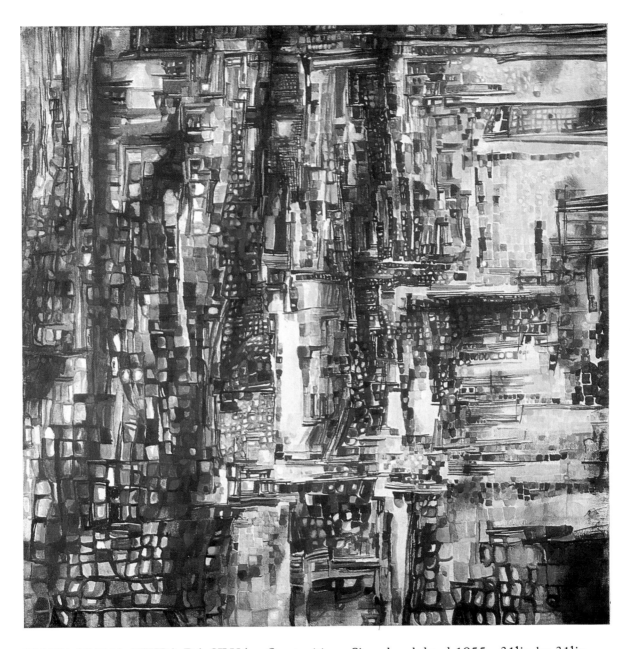

MARIA ELENA VIEIRA DA SILVA *Composition* Signed and dated 1955 31¼in by 31¼in

London £21,000 ($50,400) 3.IV.74

POST-WAR ART

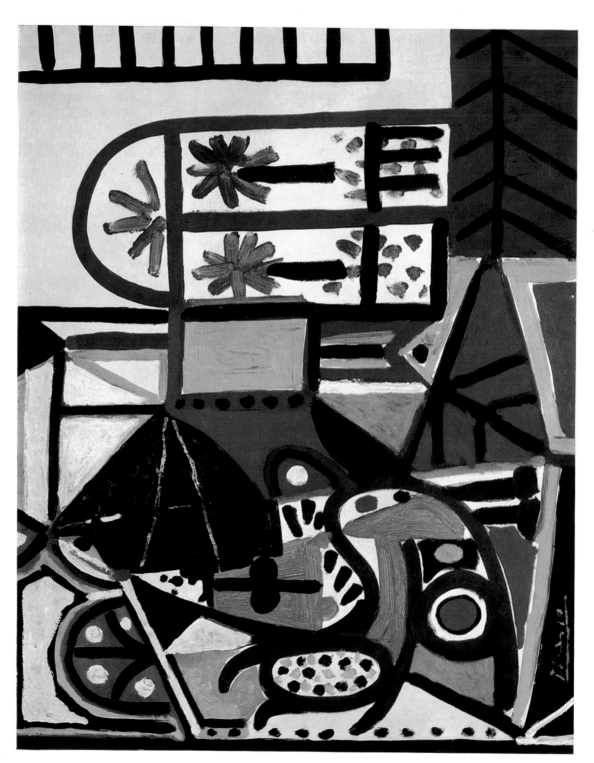

PABLO PICASSO *Femme dans l'Atelier* Signed Painted in Cannes between 11th and 19th May 1956
25¾in by 31¼in

London £60,000 ($144,000) 3.VII.74

178

JEAN DUBUFFET *La Barbe d'Otbon* Signed and dated '59 20in by 13½in

Inked paper collage

New York $34,000 (£14,167) 1.V.74 From the collection of Arnold H Maremont

PABLO PICASSO *Le Picador attablé* Brush and ink wash Signed and dated 14.7.59 20in by 25¼in

New York $32,000 (£13,333) 18.X.73 From the collection of Dr Fowler, of Washington, D.C.

179

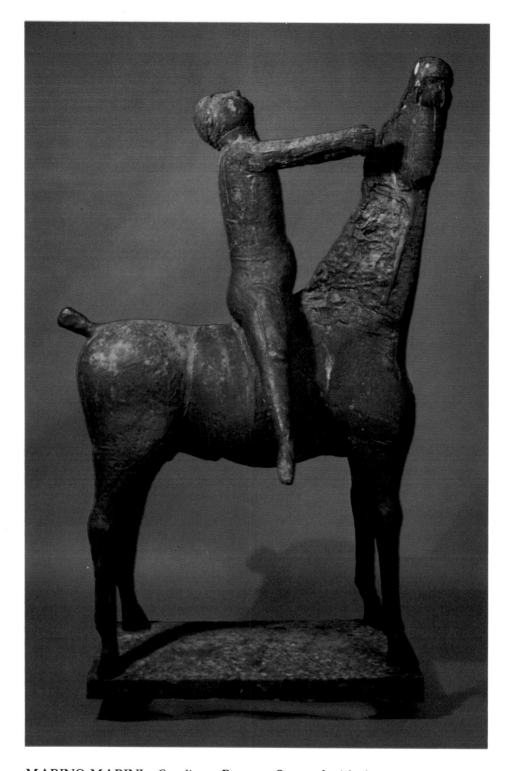

MARINO MARINI *Cavaliere* Bronze Stamped with the monogram
Executed in 1949 in an edition of three casts
Height 73½in

New York $160,000 (£66,667) 2.V.74 From the collection of the
late R Sturgis Ingersoll, of Philadelphia

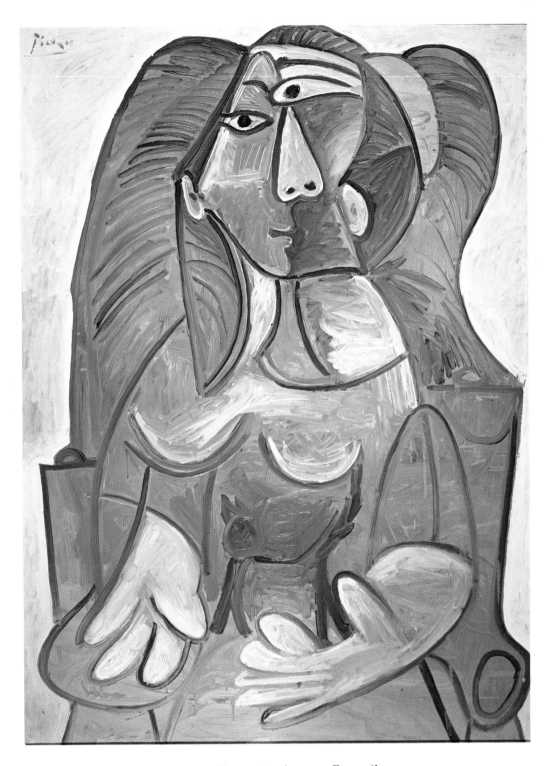

PABLO PICASSO *Femme au Chat assise dans un Fauteuil*
Signed; dated 25.2.64/12.3 51¼in by 38¼in

New York $210,000 (£87,500) 17.X.73 From the collection of
Bernice McIlhenny Wintersteen, of Pennsylvania

JEAN DUBUFFET *Paysage du Pas-de-Calais III* Signed and dated '63 63¾in by 102¾in

New York $110,000 (£45,833) 2.V.74

NICOLAS DE STAEL *Les Trois Pommes* On panel Painted *c.* 1952 10½in by 18in

New York $70,000 (£29,167) 28.XI.73

GIORGIO MORANDI *Natura Morta* Signed Painted *c.* 1952 13½in by 19½in

New York $65,000 (£27,083) 1.V.74 From the collection of Arnold H Maremont

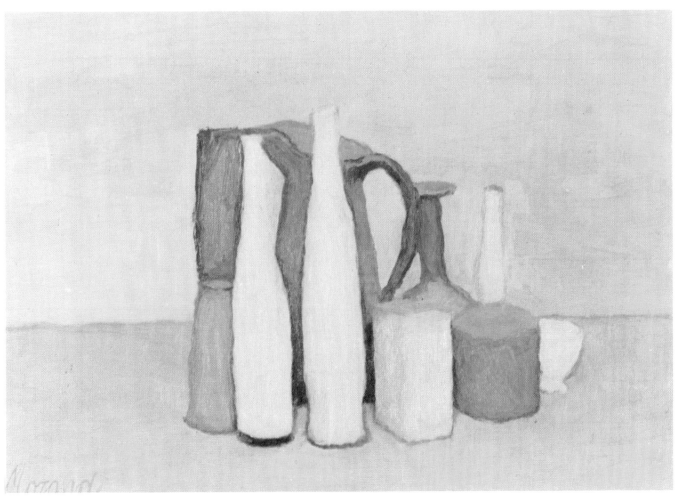

183

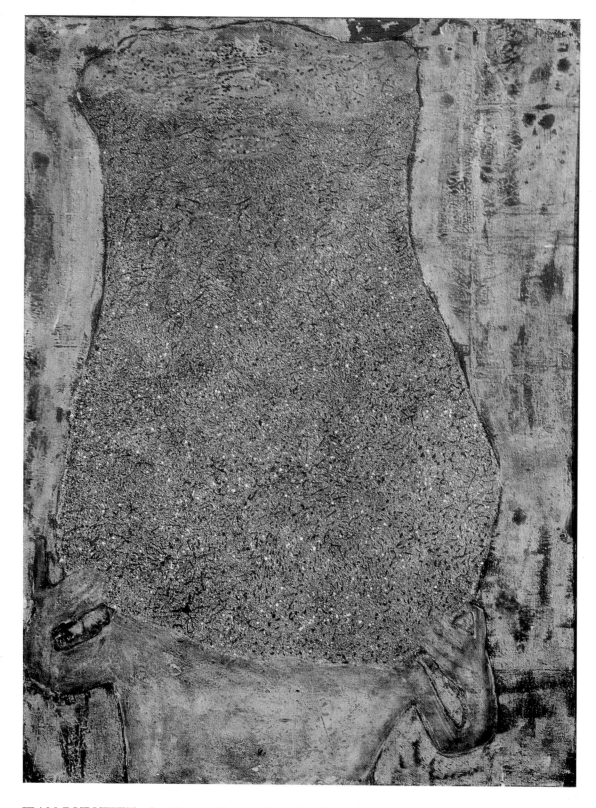

JEAN DUBUFFET *Le Vase de Barbe* Signed and dated '59 51in by 38¼in

London £44,000 ($105,600) 3.IV.74

MATTA (ROBERTO
ECHAURREN) *Quand les Roses
sont belles* On canvas Painted in
1952 39½in by 44¾in

New York $35,000 (£14,583)
3.V.74

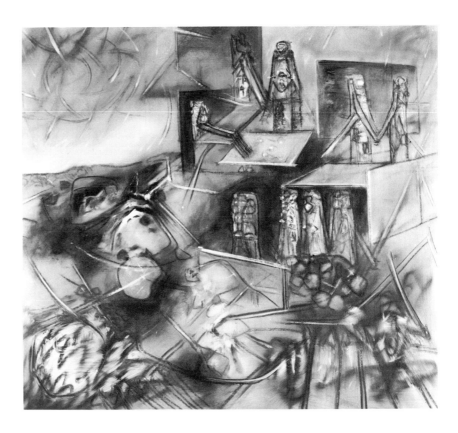

JEAN-PAUL RIOPELLE
Composition Signed and dated '51
51in by 77in

New York $38,000 (£15,833)
3.V.74 From the collection of the
late R Sturgis Ingersoll,
of Philadelphia

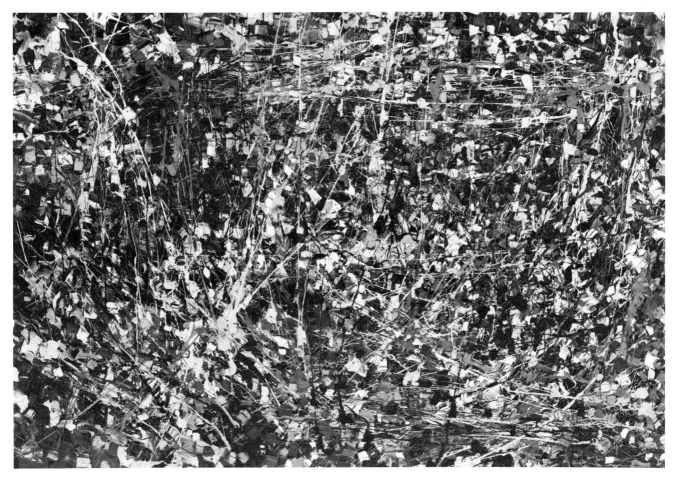

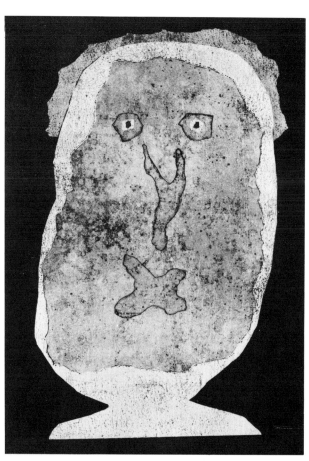

JEAN DUBUFFET *L'Enflé-Chique I* Set of ten
lithographs comprising the final state and nine
progressive colour separations and proofs, each
annotated in pencil by the artist, initialled and
numbered 4/4 (the final state was published in an
edition of 20 plus 5 numbered in Roman
numerals) 23½in by 14⅛in

New York $10,250 (£4,270) 14.V.74

PABLO PICASSO *Bacchanale au Taureau noir*
Linoleum cut printed in colours Signed in pencil
and numbered 34/50 Executed in 1959
20½in by 25¼in

Los Angeles $8,000 (£3,333) 6/7.III.74

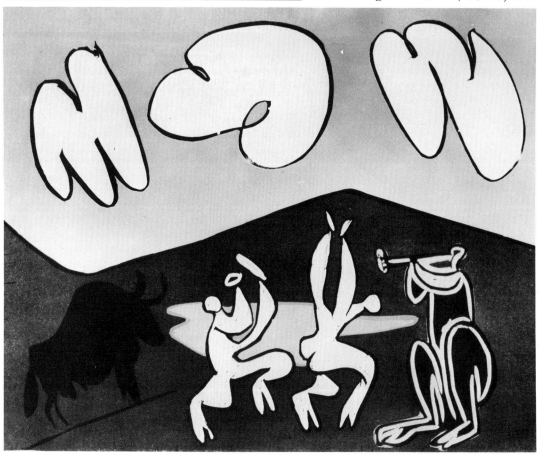

Contemporary Art

ARSHILE GORKY *Housatonic* Black ink and crayon on paper Signed and dated '43
18in by 23½in

New York $55,000 (£22,917) 3.V.74 From the collection of the Norton Simon, Inc.,
Museum of Art, Beverly Hills

WILLEM DE KOONING *Police Gazette* Oil, enamel and charcoal on canvas Signed; dated 1955 on the reverse 43¼in by 50¼in

New York $180,000 (£75,000) 18.X.73 From the collection of Robert C Scull, of New York

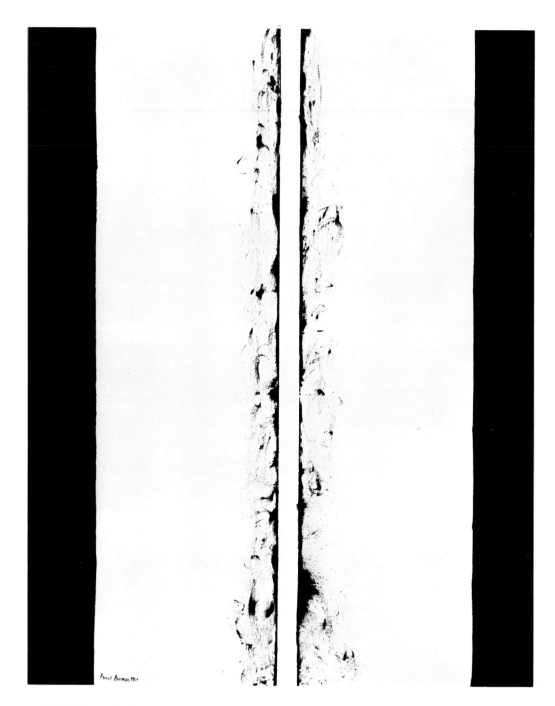

BARNETT NEWMAN *White Fire II* Signed and dated 1960 96in by 76in

New York $155,000 (£64,583) 18.X.73 From the collection of Robert C Scull, of New York

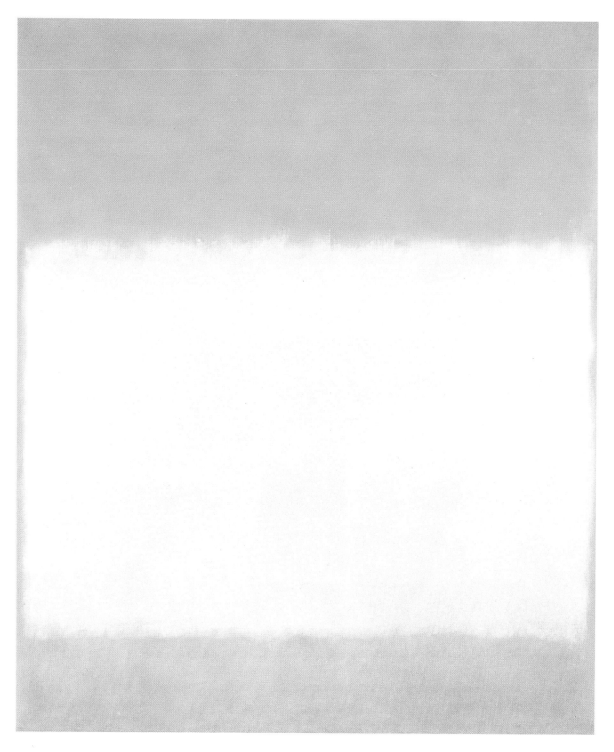

MARK ROTHKO *Yellow and White* Painted in 1956 68in by 58in

New York $110,000 (£45,833) 1.V.74 From the collection of Arnold H Maremont

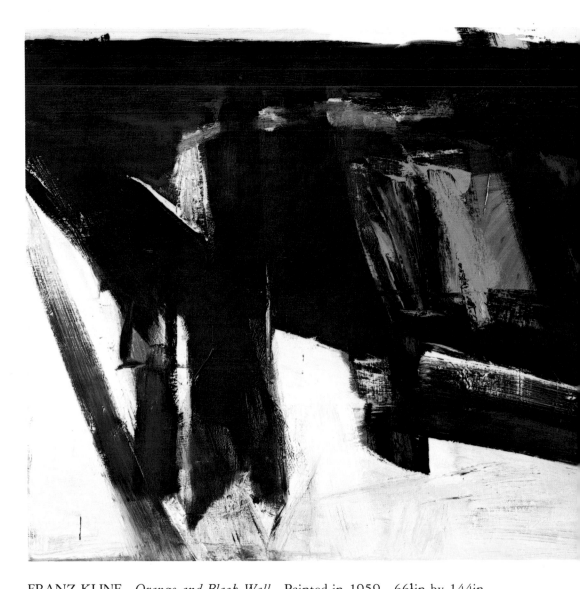

FRANZ KLINE *Orange and Black Wall* Painted in 1959 66½in by 144in

New York $125,000 (£52,083) 18.X.74 From the collection of Robert C Scull, of New Yo

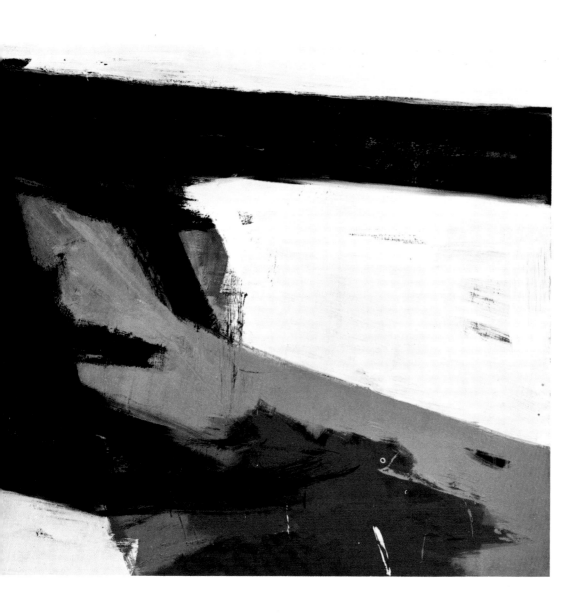

ANDY WARHOL *Flowers* Painted in 1964 82in by 162in

New York $135,000 (£56,250) 18.X.74 From the collection of Robert C Scull, of New

JASPER JOHNS *Double White Map* Encaustic and collage on canvas Painted in 1965 90in by 70in

New York $240,000 (£100,000) 18.X.73 From the collection of Robert C Scull, of New York

SAM FRANCIS *Violet, Yellow and White* Painted in 1958 57in by 38in

New York $45,000 (£18,750) 1.V.74 From the collection of
Arnold H Maremont

JASPER JOHNS *Painted bronze* Bronze Executed in 1960 This is no. 1 of an edition of two
Height 7½in

New York $90,000 (£37,500) 18.X.73 From the collection of Robert C Scull, of New York

ALEXANDER CALDER
General Sherman Stabile-mobile
Signed with the initials
Executed in 1946 Height 32in

New York $46,000 (£19,167)
1.V.74 From the collection of
Arnold H Maremont

JOSEPH CORNELL
Moon Surface (Mond-Oberflaeche)
Construction with objects Executed
in 1955 14½in by 16in

New York $35,000 (£14,583)
1.V.74 From the collection of
Arnold H Maremont

ROBERT RAUSCHENBERG *Express* Oil on canvas with silkscreen Painted in 1963 72in by 120in

New York $150,000 (£62,500) 3.V.74

ELLSWORTH KELLY *Wave Motif* Acrylic on canvas Signed with the initials and dated '59 on the reverse; 60in by 94in

London £15,000 ($36,000) 3.IV.74 From the collection of Mr David and Lady Pamela Hicks

FRANK STELLA *Sidney Guberman* Metallic paint on canvas Painted in 1963 77in by 89½in
New York $67,500 (£28,125) 3.V.74

KENNETH NOLAND *Catherine* Acrylic on canvas Painted *c.* 1959-60 72in by 69in

London £13,500 ($32,400) 3.IV.74 From the Estate of the late Joakim Bonnier, of Le Muits, Switzerland

RICHARD LINDNER *Moon over Alabama* Signed and dated 1963
80in by 40in

New York $135,000 (£56,250) 3.V.74

JAMES ROSENQUIST *Early in the Morning* Signed and
dated 1963 95in by 56in

New York $45,000 (£18,750) 18.X.73 From the collection of
Robert C Scull, of New York

CHRISTO *Wrapped Vespa Motorcycle* Plastic, rope and Vespa motorcycle Signed and dated 1963 on plastic 43¼in by 63in by 23¾in

New York $50,000 (£20,833) 3.V.74

TOM WESSELMAN *Great American Nude No. 73* Oil on canvas Signed, titled and dated 1965 on the stretcher 72in by 89in

London £18,000 ($43,200) 3.IV.74

ROY LICHTENSTEIN *Mirror* Signed and dated 1970 on the
reverse 72½in by 48¼in

London £17,000 ($40,800) 3.IV.74

LUCIO FONTANA *Concetto Spaziale—La Fine di Dio* Signed Painted in
1962-63 70in by 49in

London £28,000 ($67,200) 3.IV.74

JOSEF ALBERS *Homage to the Square: Decided* Signed with the initials and dated '60 40in by 40in

New York $55,000 (£22,917) 1.V.74 From the collection of Arnold H Maremont

DAVID HOCKNEY *Building, Pershing Square, Los Angeles* Acrylic on canvas Signed, titled and dated *February-March* 1964 on the reverse 58in by 58in

London £24,000 ($57,600) 3.IV.74 From the collection of R Chapman

CY TWOMBLY *Bolsena* Oil and pencil on canvas Painted in 1969 78½in by 94¼in

London £21,000 ($50,400) 3.IV.74

ANTONI TAPIES *Le Lit bleu* Oil and sand on canvas Signed on the reverse Painted in 1969 53¼in by 76¼in

London £21,800 ($52,320) 3.IV.74

AD REINHARDT *Abstract Painting* Signed, titled and dated '60 on the reverse
60in by 60in

London £24,000 ($57,600) 3.IV.74

ROBERT RYMAN *Composition* Oil on canvas Signed Painted in 1961 48½in by 48½in

London £8,750 ($21,000) 3.IV.74

PIERO MANZONI *Achrome* Kaolin on pleated canvas Signed and dated 1959 on the reverse 27½in by 35½in

London £4,200 ($10,080) 3.IV.74

MORRIS LOUIS *'2-10'* Acrylic on canvas Painted in 1962 81½in by 18½in

London £17,000 ($40,800) 3.IV.74

SOL LEWITT *'7 two part variations on 2 different kinds of cubes'* White painted metal; each of the seven pieces is placed at exactly 27½in from the other Executed in 1967-68
Each piece: 55in by 27½in by 27½in

London £7,000 ($16,800) 3.IV.74

RICHARD McCLEAN *Ihle Country*
Painted in 1967 60in by 60in

London £13,000 ($31,200) 3.IV.74

ROBERT COTTINGHAM *El Rey* Oil on canvas Signed, titled and dated 1969 on
the reverse 66in by 109in

London £8,200 ($19,680) 3.IV.74

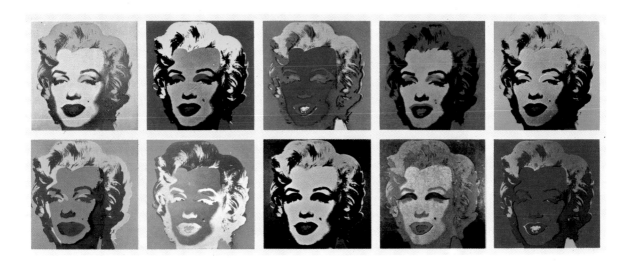

ANDY WARHOL *Marilyn Monroe* Complete set of ten silkscreens on paper, an edition of 250 Each signed and dated 1967 on the reverse Each 36¼in by 36¼in

London £5,000 ($12,000) 3.IV.74

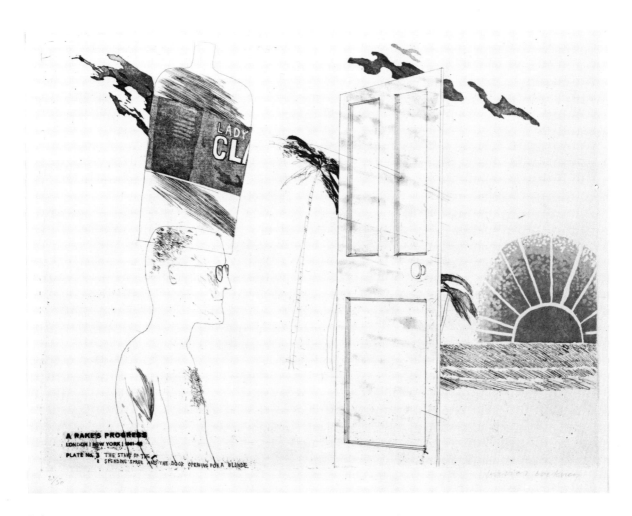

DAVID HOCKNEY *A Rake's Progress* A set of sixteen etchings, 1961 to 1963 Each signed in pencil and numbered 21/50 30.5cm by 40cm

London £5,100 ($12,240) 23.IV.74

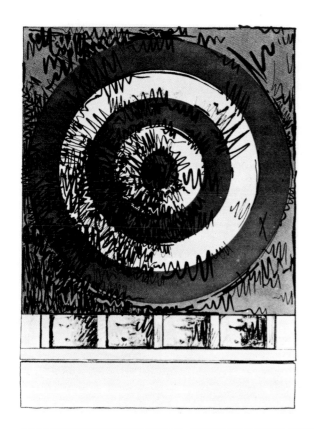

JASPER JOHNS *Target with four Faces* Silkscreen printed in colours Signed in red pen, dated '68 and numbered 62/100 36in by 26⅛in

New York $1,700 (£708) 8.XI.73

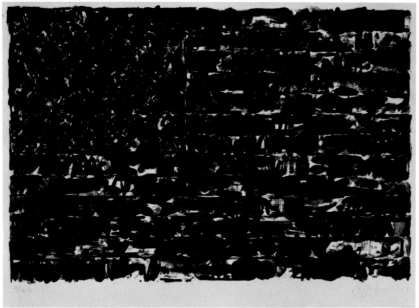

JASPER JOHNS *Flag I*
Lithograph Signed in pencil, dated '60 and numbered 4/23
17¼in by 26½in

New York $3,500 (£1,458)
8.XI.73

ED RUSCHA *Hollywood in the Rain* Lithograph printed in blue and black Signed and dated 1969 in pencil, numbered 7/8

Los Angeles $1,900 (£792)
13.XI.73

English Painting 1890-1950

JAMES ABBOTT McNEILL WHISTLER *Finette* Drypoint and etching

New York $7,000 (£2,916) 14.V.74

JAMES ABBOTT McNEILL WHISTLER *Portrait of Whistler* Drypoint on Japan
9¾in by 6in

New York $6,000 (£2,500) 14.V.74

JAMES ABBOTT McNEILL WHISTLER *Old Battersea Bridge*
Black and white chalks on buff paper Signed with a butterfly device
10¼in by 6½in

London £1,800 ($4,320) 21.XI.73 From the collection of
Christopher Norris

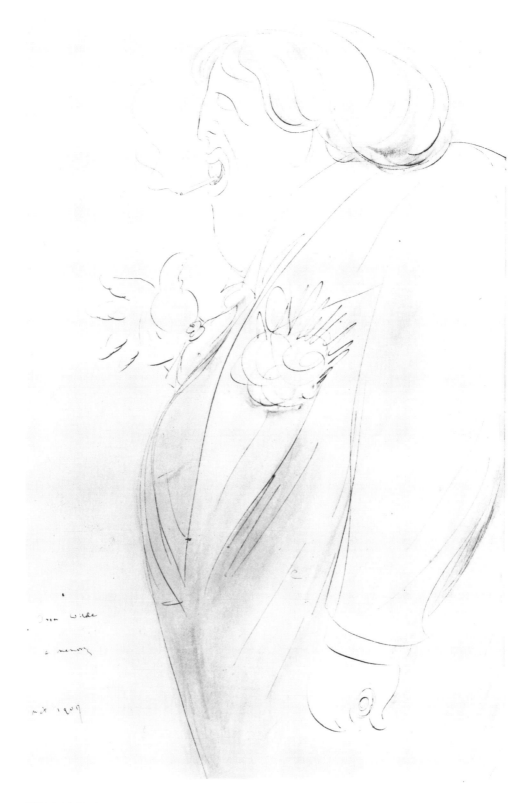

SIR MAX BEERBOHM *Oscar Wilde, a memory* Pen and ink and
grey wash Painted in 1909 12¾in by 8½in

London £1,500 ($3,600) 19.VI.74 From the collection of the late
Hugh Beaumont, of London

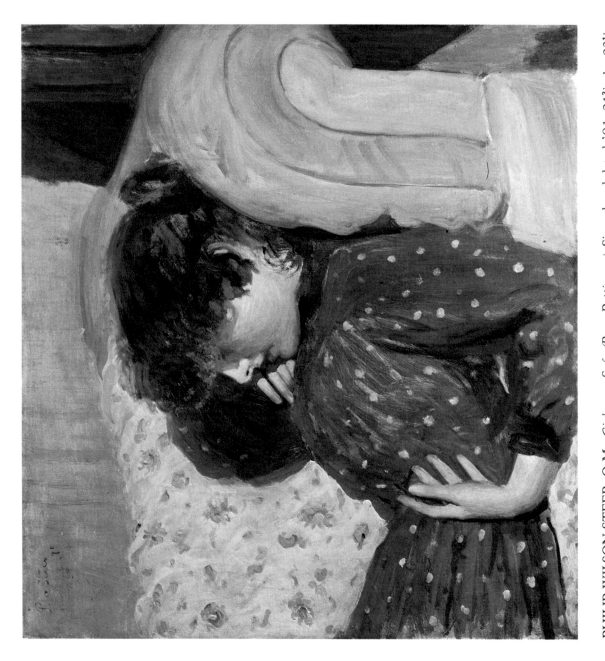

PHILIP WILSON STEER, O.M. *Girl on a Sofa (Rose Pettigrew)* Signed and dated '91 21¼in by 23½in

London £11,500 ($27,600) 21.XI.73 From the collection of D Samuel, of London

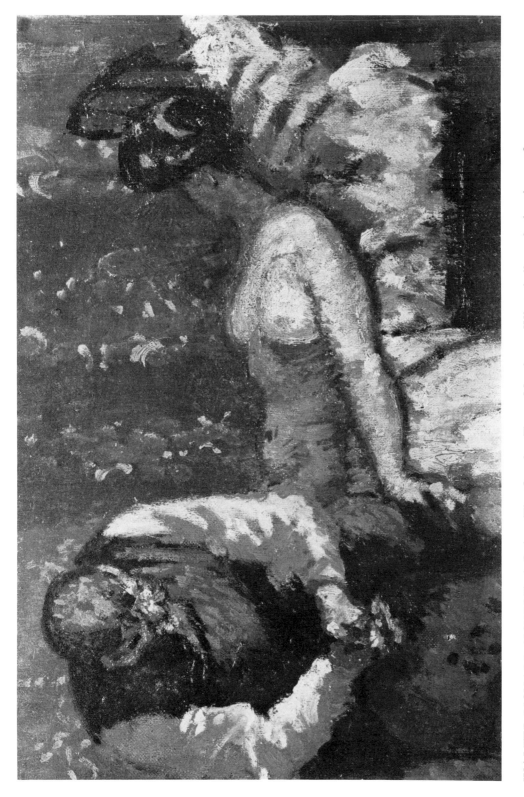

WALTER RICHARD SICKERT, A.R.A. *The Camden Town Murder or What shall we do for the rent?*
Signed Painted *c.* 1908 10in by 14in

London £9,500 ($22,800) 21.XI.73 From the collection of the late R M. Coode

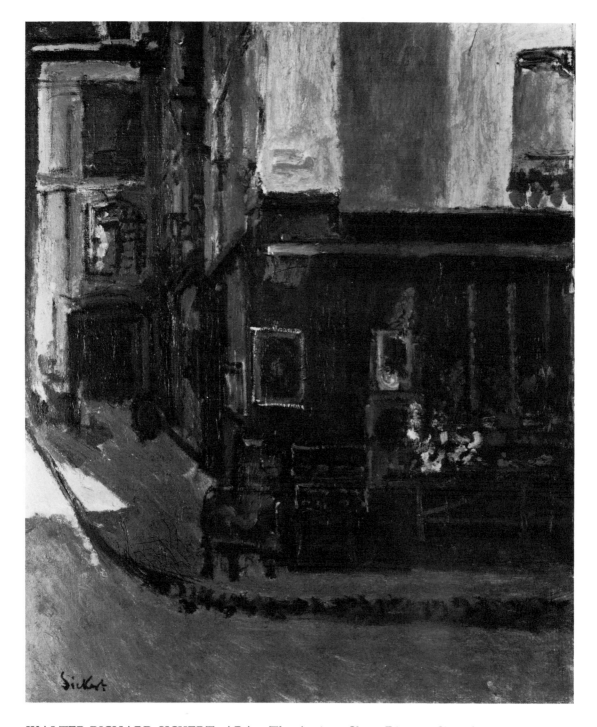

WALTER RICHARD SICKERT, ARA *The Antique Shop, Dieppe* Signed
Painted *c.* 1906 23½in by 19¼in

London £8,000 ($19,200) 21.XI.73 From the collection of D Samuel, of London

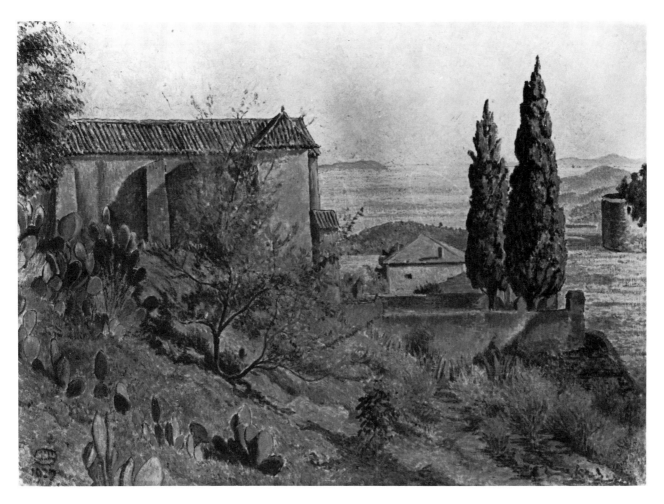

LUCIEN PISSARRO *La Chapelle de Saint François, Bormes* Signed with the monogram and dated 1927 20½in by 28¼in

London £5,500 ($13,200) 21.XI.73 From the collection of D Samuel, of London

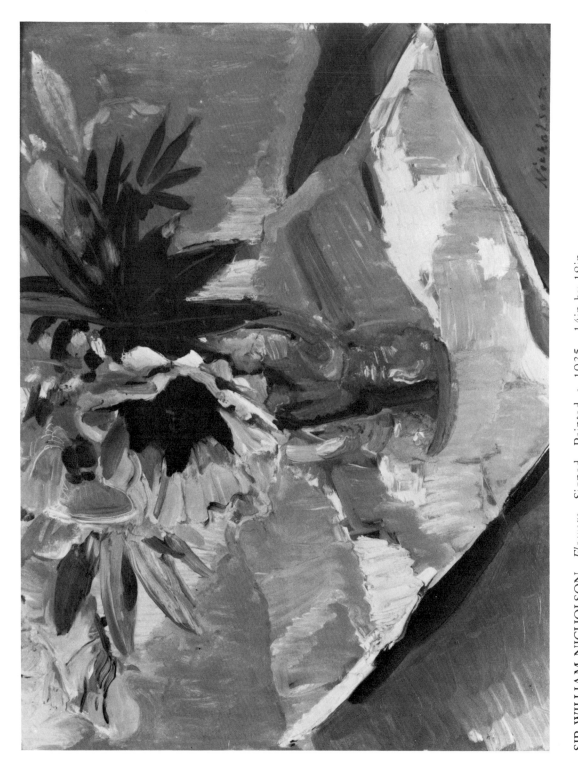

SIR WILLIAM NICHOLSON *Flowers* Signed Painted *c*. 1935 14in by 18in

London £4,000 ($9,600) 21.XI.73 From the collection of R Somervell, of Staveley, Kendal, Westmorland

GWEN JOHN *Little fair haired Boy sitting in a Church*
Pencil and watercolour heightened with bodycolour
8¾in by 6¼in

London £700 ($1,680) 21.XI.73

GWEN JOHN *Dame en Manteau vert* Pencil and
watercolour, heightened with bodycolour 6¼in by 5in

London £1.300 ($3,120) 21.XI.73

231

HAROLD GILMAN *Meditation* Painted *c.* 1913 23½in by 17¾in

London £5,000 ($12,000) 13.III.74 From the collection of the late Mrs F A Girling, of Colchester

WALTER RICHARD SICKERT, A.R.A. *The New Home* Signed Painted in 1908
19in by 15⅝in

London £18,500 ($44,400) 13.III.74 From the collection of the late Mrs F A Girling,
of Colchester

SPENCER GORE *Tennis in Mornington Crescent Gardens* Painted in 1909 Signed
19½in by 23½in

London £12,000 ($28,800) 13.III.74 From the collection of the late Mrs F A Girling, of
Colchester

ROBERT BEVAN *The Cab Yard, St. John's Wood, Evening* Painted *c.* 1910 24¾in by 30in

London £17,000 ($40,800) 13.III.74 From the collection of the late Mrs F A Girling, of Colchester

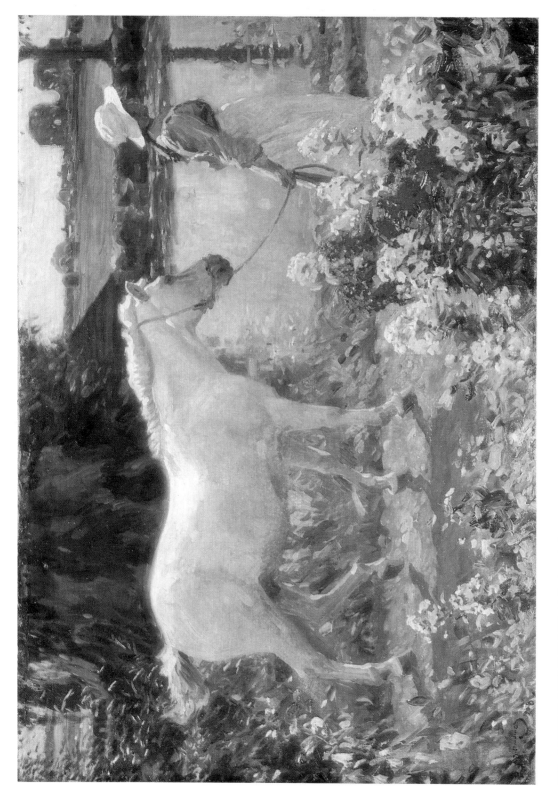

SIR ALFRED MUNNINGS. P.R.A. *The Path to the Orchard* Painted in 1908 29½in by 42in

London £32,000 ($76,800) 19.VI.74

MARK GERTLER *Self-Portrait* Pencil Signed and dated '09 10in by 7¾in

London £1,800 ($4,320) 13.III.74 From the collection of the late Kerrison Preston

AUGUSTUS JOHN, O.M., R.A. *Dorelia* Black chalk Signed 13¼in by 9¼in

London £1,700 ($4,080) 13.III.74

PAUL NASH *The Three, 1911* Pen and ink, coloured chalks and wash 15¼in by 10¼in

London £2,700 ($6,480) 19.VI.74

PAUL NASH *Pyramids in the Sea* Black chalk, pen and ink and blue-grey wash Signed
Executed in 1911 12¾in by 11½in

London £3,000 ($7,200) 21.XI.73 From the collection of Mrs J R Grimsdale,
of Forest Row, Sussex

EDWARD BURRA *Bullfight* Pen and ink and watercolour heightened with bodycolour Executed in 1934
22in by 30in

London £6,800 ($16,320) 21.XI.73 From the collection of R L Banks, of London

LAURENCE STEPHEN LOWRY. R.A. *Rounders* Signed and dated 1934 15in by 20in

London £10,000 ($24,000) 21.XI.73 From the collection of Dr Llewelyn Griffith. C.B.E.. of Berkhamstead. Hertfordshire

WILLIAM ROBERTS, R.A. *The Temptation of St Anthony* Painted *c.* 1950-51
60in by 45in

London £5,000 ($12,000) From the collection of Ernest Cooper

SIR STANLEY SPENCER, R.A. *The Temptation of St Anthony* Painted in 1945
47½in by 35¾in

London £11,500 ($27,600) 21.XI.73 From the collection of D Samuel, of London

EDWARD BURRA *Le Bal, No. 6* Pencil and watercolour, heightened with bodycolour
Executed in November 1928 26in by 18¾in

London £8,200 ($19,680) 19.VI.74

American Painting 1885-1955

CHILDE HASSAM *The Water Garden* Signed and dated 1909 24in by 36in

New York $140,000 (£58,330) 23.V.74 From the Estate of the late Therese Lownes Noble

MAURICE B PRENDERGAST *''Splash of Sunshine and Rain'' (Church of
St Mark—Venice)* Watercolour Signed and dated 1899 19¼in by 14½in

New York $67,500 (£28,125) 13.XII.73

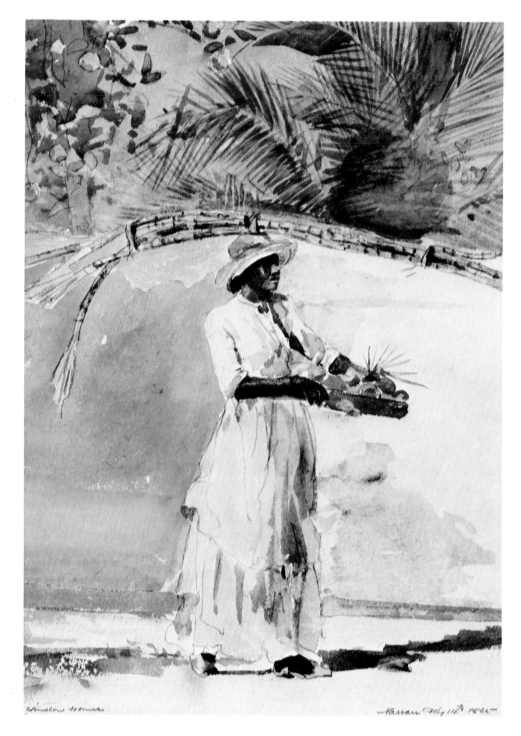

WINSLOW HOMER, N.A. *Fruit Vendor at Nassau* Watercolour and pencil
Signed and dated *Nassau* July 14th, 1885 12½in by 9in

New York $65,000 (£27,083) 17.X.73 From the collection of the late
Edwin C Vogel, of New York

CHARLES BURCHFIELD, N.A. *May Wind, Gardenville* Watercolour Signed with the insignia and dated 1945-56 30in by 40in

New York $35,000 (£14,583) 13.XII.73

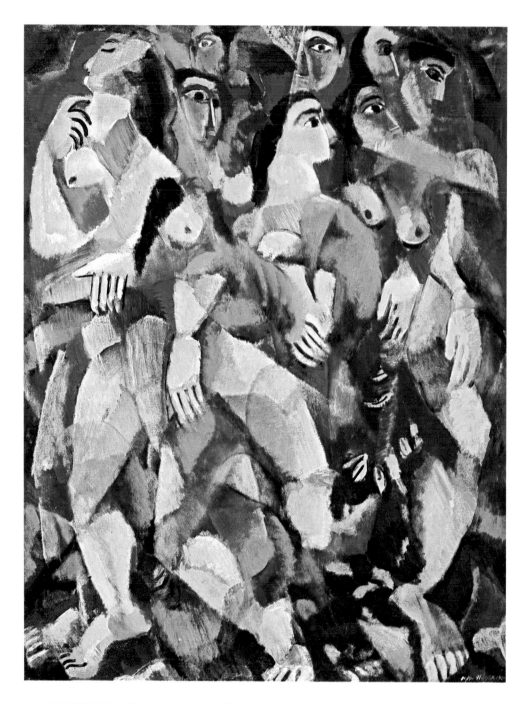

MAX WEBER *Tapestry no. 1* Signed and dated 1913 39½in by 29½in

New York $18,000 (£7,500) 13.XII.73

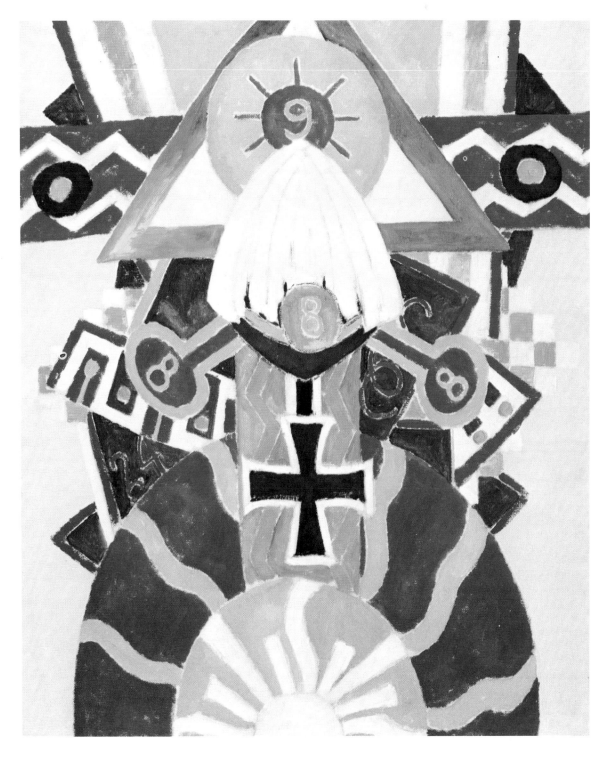

MARSDEN HARTLEY *Berlin Abstraction* Painted in 1914 47in by 39¼in

New York $80,000 (£33,333) 1.V.74 From the collection of Arnold H Maremont

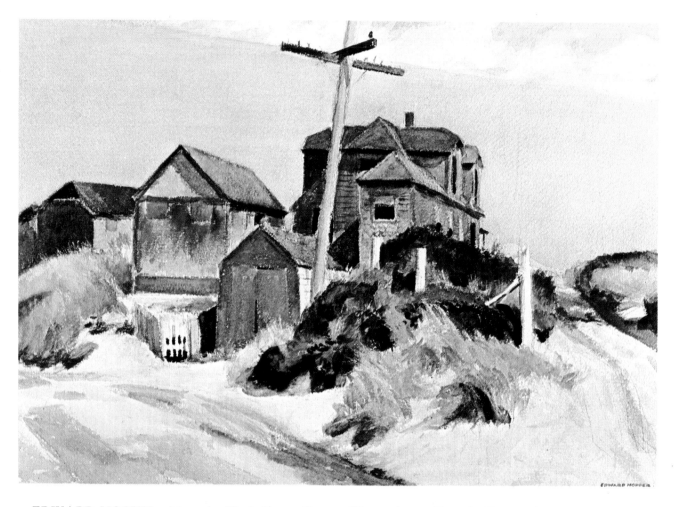

EDWARD HOPPER *Near the Black Shore, Truro* Watercolour Signed Executed in 1936 14in
14in by 20in

New York $47,500 (£19,791) 23.V.74

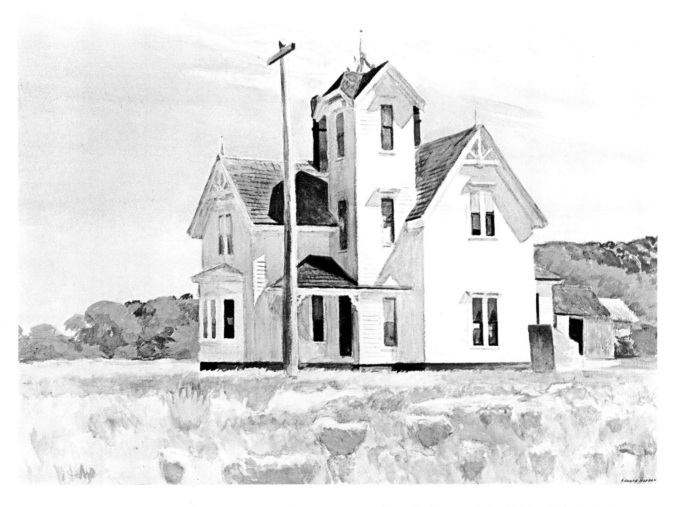

EDWARD HOPPER *House at Eastham* Watercolour Signed Executed in 1932 20in by 28in

New York $57,500 (£23,958) 13.XII.73 From the collection of Albert L Hydeman, of Massachusetts

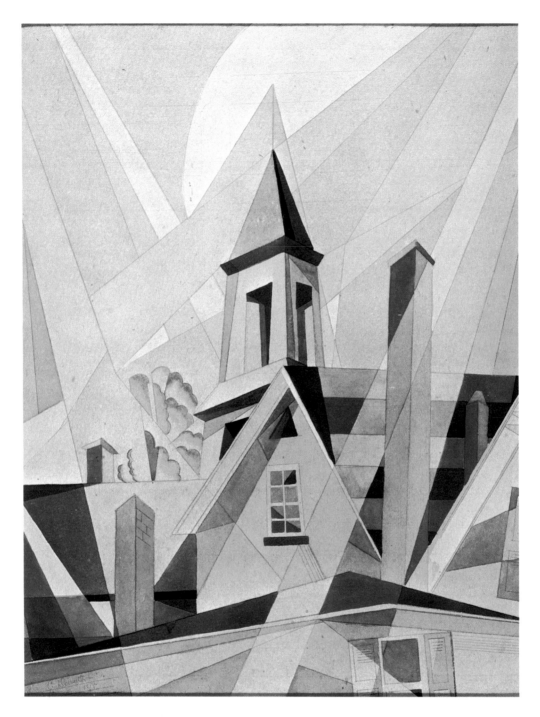

CHARLES DEMUTH *Church in Provincetown, no. 2* Watercolour Signed and dated 1919 17½in by 13½in

New York $23,000 (£9,583) 13.XII.73

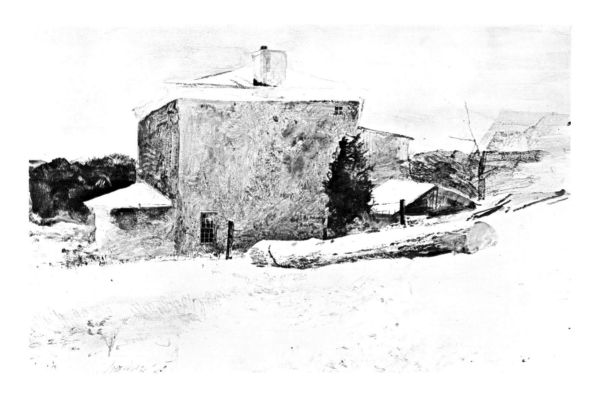

ANDREW WYETH, N.A. *Firewood* Dry brush Signed 13½in by 21½in

New York $26,000 (£10,833) 13.XII.73

GEORGIA O'KEEFFE *In the Patio V* Painted in 1948 24in by 39¾in

New York $32,500 (£13,541) 23.V.74

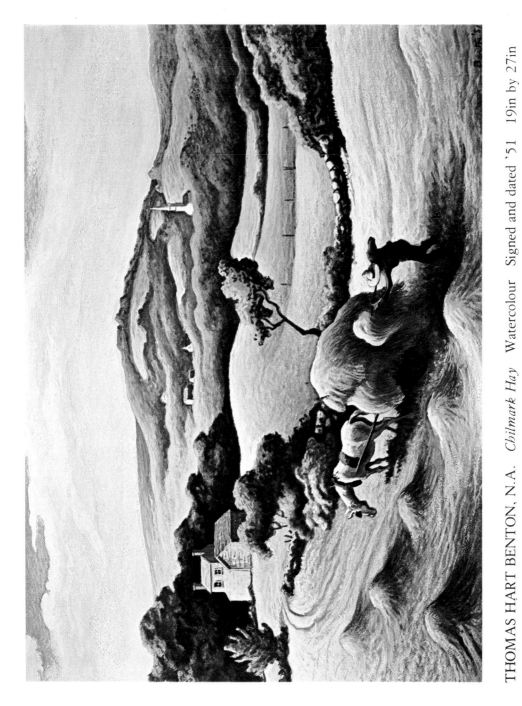

THOMAS HART BENTON, N.A. *Chilmark Hay* Watercolour Signed and dated '51 19in by 27in

New York $17,000 (£7,083) 13.XII.73 From the collection of Albert L Hydeman, of Massachusetts

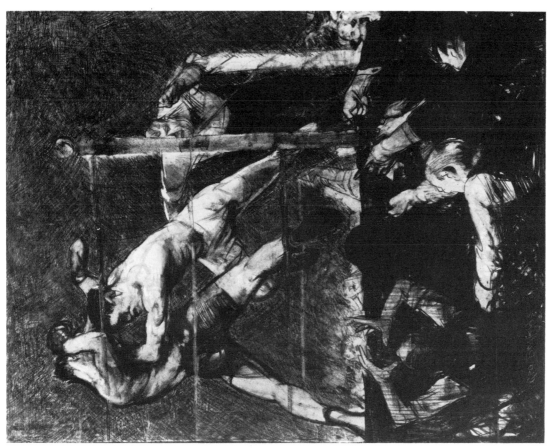

GEORGE BELLOWS, N.A. *The Last Ounce* Lithographic crayon Signed 23in by 18in

New York $15,000 (£6,250) 13.XII.73

PETER BLUME *Maine Coast* Signed and dated Sept. 3, 1926 40in by 30¼in

New York $9,500 (£3,958) 23.V.74 From the collection of the late R Sturgis Ingersoll, of Philadelphia

Index

Index